# PHOTOGRAPHERS' Essential FIELD TECHNIQUES

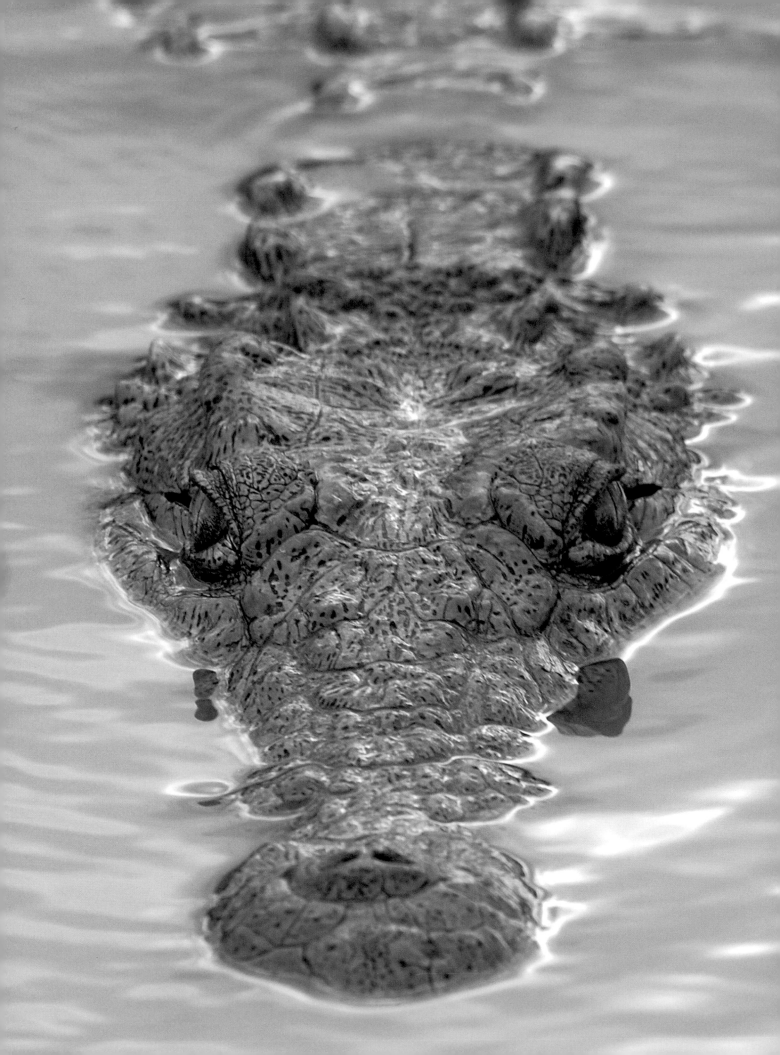

# PHOTOGRAPHERS' Essential FIELD TECHNIQUES

### CHRIS WESTON

David and Charles

A DAVID & CHARLES BOOK
Copyright © David & Charles Limited 2006

David & Charles is an F+W Publications Inc. company
4700 East Galbraith Road
Cincinnati, OH 45236

First published in the UK in 2006

Text and images copyright © Chris Weston 2006
except images pp116–123 © Paul Harcourt Davies
and product shots © the respective manufacturers
(see Acknowledgments, p136)

A catalogue record for this book is available from the British Library.

ISBN-13: 978-0-7153-2199-7 hardback
ISBN-10: 0-7153-2199-4 hardback

ISBN-13: 978-0-7153-2200-0 paperback (USA only)
ISBN-10: 0-7153-2200-1 paperback (USA only)

Printed in China by R.R.Donnelley
for David & Charles
Brunel House    Newton Abbot    Devon

Commissioning Editor   Neil Baber
Editor   Ame Verso
Copy Editor   Nicola Hodgson
Art Editor   Mike Moule
Designer   Jodie Lystor
Production Controller   Kelly Smith

Visit our website at **www.davidandcharles.co.uk**

David & Charles books are available from all good bookshops; alternatively
you can contact our Orderline on 0870 9908222 or write to us at:
FREEPOST EX2 110, D&C Direct, Newton Abbot, TQ12 4ZZ
(no stamp required UK only); US customers call 800-289-0963
and Canadian customers call 800-840-5220.

◀ [page 2] **The power of imagery**
The power of an image to communicate is matched
only by the photographer's ability to interpret and
condense the message that is being sent.

# Contents

# Introduction

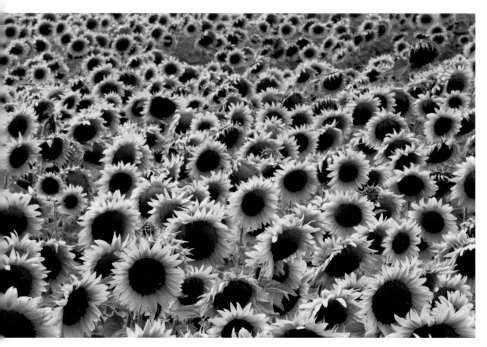

## Many facets

The tools of photography are not only the cameras and lenses but the elements of design that, when brought together with empathy and harmony, have the power to communicate on several different levels. Mastering colour, pattern, texture, shape and line is the way towards creating compelling images.

One of the things you notice when you write a book about photography is how much there is to know on the subject. Simple statements become paragraphs, paragraphs evolve into pages, and pages turn into chapters. Skills and techniques that are second nature to the professional – subconscious actions born from many years in the field – are dusted down, warranting detailed explanation. Photography is a complex science and, while modern technology has removed all but a trace of the chemical element, the underlying skills needed to create compelling images remain the same.

For the enthusiast and non-professional photographer, the problem exists that skills need practising and practice takes time. Time is at a premium when so many of us are balancing work, family and social commitments. It is important, therefore, that any book on photography is written so that the knowledge it imparts is easily assimilated by the reader and the skills it sets out to illuminate can be practised in a manner conducive to all and not just a few.

In writing *Photographers' Essential Field Techniques*, my aim has been to provide a user-friendly manual that clearly and concisely maps your route to making great images of the natural world. From unbiased opinion on choosing the most suitable equipment and deciphering the nuances of the relatively new medium of digital, I go on to explore some of the fundamental building blocks of photography, such as light, composition and exposure, and to reveal some of the mysteries of good fieldwork that can often be the difference between getting the shot and the proverbial 'one that got away'.

I have eschewed science in favour of practical advice that can be easily absorbed and acted upon. Throughout these pages, you will find useful tips that will help you immediately, whether your next photographic adventure is to your own back yard or to the ends of the earth! What I hope to have achieved in this book is a natural balance between detail and practicality that makes the job of taking good pictures an easier one.

Of course, nature photography is as much about nature as it is about photography and often in books the skills that really make the difference are ignored or warrant little more than a sidebar. It has been my experience, and that of my peers, that to succeed in this field requires a level of understanding of the subject and of fieldcraft and woods skills that transcends the bare bones of rudimentary knowledge and idle interest. There is an old saying that asserts that landscape photography is a simple matter of 'f/8 and be there!' What the author of those words failed to mention – whoever he or she was – is that knowing the location of 'there' is the fundamental skill of the successful photographer, requiring far more effort than simply turning up with your camera.

Therefore, another aim of this book is to provide you with the necessary knowledge to find your own 'there'. From understanding weather charts and tide tables to breaking through wild animals' circles of fear, the

## Mastering the art

The skills needed to produce compelling images remain the same today as they were when photography was invented. An ability to best manage light and master the art of composition, together with the essential knowledge of camera technique are prerequisites to achieving great images with a camera.

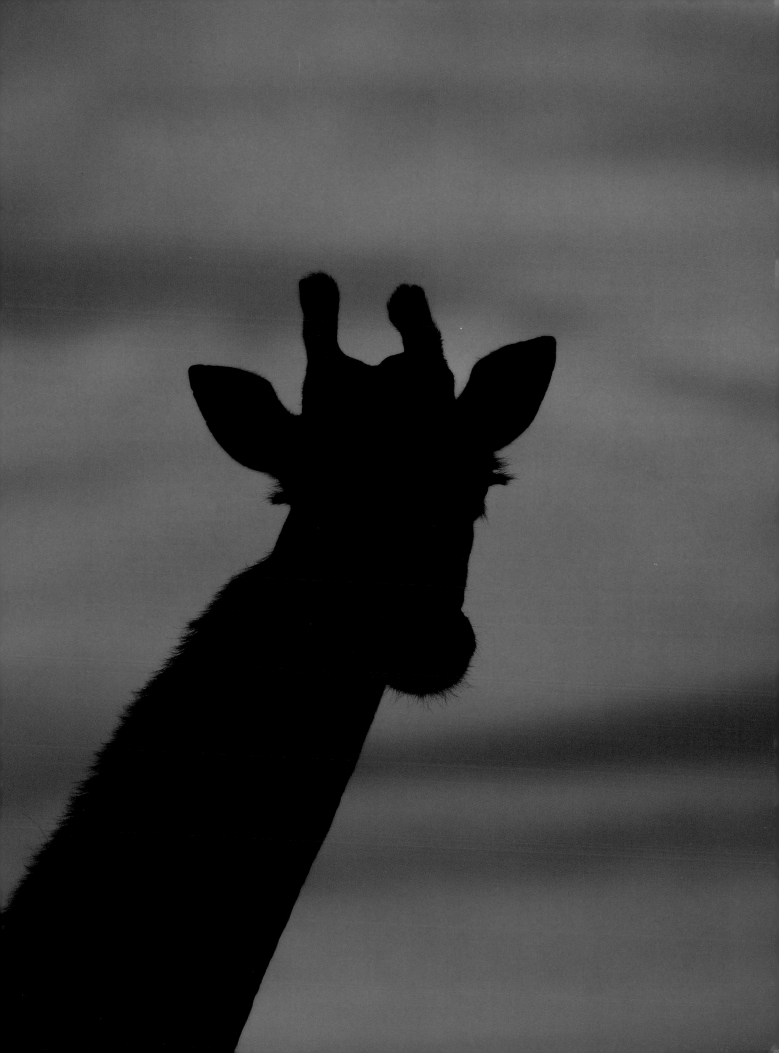

following chapters will equip you with the know-how to approach outdoor photography with the confidence of a seasoned pro.

Having done my bit in writing the book, the rest is down to you. The techniques of photography are skills that can be mastered only through practice. In the same way that a golfer spends time on the driving range, or a pianist's hands endlessly traverse an ivory keyboard, so the apprentice photographer must venture out with his or her camera and flex the index finger of the right hand. Only by taking photographs can we learn how to make better images and, with the advent of digital technology, with its immediacy and the ability to shoot, review, revise and reshoot, never has the process of mastering the photographic art been easier. You must experiment, too. There are several ways to take every picture and each slight adjustment of the camera's controls will yield a different result. Be prepared to try new techniques and even to invent some of your own. You never know what visual effects will be effective and when they're not … well, who cares? The only person who'll ever know is you.

Never be afraid to fail. Thomas Edison was once asked whether having failed so many

### Never give up

'If at first you don't succeed, try, try and try again.' This old saying is particularly apt for the craft of wildlife photography, where the most effective images, such as this one of the interaction between two sea-lions, are hewn from time spent with the subject out in the field.

times to invent a light bulb he had ever thought of giving up. 'It's not that I failed a thousand times', he replied, 'I simply found a thousand ways it didn't work.' In that statement there is a lesson for us all. In taking poor photographs, you are learning how to make great ones!

I am a lucky man. My job is taking pictures, and I love it. I also love the fact that other people share my enjoyment of this great pursuit, because it is through popularity that technology and techniques develop. I sincerely hope that my passion for photography can be found in the words and pictures throughout this book and that you will find here both the inspiration and motivation to do what I do – and do it better!

▲ **Practice makes perfect**
The skills of photography, like those of any other pastime or profession, need practice to master.

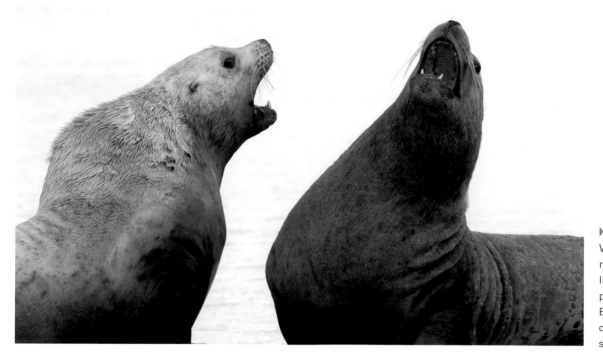

▶ **Inspiration**
With inspiration and motivation – and a little faith – anything is possible, as these two Buddhist monks found climbing Europe's largest sand dune.

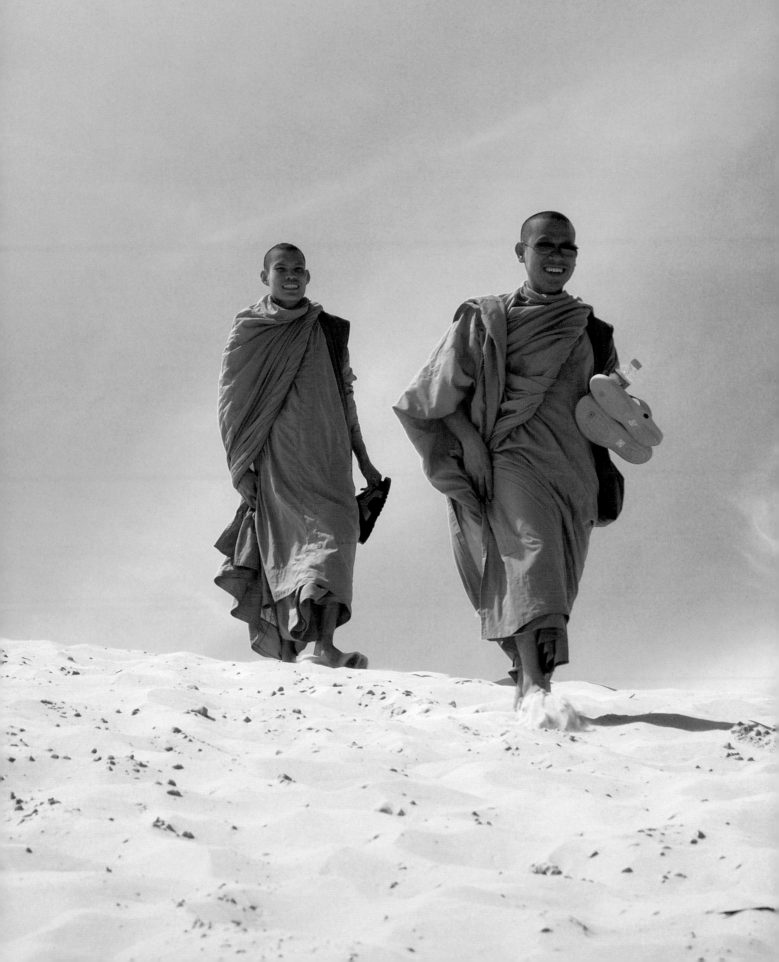

# Equipment

The equipment that you need to invest in for your wildlife, nature or landscape photography will be determined by what sort of pictures you expect to be taking. For example, a landscape photographer is likely to have no need for autofocus lenses, will use a handheld light meter for precise exposure calculations, will happily advance to the next frame manually, and will always use a tripod.

A wildlife photographer, on the other hand, will use autofocus optics extensively, will rely on through-the-lens (TTL) metering almost entirely, needs high-speed frame advance in order to capture exciting action sequences, and frequently depends upon optical stabilization technology rather than a tripod to keep images sharp.

This chapter will help you to identify your needs and goals and discern what sort of equipment you should invest in, including cameras, film, lenses, filters, flash units and specialist digital kit, before venturing out into the field.

## Cameras

There is no one model of camera that offers all things to all people. It is easy to become caught up in debates on Internet forums, or be wooed by a manufacturer's marketing spin, but when choosing a camera you must keep in mind your main areas of interest and the sort of pictures that *you* expect to be taking.

Cameras, like other types of equipment, are fundamentally a means to an end; you should always keep your particular end in sight when you are thinking about investing in a new item of kit. The checklist on page 11 identifies the need for specific camera functions for different styles of outdoor photography.

### Camera choice

Subject matter should be a defining part of your decision-making process when choosing a camera. Wildlife photographers may come to depend on the technology available to the modern photographer, whereas landscapers will often benefit from the simplicity of less sexy manual cameras.

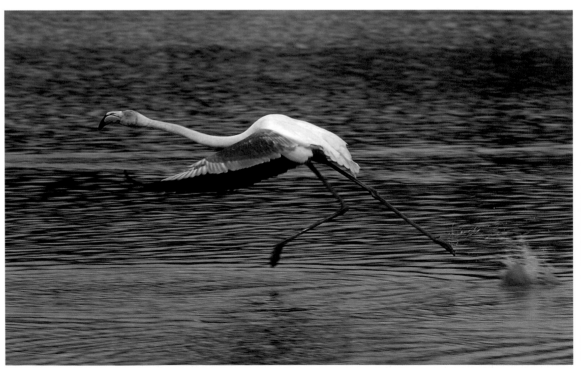

| WHAT CAMERA FUNCTIONS YOU NEED | | | | | |
|---|---|---|---|---|---|
| Function | Landscape | Wildlife | Macro | Aerial | Underwater |
| Autofocus | ✗ | ✓ | ✗ | ✗ | ✓ |
| Through-the-lens autoexposure | ✗ | ✓ | ✓ | ✗ | ✓ |
| Interchangeable lenses | ✓ | ✓ | ✓ | ✗ | ✗ |
| Auto frame advance | ✗ | ✓ | ✗ | ✓ | ✓ |
| Manual ISO override | ✓ | ✓ | ✓ | ✓ | ✓ |
| Weather-resistant | ✓ | ✓ | ✓ | ✗ | ✓ |
| 95–100% viewfinder coverage | ✓ | ✓ | ✓ | ✓ | ✓ |
| Multi-segment metering mode | ✗ | ✓ | ✓ | ✓ | ✓ |
| Spot metering mode | ✓ | ✓ | ✓ | ✗ | ✓ |
| High-speed flash sync | ✗ | ✓ | ✓ | ✗ | ✓ |
| Exposure compensation | ✓ | ✓ | ✓ | ✓ | ✓ |
| Remote shutter option | ✓ | ✗ | ✓ | ✓ | ✗ |
| Through-the-lens flash metering | ✗ | ✓ | ✓ | ✗ | ✓ |
| Manual exposure mode | ✓ | ✓ | ✓ | ✓ | ✓ |
| Aperture priority autoexposure mode | ✗ | ✓ | ✓ | ✗ | ✓ |
| Shutter priority autoexposure mode | ✗ | ✓ | ✓ | ✗ | ✓ |

✓ = Essential ✗ = Non-essential

# Handling

An important factor in deciding on a particular make and format of camera is whether you feel comfortable using it. For example, I use Nikon cameras exclusively and do so partly because I am familiar with the layout of controls and functions on Nikon bodies and can apply them instinctively. I also prefer Nikon design and ergonomics and know that I can make the camera do what I want without a second thought – a critical factor in professional photography. It could be argued that there are better cameras on the market. There may well be, but there is no better camera for *me*.

Make your choice based on your own requirements rather than on the recommendation of others. When buying a new camera or lens, be sure to hold it and use it before making a final decision. If possible, borrow or hire the same equipment from a friend or local store and test it for a few days, taking pictures in a variety of circumstances to see whether it suits your needs. This may sound like a lot of effort and unnecessary expense, but it might save you time and money in the long run.

## Comfort

If you want to capture fleeting moments, it is important that you feel absolutely comfortable holding your camera. It should be an extension of your arm and operating it needs to become second nature.

## DIGITAL CAPTURE: ADVANTAGES AND DISADVANTAGES

### Advantages

| | |
|---|---|
| Control | Because many of the image quality parameters that were previously restricted to a wet darkroom are manageable in-camera, the photographer has a far greater level of control over the appearance and quality of the final image. |
| Flexibility | Settings that are fixed on roll film (35mm and 120 formats), such as sensitivity (ISO), levels of saturation, colour space (film type) and, to a lesser extent, white balance, can now be changed for individual frames. |
| Immediacy | The captured image can be reviewed immediately on the LCD screen and analysed for accuracy of exposure, focus and depth of field, and composition. Any errors can be compensated for and, in many cases, the picture retaken. |
| Image quality | All things being equal, the quality of a high-resolution digitally captured image exceeds that of 35mm film and, in the case of professional-specification digital cameras, medium-format film. |

### Disadvantages

| | |
|---|---|
| Cost | The upfront costs involved with digital photography far exceed those of film. As well as the cost of the camera, which is likely to be three or four times that of the equivalent film camera, there is the added expense of memory cards, storage devices, printers and computers. |
| Workflow | Typically, there is more work required of the photographer to produce a finished print than is the case with film. |
| Security | There is no 'hard-copy' image, in the form of a transparency or negative. |
| Dust | Dust entering the camera and adhering to the digital sensor is a problem that manufacturers are struggling to overcome effectively. Dust is far less likely to affect film to the same extent. |

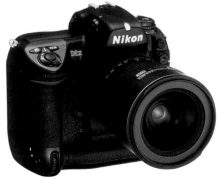

**Nikon D2X**

Digital cameras have come of age now, and the resolution and image quality produced by high-end models such as the Nikon D2X better that of 35mm and medium-format film.

At the time of writing, entry-level digital single lens reflex (D-SLR) cameras have sensors with six or eight megapixels and powerful, sophisticated image processors, while professional-specification D-SLRs exceed 12 megapixels. This means the advantages of film relating to image quality, particularly when compared to the 35mm film format, have greatly diminished.

That's not to say that film no longer has a place in photography. For some professional applications it is still the preferred format and even I, a proud digital convert, cannot escape the fact that there remains something compelling about a large-format transparency. For the enthusiast photographer, however, the argument for going digital is increasingly strong, as the chart left shows.

## Manual versus automatic

The debate on whether a manual camera is preferable to an automatic model is largely defunct in our increasingly electronic age, and few people even consider it to be an issue. I mention it here because, under certain conditions and circumstances, manual cameras maintain a distinct advantage over their automatic counterparts.

Consider again the hypothetical landscape photographer mentioned at the beginning of this chapter. With no need for autofocus (AF), autoexposure (AE) and auto film advance, where is the requirement for spending money on electronic gadgets that will never be used, powered by batteries that can run out of power

## Film versus digital

A new equipment debate has been raging in recent times: is film or digital the better format? The answer is: it depends. Both formats have their advantages and disadvantages.

When the first affordable digital cameras appeared on the market, they had inherent quality deficiencies that gave film a distinct edge. At the same time, however, it was apparent to many observers that the versatility and immediacy of digital camera technology was far more than a mere gimmick.

**Nikon F6**

Although digital cameras are now outselling film cameras, manufacturers such as Nikon continue to invest in film camera designs and technology. The flagship Nikon F6 was launched in 2004 to high acclaim.

at the most inappropriate of times? Manual cameras are also less susceptible to inclement weather and harsh environments.

If your style of photography negates the need for fancy electronics then you will find some bargains on the secondhand market. While a manual camera may not be as sexy as a shiny, new, gizmo-laden electronic variety, there are some superb examples of precision engineering and craftsmanship that will cost little to acquire and last you a lifetime.

## SLR versus rangefinder

With the exception of large-format cameras, there are two main types of camera design: the interchangeable-lens SLR and the rangefinder.

Of the two types, the SLR is the most popular and has the advantage that what you see through the viewfinder is largely what appears on the film (or sensor). The SLR design also facilitates other benefits, including TTL metering and electronic auto-TTL flash metering. Also, because of their popularity, more manufacturers produce them, making them cheaper and ensuring a ready supply of accessories to complement the camera system.

As far as most photographers are concerned, the added functionality, extended versatility and greater system availability of the SLR camera makes it the obvious choice for all forms of fieldwork. However, rangefinder cameras should not be dismissed, as they have their own significant advantages. For example, they are often much lighter than their SLR counterparts, making them more portable in the field; this is particularly useful when travelling for long periods. This is doubly true when considering medium format, where the lightest 6x7cm SLR camera weighs far more than the heaviest equivalent rangefinder.

Also, because they have no need to house a complicated arrangement of mirrors, and tend to operate with fewer microchips than the modern SLR, even some medium-format rangefinders will slip easily into the pocket of your walking jacket – convenient for occasions when a camera bag is inappropriate.

Perhaps the most significant advantage of the rangefinder camera is the optical quality of the lenses. To fully appreciate this, it helps to understand a little about lens design. For example, the underlying design principle of

**Parallax problems**

The advantage of an SLR-type camera is that what you see through the viewfinder is largely what the camera records. The problem of parallax encountered with some rangefinder cameras can make composition tricky.

SLR wide-angle lenses is a retro-focus design. This is predominantly used to increase the back-focus distance in order to accommodate the reflex mirror. However, you pay for it with a loss of resolution and increased distortion.

With retro-focus lenses designed for use with rangefinder cameras, the design enables an increased number of lens elements that help to improve correction. Symmetrical wide-angle lenses are also available, which surpass retro-focus SLR versions in both distortion and resolution.

Similarly enhanced design features also exist for 50mm lenses, where the lack of back-focus constraints allows the use of Sonnar-type lenses with their improved highlight separation capabilities. These are often unmatched by the Planar-type lenses utilized in SLR lens design. This improved highlight separation is also a feature of the Ernostar-, Sonnar- and Tessar-designed short/medium telephoto lenses available for rangefinders that rarely exist for the modern 35mm SLR or D-SLR. The main limitation of lenses used with rangefinder cameras is the lack of any significant range of zoom optics.

The phenomenon of parallax (i.e. what you see through the viewfinder and what appears on the film being different things) can be a concern, although some of the more expensive rangefinder models have overcome this using digital technology.

## Film camera formats

There are three film camera formats: small (35mm), medium and large. Each is suited to different tasks and it is not unheard of for a photographer to carry more than one format into the field. Some of the pros and cons of the various camera types are outlined here.

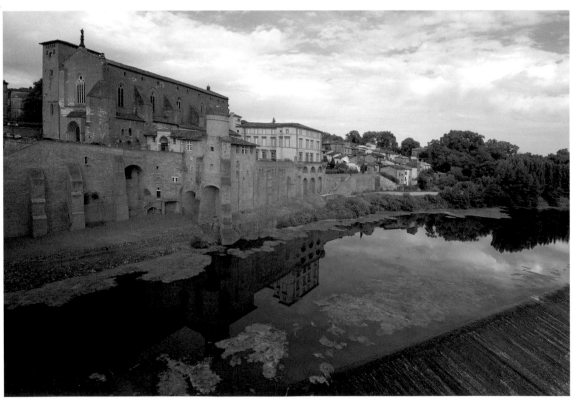

## Hasselblad H1

Some medium-format cameras, such as the Hasselblad H1, benefit from the same technology as modern 35mm cameras. Interchangeable backs also allow them to capture images digitally.

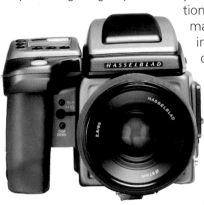

## Large-format cameras

Large-format cameras can be unwieldy; however, they offer many advantages to architectural and landscape photographers, and the quality of image from a 5x4in or 10x8in transparency is unsurpassed.

## ▌35mm

The 35mm-format camera has long been the most popular camera for both professional and non-professional photographers. What it lacks in frame size it makes up for in versatility, portability and flexibility.

The small and lightweight body of the 35mm camera makes it easy to carry, especially during extended periods working out in the field. For heavy use, many of the professional-specification cameras are constructed from durable materials that can withstand hard knocks, inclement weather and the ravages of camera-hostile environments.

Because of the versatility of the 35mm format, these cameras lend themselves to all types of photographic genres. This means that whether your interest is wildlife, landscape, natural history, travel and adventure, or close-up and macro photography, most systems provide the complete range of accessories needed to achieve the task in a format that can easily be carried into any environment.

The principal downside to the 35mm format is the relatively small size of the film frame. While this can be a deciding factor in the professional arena, it is unlikely to be an issue for most users.

## ▌Medium format

Medium format pertains to cameras that use 120-size roll film to produce an image in one or more dimensions from 6x6.45cm (645), 6x6cm, 6x7cm, 6x9cm and 6x12cm. These cameras are usually heavier and bulkier than 35mm models. They are therefore less portable and less versatile for many types of fieldwork, particularly wildlife and adventure travel photography. That said, prior to the increasing popularity of digital cameras, they formed the basis of many landscape photographers' kit, since the comparatively large size of the resulting image was of a quality suitable for most forms of professional publication.

Although a few automatic medium-format cameras are available, many models are either fully manual or part manual based systems. This, together with their ease of use, makes them most suitable for landscape work.

With the advent of high-quality digital capture, the medium-format camera has

## Medium format

Digital capture technology has led to a downturn in demand for traditional medium-format cameras, such as those made by Bronica. Subsequently, many models can now be purchased cheaply secondhand.

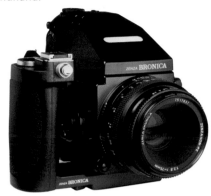

slowly lost ground, particularly in the professional arena, and recent years have seen the demise of some historic brands, including Bronica and Contax. While this means that inexpensive medium-format systems can be found on the secondhand market at very low prices, new equipment and accessories are increasingly difficult to acquire.

## ▌Large format

Although large-format photography has been primarily the preserve of professional photographers, partly due to its complexity and cost, there are many reasons for non-professional photographers to consider it for particular types of fieldwork, including landscape and architectural photography.

Because large-format cameras use single sheets of film rather than a roll of film, many of the advantages of digital photography (see page 12) apply equally to large-format photography, including the ability to set sensitivity levels and alter the film type (colour space and saturation levels) for individual frames. It does, however, involve a more painstaking process.

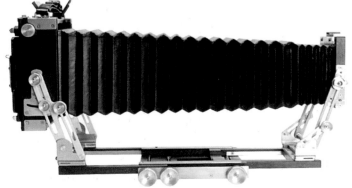

There are two further advantages to large-format cameras. While the base size of large-format film is 5x4in (or 10x8in), many of these cameras allow the photographer to attach a different format back to take 120-size roll film, giving a range of available formats from 6x4.5cm through to 5x4in or 10x8in.

Also, and perhaps most significantly, large-format cameras usually provide for the ability to tilt and shift either the lens, the film back or both simultaneously, giving complete control over perspective and depth of field. This is particularly important in architectural photography, and provides far greater flexibility to the landscape photographer.

The drawbacks to this format include the complexity of use of many of the cameras, which require a great deal of practice to perfect, the relatively high cost of the equipment compared to entry-level 35mm cameras, the cost of the film and processing and, for those wanting some of the electronic features of modern cameras, a complete lack of any automated function.

## Panoramic cameras

For landscape (including cityscape) photography, panoramic cameras have become very popular in recent years, particularly with the introduction of the (relatively) low-cost Hasselblad XPan 35mm dual-format panoramic rangefinder camera.

Panoramic cameras produce a film frame with an aspect ratio of approximately 3:1 (compared to a standard 35mm aspect ratio of 3:2), which particularly suits landscape scenes.

The Hasselblad XPan is noteworthy due to its small size and low weight, making it an ideal field camera and travel camera. Larger, medium-format panoramic cameras are available, notably the Fuji 617 and Linhof 617, which both produce an image frame size of 6x17cm on 120 roll film. However, both of these medium-format panoramic cameras are expensive to acquire, even on the secondhand market.

### Hasselblad XPan

The relatively inexpensive (compared to alternative models) Hasselblad XPan 35mm dual-format camera helped to bring panoramic photography to a wider audience. It can shoot in both standard 35mm 3:2 aspect ratio format and 3:1 panoramic format, making it ideal for travel photography.

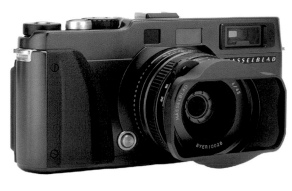

### Panoramic for landscapes

Panoramic cameras, with an aspect ratio of 3:1, are ideally suited to landscape photography, which benefits from the extra space the format achieves.

Panoramic cameras are considered specialist cameras because the aspect ratio of the resulting image suits only specific subjects and, therefore, they cannot be considered as multi-purpose cameras in the way 35mm cameras are. To some extent, the Hasselblad XPan overcomes this problem by offering dual formats (standard 35mm and 35mm panoramic) at the flick of a switch.

Even so, photographers using panoramic cameras regularly are most likely to have a second 'standard' body to complement their kit.

## Digital capture cameras

There are two principle designs of digital camera: those based on 35mm systems, and those designed around medium-format systems. The former are by far the most popular, while the latter, at the time of writing, are largely restricted to commercial advertising photographers due to their very great cost.

When choosing a digital SLR, there are a number of determining factors that you should consider. These include the pixel size of the sensor (usually quoted in megapixels) and the quality of the internal processor, both of which affect final image quality, and the size of the internal memory, which influences burst depth (the number of consecutive images that can be taken before the camera locks out).

Although manufacturers, in their race to squeeze more pixels out of the sensor, would have you believe that megapixels are the only important factor, they are only a part of the image quality equation. For example, the 4.1mp Nikon D2H produces a better final image than the higher-resolution D70 and D100 models (both 6.1mp) because of the enhanced internal signal processing incorporated into the camera.

Always be wary of the myths that surround this technology: avoid falling into the trap of believing everything the media writes and investing money where it isn't really needed.

For general use, any of the current consumer 6mp-plus D-SLRs and all of the professional-specification digital cameras available will

### Capturing scale

The panoramic format used for this image taken in the Ngorongoro Crater in Tanzania has helped to capture the scale of the environment in a way that would have been difficult to achieve with a standard film format.

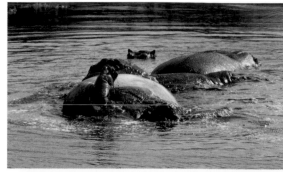

### FinePix

Digital image quality is determined by more than simply the number of available pixels. However, most of the modern crop of 6mp-plus digital cameras will produce images of a quality good enough for all but the most discerning of users.

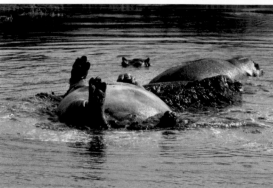

produce an image of acceptable quality up to around A4 size (12x8in) when used properly.

For some forms of photography, notably wildlife, the burst depth is equally important. Burst depth refers to the number of images the camera can record, process and download to the memory device before the internal buffer memory fills and the shutter locks. Think of it in terms of the number of frames on a roll of film – once the film is fully exposed, you have to change it before more pictures can be taken. Therefore, a 35mm film camera has a burst depth of 24 or 36 exposures. Of course, the advantage of digital capture is that you simply have to wait for the camera to process enough images to free space in the buffer.

This is important in wildlife photography when capturing action sequences, when you may expose several frames to capture the moment (see pages 109–112). The older D-SLR models had a poor burst depth – as low as four frames in some cases. Newer models have largely solved the problem by providing burst depths in excess of 50 frames.

You may also have read about sensor size in terms of physical dimensions. There are very few full-frame digital sensors (full-frame refers to a sensor that is the same size as a 35mm film frame) used in 35mm-type digital cameras. The Canon EOS-1Ds and 1Ds Mark II, Kodak DCS Pro SLR 14/n and 14/c, were the exceptions, although the Kodaks are now out of production. Other D-SLR cameras use a sub-full-frame sensor ranging from 28.7x19.2mm in Canon's EOS-ID and EOS-ID Mark II cameras, through Nikon's DX sensor measuring 23.7x15.5mm to the Olympus system based on the Four Thirds standard, measuring 18x13.5mm.

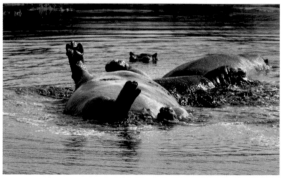

### LCD screen

From the front, it is often difficult to tell digital and film cameras apart. The rear of the camera gives the game away, with no opening back and an LCD screen for viewing images and menus.

In practical terms, the physical size of the sensor has less of an impact on image quality than other parameters. To a certain extent, the opposite of photographic logic follows in that smaller sensors can produce a better quality image for reasons discussed on the previous page.

The most apparent effect of sensor size is how it alters the picture angle, or, in other terms,

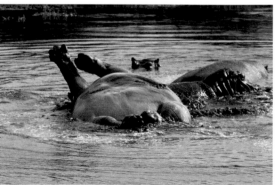

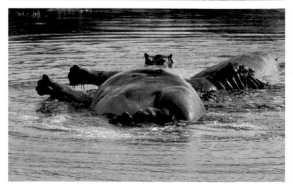

**▲ Digital for action**
Digital cameras are ideally suited to fast-action photography, be it sport or wildlife. Look at the cameras used by today's professional wildlife and modern press photographers and you'll be hard pressed to find a roll of film anywhere in sight.

the effective focal length of the lens used (see pages 25–26). Shutter lag is another misconception about the digital format. It is true that many digital compact cameras suffer from shutter lag, where the picture is taken some moments after the shutter is pressed. However, compact cameras are beyond the remit of this book and D-SLRs are unaffected by shutter lag for all practical purposes.

# Film and sensors

The first 'camera' ever invented projected an image of a solar eclipse inside a room through a hole in an outside wall. However, the 'photographer' had no means of recording the image in a permanent state. It was not until 1824 that a method of fixing an image was discovered.

Fortunately, today's photographers no longer need to be trained chemists in order to process pictures, and film (and, more recently, digital technology) has advanced to such a point that images can now be made in almost all conditions and circumstances.

Before examining the obvious question of whether to use negative (print) film or transparency (positive) film, it is worth exploring the main factors that will influence your decision.

## Sensitivity (ISO) and film grain
The sensitivity of a film, referred to as its ISO (Industry Standards Organization) rating, determines how quickly the film reacts to light and its ability to resolve detail.

**◄ Burst rate**
A poor burst rate was a limitation of early digital cameras. However, most models now are able to capture a sequence of tens or even hundreds of images before the memory buffer fills.

## WHAT'S IN THE BAG?

A question I am frequently asked at workshops or via email is what equipment I use. I have detailed below the current contents of my kit bag, with the caveat that my equipment of choice is based upon the guidelines outlined in the opening section of this chapter.

### CAMERAS
- Two Nikon D2X D-SLRs
- Nikon F3 semi-manual 35mm SLR
- Nikon Nikkormat FT manual 35mm SLR

### LENSES
- Nikon 200–400mm f/4 VR AF zoom
- Nikon 80–400mm f/4–5.6 VR AF zoom
- Nikon 70–200mm f/2.8 VR AF zoom
- Nikon 24–120 f/3.5–5.6 VR AF zoom
- Nikon 12–24mm f/4 DX AF zoom
- Sigma 800mm f/5.6 EX AF
- Nikon 28mm f/2.8 AF
- Tamron 180mm f/3.5 SP Di AF macro
- Nikon Nikkor 50mm f/1.4 (manual)
- Nikon Nikkor 50mm f/2 (manual)
- Nikon TC-20E 2x teleconverter

### ACCESSORIES
- Nikon SB-800 i-TTL flash with off-camera cord and bracket
- Electronic cable release with extension
- Infrared remote shutter release
- Gitzo carbon fibre G1548 Mk2 tripod with Wimberley head and G1570 magnesium pan and tilt head
- Velbon Neopod 6 carbon fibre monopod
- 81A and 81B filters, CC filters, UV filters, ND and NDG filters and circular polarizing filters
- Sekonic L-608 handheld light meter
- Steiner safari 8 x 40 binoculars
- Spare batteries

### DIGITAL ACCESSORIES
- Apple iBook with Adobe Photoshop and Nikon Capture 4.2 image-processing software
- 2 x 2Gb CF cards
- 2 x 1Gb CF cards
- 1 x 1Gb Microdrive
- Apacer Disc Steno portable CD writer
- Phototainer portable HDD
- DPS cleaning accessories

### PHOTO BAGS
- Crumpler photographic backpack
- 2 x Peli hard cases (for hold luggage)
- 2 x Storm hard cases (for hold luggage)

**Fuji Velvia**

Film comes in varying sizes and with different ISO (sensitivity) ratings to meet the demands of modern photography.

Film that has a high, or fast, ISO rating, such as ISO 800 and upwards, is extremely sensitive to light and needs less exposure time. Conversely, film that has a low, or slow, ISO rating, such as ISO 100 and below, reacts slowly to light and therefore requires exposure times to be longer in order to record the image.

Bearing this in mind, it would make sense that for subjects where shutter speed is less of a priority, such as landscapes, you might use a slow film. With subjects that predominantly dictate a fast shutter speed – wildlife, for example – you would opt to use a faster and more sensitive film.

The spanner in the works of this argument is film grain and the film's ability to resolve detail. Film consists of a coated strip of plastic. Several coatings are used, but the imaging layers contain sub-micron-sized grains of silver halide crystals. These grains can vary in size, shape and composition and are chemically modified to alter their sensitivity to light.

One effect of these modifications is film grain, which becomes more apparent in photographs taken with highly sensitive films. Except for specific artistic applications, this visible grain is considered to impinge on image quality, as detail is lost. For this reason, most photographers, particularly professionals, prefer to use a slow film for most subjects, even when working in low light.

## Latitude

In comparison to human eyesight, which allows detail to be discerned simultaneously in disparate areas of shadow and highlight, the latitude of film is far more restricted. Film latitude is a term that refers to the maximum brightness range, measured in stops, within which film is able to record detail in both the brightest areas of the scene and the darkest. The greater the latitude of the film, the more capable it is of dealing with contrast.

Negative (print) film has greater latitude than transparency film, being able to cope with a brightness range of up to seven stops. This means that as long as the brightest part of the scene is no more than seven stops brighter than the shadow areas, detail will be recorded throughout the frame. Transparency film is less forgiving with latitude of no more than five stops, making it harder to work with in conditions of even the slightest contrast.

## Colour and saturation

Colour film 'makes' colour by mixing together different quantities of red, green and blue (RGB). Films from different manufacturers are weighted towards one or another of the RGB colours depending on the subjects that they are intended for. For example, Fuji's Velvia film is weighted towards green, as it is used mostly for nature subjects. On the other hand, Kodak's Portra film is weighted to produce accurate skin tones, as its intended use is for portraiture. Other films are more evenly balanced between the three colours and are intended for general use.

Similarly, some films are more heavily saturated to make colours bolder. Fuji Velvia is a good example of this, as is Kodak's Ektachrome VS film. For some subjects, such as landscapes, these overly saturated films imbue images with a vibrancy that helps them to stand out, and often is a prerequisite for publication. Other subjects, such as wildlife, benefit from the more natural, less vivid, colours of a standardly saturated film.

**Film grain**

Film grain occurs with high-sensitivity films and often degrades image quality. In some cases, however, it can be used for artistic intent, to create a particular mood or to evoke a specific emotion.

**Colour film**

Not all colour films react the same. Some are geared towards producing neutral skin tones and are ideal for portraiture. The outdoor photographer often prefers the punchier, more vividly saturated colours produced by films such as Fuji Velvia.

## Print film or transparency

Armed with the above information, it is possible to make an informed decision on whether to select print or transparency film. As when choosing cameras, your decision will come down to personal circumstances.

If you are interested in selling your photographs for publication in magazines or books, or to image libraries, then your only real option is to use transparency film. No publisher of any quality will consider using anything else except in very exceptional circumstances.

Also, if image quality is high on your list of priorities or you want to scan images for enhancement in computer, then transparency film is likely to give you the best results.

If your pictures are to be used for your own pleasure and the occasional viewing by friends and family, then negative film is easier to work with and more tolerant of slight miscalculations in exposure. It is also easier and cheaper to produce a set of prints from negative film.

## Digital sensors

Unlike film, digital sensors are fixed in the camera and cannot be changed once you have decided on a particular camera model. While different types of sensor exist, choice is less the photographer's conscious decision and rather a predetermined state dictated by choice of camera.

This lack of choice may appear to be a limiting factor of digital camera technology. However, most of the parameters that distinguish one film from another can, on a digital sensor, be altered from shot to shot (e.g. level of saturation, ISO sensitivity and colour space), making the digital option a far more flexible medium.

There currently exist two main types of digital sensor: CCD (charge-coupled device) and CMOS (complementary metal-oxide-semiconductor). A third type is the proprietary Nikon LBCAST JFET sensor, used only in the D2H and D2Hs professional cameras.

### CCD sensors

CCD sensors are the most common type found in digital cameras today. They are cheap to produce, making them, from the manufacturers' perspective, ideal for use in consumer-specification cameras. They also suffer less from digital noise (see page 23) than CMOS sensors. This reduces the need for higher-specification in-camera processors to maintain image quality, also reducing cost.

### CMOS sensors

CMOS sensors are often utilized in professional-specification digital cameras because of their greater versatility. Early CMOS sensors were prone to the problems of digital noise, often producing inferior results. However, modern design techniques have greatly improved their effectiveness, as has the development of sophisticated in-camera image processors.

## Megapixels: a cautionary tale

It would be easy to believe, given the level of marketing hype generated by the manufacturers, that the size of the digital sensor measured in pixels is the only relevant measure of digital image quality. In truth, there are many more aspects to image quality that you should consider when choosing a digital camera.

**Sensors**

Digital sensors come in various different guises, but look much the same from the outside.

For example, the structure of a digital sensor differs to that of film, making the angle at which light hits the sensor far more important to the quality of the final image. Film is able to accurately record light falling on it from almost any angle, however obtuse. However, because photo-diodes (the light-detecting components of a digital sensor) sit within a chamber on the sensor plate, light must strike them head-on to maximize their effectiveness. In part, this is one reason why sub-full-frame sensors can produce better quality images.

Also, because digital photography involves an analogue-to-digital conversion – light wave (analogue) to binary code (digital) – the sophistication of the processor used in this process is equally important.

## File types

Whether to set the file type to JPEG or RAW is a decision that should be based on what you're going to do with the pictures you take. For printable pictures straight from the camera and non-commercial use, my recommendation would be to set the file type to FINE JPEG. However, for maximum image quality and for anyone considering selling images for publication, the only real option is to shoot in RAW mode.

### ADVANTAGES OF SHOOTING IN RAW MODE

- In RAW mode, shooting parameters such as white balance, sharpening and tone can be adjusted in-computer without any degradation of image quality. Compare this to having the ability to retrace your steps and reshoot the picture at different settings as many times as you like and for different uses of the image, (e.g. fine-art printing, high-quality reproduction, press reproduction, image samples).

- Colour conversion, or interpolation, is managed in-computer, where the algorithms used are more complex than the current crop of camera microprocessors would allow.

- Because RAW files take advantage of the 16-bit mode, which gives more than 65,000 extra brightness levels, post-camera processing is far more expansive.

- RAW files are far more flexible. It is possible to create a JPEG file from a RAW file, but not vice versa. Similarly, a large file can be compressed to make it smaller, but once the JPEG algorithms have discarded their data, that data is lost forever, making enlargement via interpolation a less effective process.

### ADVANTAGES OF SHOOTING IN JPEG MODE

- JPEG files are smaller in byte size and use less of the capacity of a memory card and storage device.

- Camera productivity is improved with higher burst depths for JPEG files.

- For the average user, there is little discernible difference between a high-resolution JPEG (sometimes referred to as a FINE JPEG) and a RAW file.

- JPEG files are more easily and speedily transferred electronically.

- JPEG files can produce high-quality, processed images that are ready to print direct from the camera.

- Practically all image processing and graphics software applications are capable of opening a JPEG file, while RAW files typically require expensive or proprietary software in order to be opened.

The debate about image file types is ongoing, so see the boxes on this page for a few reasons for my assertions.

### TIFF files

TIFF files are processed in-camera in the same way as a JPEG. They tend to have large file sizes, although lossless compression can be applied. TIFF is the industry standard for publishing. However, there is little reason to shoot TIFF in-camera, as it provides no distinct advantage over a RAW file, which can be saved as a TIFF after processing and is more flexible.

### RAW+JPEG

Many digital cameras now have the function that enables a picture to be saved as a RAW file and a JPEG file simultaneously. Although this results in a larger combined file size, it means an image can be both easily and speedily transmitted electronically, or be printed without any further processing, while, at the same time, be available for advanced image processing.

## Understanding compression

Two methods of compression are used in digital photography. Loss, or lossy, compression is used to reduce the file size of JPEGs, where algorithms reduce the number of bytes and some original data is discarded permanently. When the file is opened, algorithms reconstruct the image and the discarded data is replaced with interpolated information, often compromising image quality, in particular the occurrence of 'artefacts' (faults).

The other method of compression is called lossless compression and can be applied to RAW and TIFF files. When reducing file size, lossless compression algorithms retain all of

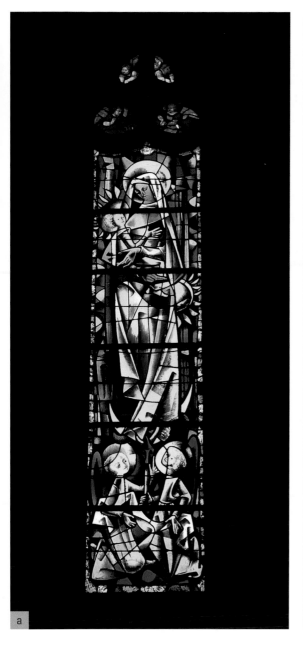

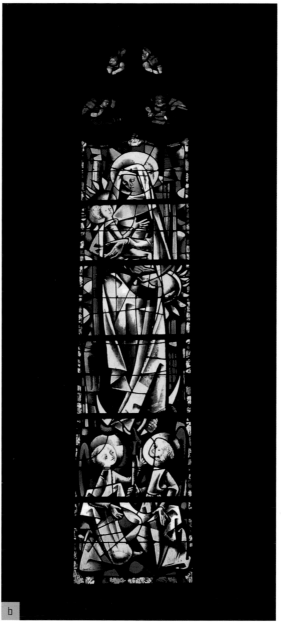

**Compression**
The type of compression used in digital photography can affect image quality. Lossless compression produces superior results (image a) to the lossy-compression algorithms used by JPEG technology (image b).

the original data and the reconstructed image is an exact replica of the original.

## ISO-E (equivalency)

The sensitivity of a digital sensor can be altered using a standard rating equivalent to the ISO rating of film, known as ISO-E (equivalency). Most digital cameras have a range of ISO-E settings from around 100 to 1600 (some cameras have both slower and faster ISO-E settings available), where 100 is the least sensitive rating and 1600 the most sensitive.

Unlike film, because of the way in which they are constructed, digital sensors have no grain and are unaffected by the effects of grain, whatever the ISO-E setting used. However, they do suffer from noise, as described right.

## Digital noise

Noise appears on digital images in the form of random, unrelated pixels. These are often brightly coloured and are most prevalent in areas of shadow. Although unrelated to film grain, the appearance of noise can often be similar and its effect in degrading image quality the same. Heat, generated by the sensor when it is active, and amplification, the means by which sensitivity (ISO-E) is increased, are what cause digital noise.

### Heat-generated noise

The longer the sensor is active, the greater the level of heat generated and the more noise appears. This type of noise often becomes noticeable when shutter speeds exceed 1/2 sec.

### Amplification

To increase the ISO-E rating (sensitivity) at which a digital sensor operates, the analogue signal is increased using amplification in much the same way as sound is amplified to make it louder. The greater the level of amplification, the more noise is produced.

### Overcoming digital noise

Because noise is caused by heat and/or amplification, the more you do in camera to reduce the possibility of noise occurring, the better the final image will be. Keeping shutter speeds faster than 1/2 sec (reducing heat) and keeping sensitivity below ISO-E 400 (reducing amplification) can achieve this.

For occasions when either one or both of the above are impossible, many cameras have a noise reduction function built into the menu options, and applying this helps to reduce the appearance of noise. Alternatively, there are several computer software solutions available.

### Noise

Digital sensors suffer from a phenomenon known as noise, caused by either heat or amplification. This noise appears as random, unrelated pixels and can degrade image quality (image b). Setting a slow ISO-E rating and avoiding long exposure times helps to alleviate the problem.

There is an element of brand recognition in lens pricing, but usually the more you spend on a lens the better the quality. It is a wise photographer who invests his or her money in top-of-the-range lenses rather than camera bodies. While two competing lenses may appear the same, even down to their design and dimensions, often it is what you cannot see that sets one lens apart from another. The quality of the glass used and how that glass is coated will always be the primary factor in lens performance in relation to image quality.

Increasingly, lenses are designed specifically for use with digital cameras to take account of the need for telecentric properties to maximize the potential of the digital sensor. This is a new and important aspect of lens design that is covered later in the chapter (see page 26).

## Lens types

There are five main types of lenses, which can be categorized by their 35mm equivalent focal length. They are:

- Standard: 43–60mm
- Wide-angle: 24–42mm
- Super wide-angle: less than 24mm
- Telephoto: 61–300mm
- Super telephoto: above 300mm.

Zoom lenses have variable focal lengths of differing ranges and may fall within a single category (e.g. a 70–200mm zoom lens is classified as a telephoto zoom) or cross over one or

**Lenses**

The choice of lenses available to the modern photographer is wider than it has ever been. From super wide-angles to extreme telephotos and numerous specialist lenses, there is something to suit almost every occasion.

## Lenses

More than any other single component, lenses are the most important piece of photographic equipment in terms of influencing image quality. The purpose of the lens is to focus the rays of light reflecting off a subject onto the focal plane (film or sensor). Lenses utilize a number of lens elements from a minimum of one (typically only in the case of very inexpensive cameras) to several, some specially designed, to optimize image transmission.

## ▸ Angle of view

The shorter the focal length of the lens the greater its angle of view. For example, a 28mm lens has a wide angle of view of 74 degrees – hence the term wide-angle lens.

## ▾ Telephoto lens

A telephoto lens has a narrow angle of view that reduces background detail, which helps to focus the viewer's attention solely on the subject of the photograph. Telephotos are often used for this purpose in wildlife photography, and to create almost abstract images in other genres.

more categories (e.g. a 28–300mm zoom would be designated a wide-angle to telephoto zoom).

There are also specialist lenses, such as macro lenses and tilt and shift lenses, designed for use in specific types of photography.

## Focal length, angle of view and perspective

The focal length of a lens is determined by the distance between the film (sensor) plane and the optical centre of the lens when the lens is focused on infinity. A standard lens is considered one where the focal length is approximately equal to the diagonal of a camera's picture format. For example, in 35mm terms, a standard lens would have a focal length of 43mm. In this instance, any lens between 43mm and 60mm is considered 'standard'.

Subject magnification doubles with every doubling of focal length and is reduced by half for every halving of focal length. For example, taken from the same viewpoint and compared to a focal length of 50mm, the same subject photographed with a 100mm lens is reproduced on film/sensor at twice the size and at roughly half the size when a 24mm lens is used.

Focal length can be used to affect the visual impact of a picture. Wide-angle lenses can help create a sense of place by emphasizing space, whereas telephoto lenses make it easier to isolate subjects from their surroundings.

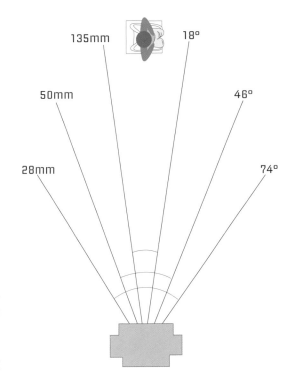

## ▾ Wide-angle lens

A wide-angle lens takes in more of the scene, having a wide angle of view. Used well, they can create a sense of space and for this reason are a favourite with landscape photographers.

## FOCAL LENGTH CONVERSION CHART

Use this information to ascertain the 35mm equivalent angle of view for different film/digital formats.

| Format | 35mm | 6 x 4.5 MF | 6 x 6 MF | 6 x 7 MF | 5 x 4 LF | Full-frame digital | Nikon DX digital | Canon non-full-frame digital | Four Thirds Digital |
|---|---|---|---|---|---|---|---|---|---|
| Approx image effective FL magnification factor | 1x | 0.6x | 0.6x | 0.5x | 0.3x | 1x | 1.5x | 1.6x | 2x |
| Equivalent focal length | 20mm | 12mm | 12mm | 10mm | 6mm | 20mm | 30mm | 32mm | 40mm |
| | 24mm | 14.4mm | 14mm | 12mm | 7mm | 24mm | 36mm | 38.4mm | 48mm |
| | 28mm | 16.8mm | 17mm | 14mm | 8mm | 28mm | 42mm | 44.8mm | 56mm |
| | 35mm | 21mm | 21mm | 18mm | 11mm | 35mm | 52.5mm | 56mm | 70mm |
| | 50mm | 30mm | 30mm | 25mm | 15mm | 50mm | 75mm | 80mm | 100mm |
| | 70mm | 42mm | 42mm | 35mm | 21mm | 70mm | 105mm | 112mm | 140mm |
| | 80mm | 48mm | 48mm | 40mm | 24mm | 80mm | 120mm | 128mm | 160mm |
| | 105mm | 63mm | 63mm | 53mm | 32mm | 105mm | 157.5mm | 168mm | 210mm |
| | 135mm | 81mm | 81mm | 68mm | 41mm | 135mm | 202.5mm | 216mm | 270mm |
| | 180mm | 108mm | 108mm | 90mm | 54mm | 180mm | 270mm | 288mm | 360mm |
| | 200mm | 120mm | 120mm | 100mm | 60mm | 200mm | 300mm | 320mm | 400mm |
| | 210mm | 126mm | 126mm | 105mm | 63mm | 210mm | 315mm | 336mm | 420mm |
| | 300mm | 180mm | 180mm | 150mm | 90mm | 300mm | 450mm | 480mm | 600mm |
| | 400mm | 240mm | 240mm | 200mm | 120mm | 400mm | 600mm | 640mm | 800mm |
| | 500mm | 300mm | 300mm | 250mm | 150mm | 500mm | 750mm | 800mm | 1000mm |
| | 600mm | 360mm | 360mm | 300mm | 180mm | 600mm | 900mm | 960mm | 1200mm |
| | 800mm | 480mm | 480mm | 400mm | 240mm | 800mm | 1200mm | 1280mm | 1600mm |

## Digital camera 'focal length magnification factor'

Many digital cameras, in fact all those having a sub-full-frame sensor, are described as having a focal length magnification factor, usually between 1.5x and 2x. The term 'focal length magnification factor' is somewhat misleading, as focal length is determined by the lens, not by the camera, and is fixed at a single value (prime lenses) or within a range of values (zoom lenses).

In fact, what changes is the picture angle, being similar to the angle of view. This is reduced by the smaller total area of sub-full-frame sensors, with the effect that less of the area surrounding the main subject is included in the picture, giving the appearance of an increase in focal length. However, magnification, which is directly affected by focal length, remains unchanged. For example, a tree standing 10m (30ft) tall would be reproduced at the same magnification if photographed using a 50mm lens, irrespective of the size of the sensor or the format of the film. The distinction is important when you consider printing your images because the same level of enlargement is required in all cases.

## Digital lens design

Because of the differences in how film and digital sensors record light (see pages 20–21), manufacturers are now releasing digital-specific lenses. The purpose of these lenses is to ensure that light reaches the sensor as close to straight-on as possible. This maximizes the amount of light recorded by the photo-diode, thereby improving digital image quality.

The best example of this can be found in the Four Thirds system. This is used by some of the leading manufacturers, including Olympus and Sigma, and aims to exploit the new rules of optics set down by the digital format.

Other manufacturers also offer variations on the theme, including Nikon (DX lenses), Tamron (Di lenses) and Canon (S lenses).

## Lens speed

Lens speed refers to the light-gathering capability of a lens. It is determined by the maximum aperture: the bigger the hole, the faster the lens. Typically, lens speed is important in wildlife photography, where the additional quantity of light achieved by a wider aperture allows for the setting of faster shutter speeds, particularly when photographing rapid movement.

Landscape photographers are often less concerned by lens speed since many of their pictures require significant depth of field and so are shot with much smaller apertures (f/8–f/22).

Most professional-specification lenses have a maximum aperture of f/4 or f/2.8 for super-telephoto lenses and extreme wide-angle lenses, and f/2 or larger for other focal lengths. However, these exacting standards come at a price and these types of lenses are heavier, bulkier and more expensive than slower alternatives.

Consumer-grade lenses and zoom lenses with very wide focal length ranges often have a maximum aperture of f/5.6 or even f/6.3. These relatively small maximum apertures can restrict choice when setting exposure values and may limit the type of accessories used with your camera.

## Closest focusing distance

The closest point on which a lens can focus (its closest focusing distance) is often neglected as a buying parameter outside of macro photography, yet can be a vital factor in determining the usefulness of the lens.

### Focusing distance

Often ignored, a lens' closest focusing distance can be an important consideration if you intend to photograph close to your subjects. With many consumer-grade lenses, this image would have been unachievable.

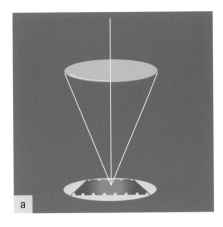

Consider trying to capture a frame-filling image of a small animal, such as a garden bird. Even with a long telephoto lens, camera-to-subject distance will need to be relatively small; say, 1–2m (3–6ft). However, if the closest focusing distance of the lens is outside this range, you will be unable to focus on the subject, making the shot impossible.

## Autofocus

Most lenses bought today are autofocus (AF) lenses that work in conjunction with the camera body to automatically detect and set focus distance. However, not all AF lenses are equal and the systems that drive the motors in these lenses can vary in both accuracy and speed.

For some applications, such as landscape photography, AF speed is less critical, whereas for others, such as wildlife photography, it can mean the difference between getting the shot you want or missing it. It is always worth testing different AF lenses before committing to buying one to ensure that it is capable of delivering the performance you require.

## Prime lenses and zoom lenses

When zoom lenses first appeared, they were of questionable performance optically compared to prime (fixed focal length) lenses. Professional photographers often avoided them other than for very specific situations. However, things have changed; prime lenses usually still outperform zooms, but the gap in quality has narrowed significantly, and the versatility of zoom lenses can provide distinct compositional advantages.

### Digital lens design

Lenses for digital cameras are designed so that light is correctly captured for both the centre and the periphery of the image space (illustration a). For a traditional lens to achieve the same result, it would need to be enormous (illustration b).

### Digital lenses

The advent of digital SLR cameras has caused some manufacturers to design digital-specific lenses, such as this DX lens from Nikon.

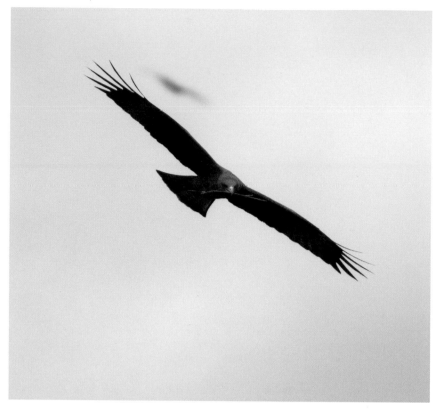

Optical stabilization technology, such as that used in some Nikon, Canon and Sigma lenses, aids handholding the camera for subjects that would be difficult to photograph using another form of camera support, e.g. the erratic movement of birds in flight.

These independent lenses are generally cheaper than the proprietary brands. Although they can sometimes be of a slightly lower optical quality, some can match and even surpass the quality of own-brand equivalents. For example, the Sigma 105mm EX macro lens is considered by many to be the best of its kind.

Most of the independent companies produce a professional range of lenses that use more expensive, higher-quality glass and stronger materials, and these are always worth considering. However, it is important that you check full compatibility with your system before making any purchase.

## Optical stabilization technology

To help overcome the problems of image blur caused by camera shake when handholding the camera, some manufacturers have introduced a range of lenses that utilize a technology known as optical or image stabilization.

### Lens quality

The quality of many independent lenses has greatly improved in recent years and they offer a less expensive alternative to proprietary, branded lenses.

When choosing a zoom lens, avoid those having a very wide range, such as 28–300mm and 50–500mm, as their extreme nature tends to compromise their optical performance. For extreme wide-angle lenses and super-telephoto lenses, prime lenses remain the preferred choice.

## Independent lenses

Most SLR (and D-SLR) cameras have a proprietary lens mount specially for use with the manufacturer's own lenses. Therefore, once you have bought into one manufacturer's system, it becomes a very expensive operation to switch to another. Although it is possible to attach one brand of lens onto a different make of camera via an adaptor, invariably you lose any automatic functions.

A number of independent companies, such as Sigma, Tamron and Tokina, also produce lenses that will fit the most popular camera makes, including Nikon, Canon, Pentax and Konica Minolta.

### Anti-Shake system

The Anti-Shake system employed in Konica Minolta D-SLR cameras is an alternative technology to optical stabilization. It has the same effect, helping to reduce the effects of camera shake when handholding the camera or, in this case, when photographing from an unstable platform (a boat).

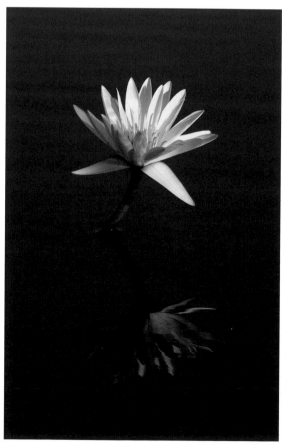

These optically stabilized lenses use a system of motors to compensate for slight movements of the camera body and enable handholding the camera at shutter speeds up to three times slower than normal. Although their effectiveness is subjective, they work remarkably well within their limitations and have made some field techniques, such as photographing birds in flight, far easier than was possible before.

The better systems automatically detect for camera panning and switch off the horizontal motor to avoid compensating for the voluntary movement of the camera from one point to another along the horizontal plane. However, in all cases, it is important to switch off the motors that drive the stabilization system when the camera is attached to a tripod.

## Konica Minolta Anti-Shake system

Konica Minolta has taken a slightly different approach to the problem of camera shake, installing in some of their digital camera bodies a system called Anti-Shake, or AS. This version of stabilization works by adjusting the position of the digital sensor rather than the optics to compensate for involuntary camera movement. In so doing, all lenses compatible with the body can make use of the AS system, rather than only lenses that have been specially designed.

## Specialist lenses

Depending on what field of photography most appeals to you, you may find that you require certain specialist lenses to help you obtain the images you desire. Some of these are discussed below.

### Macro lenses

Macro lenses are specially designed for close-up photography. They are far more convenient to use than close-up attachments, such as bellows and tubes, and provide better quality than close-up filters. Alongside quality and convenience are reproduction ratios of 1:1 (life-size) and the maintenance of AE and AF functions. Macro lenses are also specially corrected for working at very short camera-to-subject distances, with lens elements designed to reduce aberrations.

### Tilt and shift lenses

Few manufacturers produce tilt and shift lenses, but these specialist lenses can be useful when photographing buildings and in situations when you need to maximize depth of field.

These lenses allow movement of the optic by tilting up or down up to a maximum number of degrees and/or by shifting the lens along the horizontal or vertical axis. The shift mechanism, in particular, helps to overcome the distortion of converging verticals by keeping the film plane parallel to the subject.

### Teleconverters

Teleconverters provide a less expensive alternative to long telephoto lenses by multiplying the focal length of a compatible lens by a magnification factor of, typically, 1.4x, 1.5x, 1.7x, 2x or 3x depending on the model used. For example, a 200mm lens with a 1.5x teleconverter applied will have an actual focal length of 300mm. The same lens with a 2x teleconverter attached would have a focal length of 400mm. Using a teleconverter reduces image quality, and the loss of between 1 and 3 stops of light can severely limit their use in some situations (see page 26).

**Tilt and shift lens**
Specialist lenses are available for many applications. Here, a tilt and shift lens has helped to eradicate the converging verticals caused when photographing with the camera pointed up at a building.

# Camera supports

For pin-sharp images, it is advisable always to use a solid support for the camera and lens. This will help to minimize any involuntary movement of the camera and vibrations during exposures, thereby reducing the risk of image blur caused by camera shake. Depending on the equipment that is used, the subject being photographed, and the situation in which you are photographing, different types of support can provide different solutions.

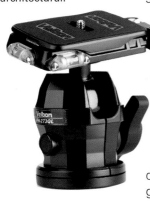

**▲ Tripods**
Tripods are an indispensable accessory in many areas of photography, particularly landscape and architectural.

**▲ Ball and socket head**
More expensive tripod models have interchangeable heads, making them more versatile. A ball and socket head, shown above, is ideal for photographing subjects that move erratically.

## Tripods

If absolute support is the primary factor, a tripod is the most reliable option. When choosing a tripod, ensure that it is designed to support the full weight of your heaviest camera/lens combination and that you can manage it comfortably, particularly if you are considering working for extended periods in the field. In such instances, you will find that carbon fibre models generally weigh one-third less than metal ones but typically cost more. Ultimately, it comes down to a balance between rigidity and portability; my advice is to opt for the sturdiest model that you can carry comfortably.

### Tripod heads

There are three main types of tripod head: ball and socket, pan and tilt, and gymbal. The different types of head suit different photographic applications. The pan and tilt variety is most suited to landscape work; the ball and socket type is ideal for wildlife; and the gymbal type is specific to use with super-telephoto lenses. Gymbal-type tripod heads, such as those made by Wimberley in the USA, make manipulating very long, heavy telephoto lenses simple and effective. They incorporate an elevated tilt mechanism and an adjustable platform to perfectly align the centre of gravity of the lens with the head. When set up correctly, once aimed at a subject the lens will remain static until moved by the photographer.

### Quick-release systems

Quick-release systems allow for the speedy removal and attachment of a camera or lens to a tripod and help to save time when you are switching between camera

**◄ Monopods**
A monopod is a useful alternative to a tripod. They are less stable but more portable and can often be used in situations where a tripod would be unfeasible.

**▼ Pan and tilt head**
A pan and tilt head is ideal for general landscape photography.

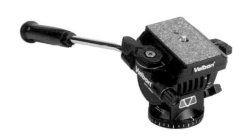

bodies. They work by fixing a quick-release plate to the camera or lens via the standard tripod screw socket, which can then be snapped in and out of a special mount on the tripod head. Ideally, a plate should be attached to all of your frequently used cameras and any lenses having a tripod collar.

## Monopods

Consisting of a rigid, telescopic pole with a standard mount at its head that screws into the tripod mount on the camera, monopods are a less stable, more portable, alternative to the tripod, and can be used almost anywhere. The advantages of the monopod are that it is easy to carry and relatively compact, making its use possible in situations where erecting a tripod could be tricky or even impossible. Used well, a monopod can help to reduce camera shake and allow exposure settings up to 2 stops slower than when you are handholding the camera. Monopods can also make effective lion repellent sticks in a tight spot, as I found out recently while on a trip to Africa!

## Beanbags

In situations when you are photographing wildlife away from a hide – in particular from a car, boat or floating hide – beanbags offer an ideal form of camera support. Made from a cloth bag filled with rice, maize or polystyrene, beanbags are useful for supporting long, heavy lenses. The malleable filler moulds around the lens and absorbs any vibrations, producing a very stable platform for the lens and camera. A beanbag placed on top of the lens can also help to reduce vibrations.

Synthetic beanbag fillers, such as polystyrene, tend to flatten out over time and will need to be replaced regularly for the beanbag to remain effective. Rice and maize are better options. However, they can attract the attention of hungry elephants, as I once found out to my cost in Africa!

**Beanbags**
Beanbags make ideal camera supports when photographing wildlife or shooting from a vehicle. They are remarkably stable when used correctly.

## Makeshift supports

It is possible to improvise a makeshift camera support if none of the traditional options are available to you. A camera placed on a rolled-up jumper or coat and supported by a solid wall can make an effective alternative to a tripod/ beanbag combination. I even once used a life vest and the inside of a seat cushion held together with a bungee cord when photo- graphing from a kayak in the Okefenokee swamp in Georgia, USA. Resting the lens on a fence or between the branches of a small tree are practical alternatives to a monopod, albeit less portable ones.

# Filters

One of the challenges of photography is to learn to see how a camera sees and be able to apply the necessary fixes in order to overcome the limitations of film/sensors. For example, humans can discern detail in areas of dark shadow and bright highlights simultaneously. That is, we see with significant latitude. Film, on the other hand, can record detail only with very narrow latitude – around 5 stops in the case of transparency film.

Although there are several hundred different filters available on the market, there are just a few that are used in the field regularly. These filter types are referred to as technical filters. Their primary purpose is to provide the fixes that enable you to record an image faithfully given any set of lighting conditions and photo- sensitive material.

There are two main types of filter systems: screw-in filters and slot-in filters.

## Screw-in filters

Screw-in filters are fixed in metal rings of varying diameters to suit different sized lenses. These include all the common lens diameters from 42mm to 77mm. The primary advantage of screw-in filters is that they are convenient and simple to use. Also, they are typically made of glass and provide a high quality of light transmission. Their main downfall is the need to carry several of each filter type for different sized lenses. For example, my kit bag includes lenses with diameters of 52mm, 58mm, 62mm, 72mm and 77mm, plus one rear-fitting filter size of 46mm. That's six different sizes requiring six of each of my main filters, of which there are 13, meaning that I would have to carry (and purchase) 78 filters in total.

Another disadvantage is a lack of flexibility when using split filters, such as the important neutral density graduated filters. Because it is impossible to adjust the placement of the line of graduation, you are very restricted in where you position the horizon line in the picture space when photographing landscapes, for example.

## Slot-in filters

An effective alternative to screw-in filters is the slot-in type of filter system, available from manufac- turers such as Lee Filters and Cokin. These systems use a standard-sized filter holder that attaches to the lens via an attachment ring. Different sized rings can be bought to fit the various sizes of lens diameters and, because the holder is a standard size, only one filter of each type need be bought. In other words, going back to my kit bag, I would need one filter holder, six attachment rings and only 13 filters – which is a far neater package than the 78 screw-in filters than I would otherwise have to carry with me.

**Screw-in filters**
Screw-in filters are available to fit most lens sizes. They are convenient and simple to use.

**Slot-in filters**
Filter systems, such as those manufactured by Cokin and Lee, are versatile and prevent you having to invest in several of one filter type for different sized lenses.

**NDG filter**

In this shot, a neutral density graduated (NDG) filter has helped to even the tones between the bright sky and the darker foreground area. The result is an even exposure that falls within the latitude of the film used.

Multiple filters can be fitted into the filter holder, so they can be used in combination. Graduated (split) filters can be adjusted up and down for precise composition – another key advantage of this type of system.

On the downside, these systems can be a little cumbersome to use and, because of their dimensions, may cause vignetting when using wide-angle lenses. Also, most of the filters made for these systems are manufactured using either plastics or resins and are not always of the same quality as glass filters. If this is a concern, glass slot-in filters are available, although at a high price. Otherwise, always opt for resins, which perform better than the less expensive plastics.

## Choosing and using filters

There are certain filters that I recommend you always carry with you. Some others are worth owning for specialist use when the need arises. Always buy the most expensive filters you can afford and treat them with the same level of care as you would your lens, cleaning them regularly. Replace any scratched filters immediately. Your very best lens is only as good as the filter you place in front of it.

### Ultraviolet filters

Ultraviolet (UV) filters absorb ultraviolet light that is invisible to the naked eye but that shows on colour film as an intensified blue cast and an enhanced mistiness of haze. By absorbing this short wavelength radiation, UV filters help the camera record the image closer to how we perceive it through our own eyes. The effects of UV light are most apparent at high altitude and close to the sea.

UV filters are also often used as a means of protecting the delicate front element of the lens from dust, dirt and scratches. If you opt to use UV filters in this way, buy the most expensive filter you can afford, as the quality of the filter will ultimately affect the optical performance of the lens.

### 81 series filters

The 81 series of warm-up filters reduces the level of blue light reaching the film or the digital sensor. These filters are available in varying strengths from slight (e.g. 81A) to very pronounced (e.g. 81D). The stronger the filter, the more blue light it absorbs and the warmer the picture appears.

More technically, 81 series filters can be used to match the Kelvin value of the light source with that of the film used to produce natural-looking, neutral white light.

### Colour correction filters

Colour correction, also known as colour compensating (CC), filters are used to fine-tune the colours in your images. For example, if an image has a slight bluish shift, a yellow CC filter helps to achieve a more accurate colour rendition.

CC filters come in various colours and strengths. The most useful are yellow, red and magenta in CC10 and CC20 strengths (these can be combined to produce CC30). Different CC filters can be combined to enhance a scene. For example, a CC20G combined with an 81A filter is ideal for photography in rainforests.

### Neutral density filters

Neutral density (ND) filters cut down the amount of light entering the lens by a fixed amount without affecting the colour tone. They are available in strengths between 1 and 3 stops in half-stop increments and are often used to enable slow shutter speeds in bright conditions.

### Neutral density graduated filters

A variation on the ND filter is a graduated ND (NDG) filter. Half the filter is clear, with no light-absorbing properties, while the other half acts like a normal ND filter, blocking light from entering the lens in varying strengths.

The purpose of these filters is to reduce the subject brightness range to bring it within the latitude of the film/sensor.

### Polarizing filters

Non-polarized light waves vibrate in all planes at right angles to their direction of travel. They exist all around us, for example in light reflected off non-metallic surfaces, such as water, and in light from blue sky at right angles to the sun. We are unable to differentiate between polarized and non-polarized light. However, photographic film/sensors record this light, making reflections on windows, glass and water, for example, more apparent. Polarizing filters polarize the light entering the lens, which removes these reflections.

Another effect of polarizing filters is to darken blue skies and make white clouds more prominent. In much the same way, they saturate colours making bold colours such as red, in particular, more vivid and striking. They can be used to good effect on foliage, which reflects a surprising amount of non-polarized light, particularly when wet, causing the colour of leaves to appear bolder and closer to how we perceive them.

Two versions of polarizing filter exist: linear and circular. Both affect light in the same way; however, a linear polarizing filter will adversely affect your camera's AE and AF functions, making the circular type a better option for automatic cameras.

### UV filter

When photographing this coastal scene on South Island, New Zealand, I fitted an ultraviolet (UV) filter to protect the front element of the lens from sea spray, which can damage unprotected lenses.

**Warm-up filter**
Here, an 81A filter has helped to enhance the warm tones of image b compared to the cooler photograph taken without a filter (image a).

# Flash units

Flash lighting of some kind is an essential piece of equipment for most forms of nature and wildlife photography. The main options are considered below.

## Built-in flash units

Most modern consumer-specification cameras have a built-in flash unit. These can be handy for quick bursts of fill-in flash but have two distinct limitations: because of their position directly above the lens, they produce direct, hard lighting and, when photographing people or animals, they produce the disconcerting effect known as red-eye. An additional drawback of built-in flash units is that they have a limited range. However, they should not be discounted in all circumstances, and they can help to add a catchlight in the eyes of wildlife in certain situations (see page 122).

## External flash units

External flash units are mounted on the camera via the accessory shoe or are supported off-camera on a flash bracket linked to the camera via an electronic connecting cord. Both options provide a dedicated link between the flash and the camera that ensures an accurate discharge of illumination when the shutter opens.

Typically, external flash units are more powerful, having greater range than the built-in variety. However, when attached directly on the camera they too produce hard, front-on lighting. When mounted via a flash bracket, the angle of the flash relative to the subject overcomes this limitation. More sophisticated external units have a bounce-flash facility, which also helps to alleviate the problem of front-on flash.

## Hammerhead flash

Hammerhead flash units provide maximum power, range and recycling times and are designed to work off-camera. They consist of a large flash head mounted on a stem that doubles as a handle. Although they are less portable than the smaller external units, a wide choice of accessories greatly increases the possibilities for practical application in the field.

## Ring flash

Ring flash units produce distinctive all-round, near shadowless lighting. They are commonly used in close-up and macro photography. They attach to the front of the lens with the front element poking through a hole in the middle of the flash unit. Synchronization with the camera is achieved via an electronic connecting cord and adaptor that fits into the hot shoe.

## Slave flash

Slave flash units are dependent on and activated by the main flash unit. Typically smaller than the principal unit, they are generally used to provide fill flash or to create specific lighting effects. They operate via a built-in sensor that detects when the main flash fires and then sets off the slave flash. They are useful accessories to carry, providing fill-in flash when artificial light is the primary source of illumination.

## Tilting and rotating heads

Tilting and rotating heads enable the flash to be bounced off a light subject, such as a reflector, helping to overcome the problem of flash illumination being direct and hard. By bouncing the light from a flash unit, you are effectively increasing the size of the source from a point source to an omni-directional one, which produces softer lighting.

## Diffusers

Diffusers also increase the relative size of the light source. Diffusers can be a simple, translucent plastic cover that fits directly over the flash head or a larger, more sophisticated gadget resembling a scaled-down version of a studio softbox. Alternatively, you can make one yourself using a suitable framework and some white nylon. Diffusers negate the need to angle the flash, which can remain pointed directly at the subject.

## Choosing a suitable flash unit

The most important factors when choosing a flash unit are: power, coverage, recycling times, levels of automation, and dedication to your camera type.

### Power

Generally, the more powerful the flash unit, the greater its flexibility. Power is given in terms of a guide number (GN), which varies depending on the ISO rating of the current film (ISO-E setting for digital). Typically, the greater the GN (with a constant base ISO value), the more powerful the flash and the greater its range.

Flexibility is seen when applying exposure settings. For example, assume that you are photographing a distant subject from a fixed position. Because flash-to-subject distance is fixed, it is impossible to influence exposure settings by moving the light source closer. In

▲ External flash
An external flash unit is ideal for many forms of outdoor photography. Some portable units can be unexpectedly powerful and prove very practical in the field.

this instance, using a flash unit with limited power will necessitate shooting at a wide-open aperture and relatively slow shutter speeds. However, a more powerful flash unit will enable the use of faster shutter speeds and/or narrower apertures without needing to get closer to the subject.

### Coverage

Essentially, flash coverage will determine which of your lenses will be compatible with the flash unit. Most modern flash units have coverage in the range of 28 to 135mm, meaning that they can be used with any lens with a focal length between 28mm and 135mm.

If you use a lens beyond this range, anomalies are likely to occur. For example, using wide-angle lenses with a focal length shorter than 28mm will result in some parts of the scene falling outside the area of illumination, causing vignetting (darkening of the corners of the frame). With a telephoto lens greater than 135mm, a quantity of light from the flash falls outside the frame, resulting in inaccurate exposures.

### Recycling time

Recycling times refer to the speed at which the flash tube recharges after it has been discharged. It is an important factor, particularly when you want to take several consecutive shots in quick succession, such as when photographing fast-moving wildlife.

Recycling times are often subject to battery life and, for this reason, a new set of batteries should always be used when you are photographing in critical situations.

### Automation

Manual flash units can be complicated to use and unproductive in the field. Modern flash units have taken much of the complexity out of flash exposure and have made life far simpler for the enthusiast photographer.

With an automated unit, once the ISO rating is set, the flash will indicate an appropriate aperture setting, depending on flash-to-subject distance. Some of the more sophisticated models that are available will even give you a range of apertures together with the range of the flash illumination with each, giving you greater flexibility.

▼ Built-in flash
Many cameras have a small, built-in flash unit. While these units are limited in their practical application, they can often be used to add a subtle amount of fill-flash or to create highlights in the eyes of animals.

▶ Bouncing flash
Some flash units have a tilting and/or rotating head, which allows the flash light to be bounced off a reflective surface, changing the quality of light relative to the subject.

## Dedicated flash

Dedicated flash units are the most evolved form of photographic flash. They communicate directly with your camera, accessing the information they need to calculate the relevant settings independently of the photographer, setting shutter speed and adjusting flash output levels depending on the lens aperture set.

In order to operate effectively, dedicated flash units must be used with cameras that have been designed to work with them. For example, a dedicated flash unit manufactured by Nikon will not work properly on a Canon camera and vice versa.

# Portable storage for digital photography

One of the significant advantages of digital photography is the flexibility it offers. You are not limited to the usual 24 or 36 frames of roll film, and can delete whatever images you deem to be sub-standard. However, the increased opportunities that digital offers for capturing images means that you will need some form of storage for your pictures, particularly when you are working in the field and are not able immediately to download your images to your hard disk.

## Memory cards

Memory cards provide semi-permanent storage until image data can be downloaded to a computer's hard disk drive (HDD) or other form of long-term storage media, such as a portable HDD, DVD or CD-ROM.

There are two popular forms of storage media used in digital SLR cameras: the Microdrive and the CompactFlash (CF) card.

### CompactFlash cards
CompactFlash cards are the preferred storage media for most digital camera users.

### ▶ Reliability
In the field, reliability is key, as there is often little or no time to reshoot. Minimizing the potential for errors by working with high-quality equipment helps ensure that you always get the shot you want.

## ▌Microdrives

Microdrives are miniature HDDs that, because of their robustness and high-speed, high-capacity (170Mb–1Gb) features, were originally intended for use in professional camera systems. However, with the advances that have been made in CF card design, the main benefits of Microdrives appear outdated. Their main advantage today is cost-per-megabyte (Mb) value, which is significantly lower than equivalent-capacity CF cards.

A principle disadvantage of these devices is reliability. Microdrives contain moving parts, which can be prone to wear and tear, as well as being vulnerable to heavy-duty usage in camera-hostile environments. For this reason, I have avoided using them, preferring the solid-state CF card.

## ▌CompactFlash (CF) cards

CF cards suffer fewer potential problems than Microdrives. They use solid-state technology (i.e. they have no moving parts), which makes them less susceptible to excessive heat generation, increased power usage and fragility. Their one disadvantage is price. A recent comparison I ran on the Internet showed a 1Gb high-speed CF card to be twice the price of an equivalent Microdrive.

The main manufacturers offer two versions of CF card, one for the consumer market and one for professionals. The principle difference is in write speed, the latter offering much faster data-transfer speeds. For some forms of professional use this can be essential, but most users will find the standard card types perfectly adequate for their needs.

There are two physical sizes of CF cards, referred to as Type I and Type II. Type II cards are thicker and, while most of the later D-SLR cameras accept both card types, some earlier models accept only the thinner Type I devices. The main difference between the two types, other than the physical size, is capacity: Type II cards generally have a higher capacity than Type I cards.

## Card size and write speed

CF cards come in various different sizes, from (currently) around 64Mb to 8Gb, and

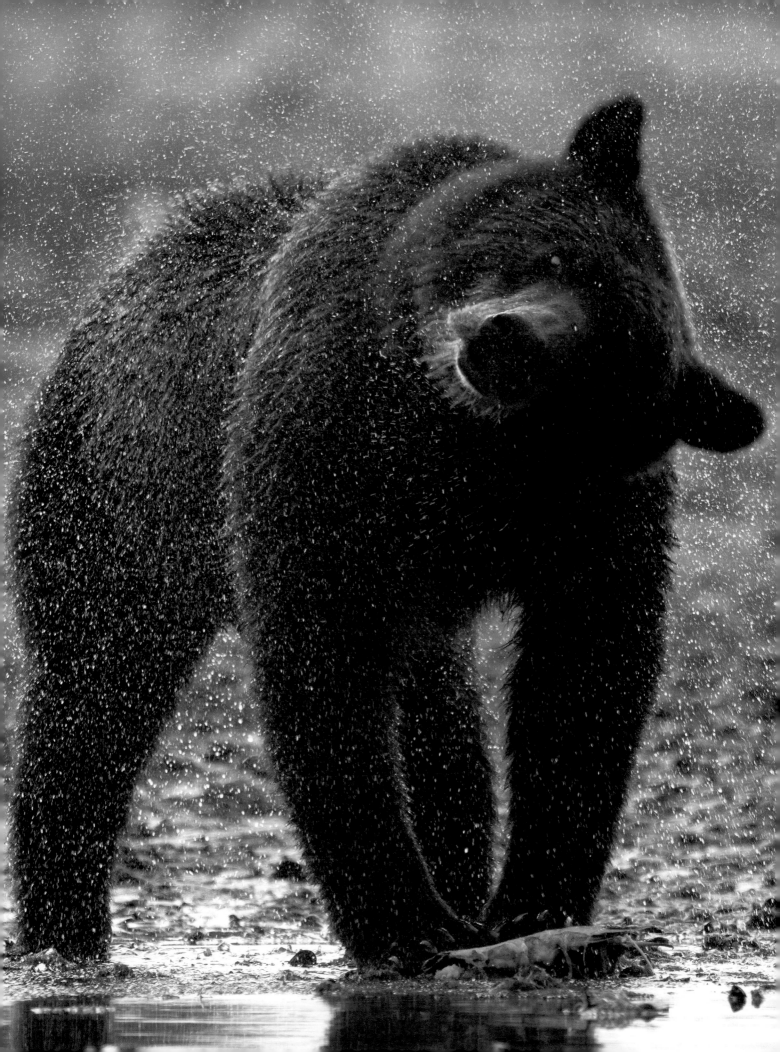

have different write (data transfer) speeds. The larger the capacity of the card, the greater the number of images it can hold. The faster the write speed (quoted as, for example, 20x, 40x, 80x), the quicker the data is transferred out of the camera's internal buffer. This can increase the number of consecutive images exposed at any one time (the burst depth – see pages 17–18). To use some of the larger-capacity and faster cards, your camera needs to support Lexar's Write Acceleration (WA) and FAT32 technologies. You will need to refer to the manufacturer's specifications to check whether this applies to your camera.

### Card capacity

Higher-resolution digital cameras need greater card capacity. I recently upgraded all my 1Gb CF cards to 2Gb versions to cope with the increased demands of my 12.5mp Nikon D2X. Even so, I still manage only 100 images per card.

## Choosing the best card size

There is no definitive ideal when it comes to best card size. It depends on many things, not least the size of the image files produced by your camera. Using my Nikon D2X, which produces approximately 20Mb image files, I prefer to shoot with a 2Gb CF card. This is because I find it easier to manage cards with fewer images on than one with several thousand. I also prefer to

## INTERPRETING WRITE SPEEDS

The information below provides the actual speed of data transfer for given CF card write speeds. The figures given are approximate and refer to FINE-resolution JPEGs. Figures will vary for other image-quality settings.

| Card speed | Data transfer speed (Megabytes per second) |
|---|---|
| 8x | 1.2 |
| 12x | 1.8 |
| 20x | 3.0 |
| 25x | 3.8 |
| 30x | 4.5 |
| 40x | 6.0 |
| 60x | 9.0 |
| 66x | 10.0 |
| 80x | 12.0 |

download images from the card to a long-term storage medium frequently so that if the card fails, or is lost, damaged or stolen, I don't lose hundreds or thousands of images. If shooting with a 6mp digital camera, I would switch to 1Gb cards for the same reasons.

## Using memory cards

The first time you use a CF card in a specific camera, you may need to format it using the Format menu option on your digital camera. Once in use, cards can be removed at any stage, either to change to a different card or to transfer the written files to a computer or other storage device. You can also erase any images you don't like as you go along, making room for additional images. The only time you shouldn't

| APPROXIMATE NUMBER OF IMAGES STORED PER DEVICE | | | | | | | | | |
|---|---|---|---|---|---|---|---|---|---|
| DPS size (Megapixels) | File size | 32Mb | 64Mb | 128Mb | 256Mb | 512Mb | 1Gb | 2Gb | 4Gb |
| 2 | 0.9Mb | 35 | 71 | 142 | 284 | 568 | 1137 | 2275 | 4551 |
| 3 | 1.2Mb | 26 | 53 | 106 | 213 | 426 | 853 | 1706 | 3413 |
| 4 | 2.0Mb | 16 | 32 | 64 | 128 | 256 | 512 | 1024 | 2048 |
| 5 | 2.5Mb | 12 | 25 | 51 | 102 | 204 | 409 | 819 | 1638 |
| 6 | 3.2Mb | 10 | 20 | 40 | 80 | 160 | 320 | 640 | 1280 |

state, they are more reliable than hard drives. The devices themselves are larger than most portable HDDs, but only just, so carrying them in the field is no issue. They have two limitations. The first is that their capacity is limited by the capacity of the CD (usually around 700Mb), so you will need to carry several blank CDs for extended trips. Also, and importantly, it is not possible to visually verify that the data has been transferred successfully, which requires a significant leap of faith before deleting images from the memory device.

### Portable HDD

Portable hard disk drives are the most user-friendly means of storing digital images in the field during a shoot. Some models, such as the Jobo ProView, are specifically designed to withstand the rigours of outdoor photography.

### Inserting cards

Care should be taken when inserting a memory card into a camera. Always follow the instructions given with both your camera and your card.

remove the card from a device is when it is being accessed. Always refer to the indicator lights to tell you it is safe to remove the card.

The question of whether memory cards are affected by airport X-rays has been open to some debate. The truth is that they are not affected, either by the low-powered hand-inspection X-ray machines, or by the more powerful devices used to scan hold baggage.

## Portable storage

In the field, it is often necessary to transfer digital files stored on the memory card to a portable permanent storage device, such as a HDD or CD, freeing space on the memory card so that more pictures can be taken. There are several of these devices available, with varying capacities and prices. However, the most important quality of any portable storage device is reliability.

### HDDs

Portable HDDs are available in compact units with capacities exceeding 80Gb. Typically, they provide a small screen on which images can be viewed, and some simple editing functions, allowing you to delete sub-standard images or write-protect special shots you really don't want to lose.

Reliability is the main issue here. Hard drives are mechanical and are the most likely part to fail of any computer system. The moving parts of a HDD are susceptible to heavy knocks and bumps, which can cause them to fail in harsh conditions.

### CD writers

Portable CD writers allow you to download and write images to CD and, because of their solid

### Portable storage

Portable CD writers are useful tools for storing digital files when on the move. An alternative is to use a portable HDD (see above).

# Photographic principles

**A**nyone who wants to take compelling images in the field needs to be fully conversant with the fundamental principles of photography. These principles involve understanding light, exposure and focus. The new medium of digital has also brought with it its own challenges and complexities that need to be mastered.

## Understanding light

Photography is all about light. Understanding quality of light, contrast, direction of light, and colour temperature are important if you are going to succeed in creating images that communicate energy and emotion.

### Quality of light

The quality of light is a term used to describe its visual strength. In relation to photography under natural lighting, it is influenced by the effective size of the light source – the sun. On a cloudless day, light rays from the sun are similar to those from a spotlight, as they are directional and strong in intensity. Direct, or directional, light is described as hard lighting, as it produces well-defined shadows and intense contrast. In overcast conditions, the relative size of the light source is increased: the direct rays from the sun pass through the clouds and are scattered into many more light points emanating in all directions from the area of diffusion. Some of this extra light will fall around the subject rather than directly onto it, and areas previously in full shadow will receive at least some amount of illumination. Omni-directional lighting such as this is described as being soft, with shadow edges being less well defined and levels of contrast greatly reduced.

The same situation arises when using flash. Light direct from a flash unit acts in the same way as non-diffused sunlight; it has a hard quality, and often creates harsh shadows that

**Understanding light**
Light is the fundamental basis of photography. Understanding how to make the most of ambient light will help you to create images in the field that are full of graphic power and emotion.

**Direct light**

Here, the direct light from an unobscured sun has helped to draw attention to the principal subject of this photograph – the man in the middle. In this instance, contrast enhances the compositional strength of the image.

detract from the composition. By bouncing the flash light off a large bright object such as a piece of white card, or by adding a diffuser to the flash unit, flash lighting can be made omni-directional, just like sunlight on an overcast day.

## Contrast

Contrast refers to the subject brightness range (or SBR). Put another way, it is the difference in brightness between the darkest shadow areas and the brightest highlights. When we look at a scene, our eyes will automatically compensate for different levels of brightness and we are able to see detail with a high degree of latitude. Film and digital sensors, however, are less sophisticated and have only a fraction of the latitude of the human eye. Positive (transparency) film has around 5 stops of latitude; negative film has around 7 stops; and digital sensors have around 8 stops. This means it is impossible to record detail across the whole SBR without the aid of fill-flash or certain types of filter, if the shadow areas are 6 stops darker than the highlight areas and colour transparency film is being used.

Contrast is greatest when the subject is lit by a point light source from the side or from directly overhead – such as a landscape scene

photographed on a sunny day around noon. This is why landscape photographers prefer not to photograph in the middle of the day.

However, contrast should not be avoided at all costs; it can be used to great creative effect. Take as an example one of landscape photography's greatest practitioners, the American photographer Ansel Adams (1902–1984). He was a master at using contrast to create dramatic and powerful images that stand the test of time.

**Diffused light**

It would have been difficult to photograph this scene successfully had the light not been diffused. Naturally high-contrast scenes are often best photographed on a cloudy day.

**▲ Side lighting**

In this image of contours in sand on a beach in France, side lighting creates the contrast needed to produce an abstract image.

**◀ Front lighting**

Front lighting helps to reproduce the features of this church in an ideal way. Although often considered the worst kind of light for photography, front lighting can be exploited for creative purposes.

## Direction of light

The direction from which light strikes your subject can have a strong influence on how that subject appears in the final image. Direction of light dictates whether surface detail appears flat or textured and how and where shadows fall, and therefore whether your images are imbued with a sense of depth or appear flat and lifeless. You can also exploit the direction of light for artistic effect, creating silhouettes or beautiful golden 'haloes' around your subject.

### ▌Front lighting

Front lighting generally eradicates shadow from a photograph, minimizing any sense of depth. The lack of contrast from frontal lighting also flattens surface detail and is useless if you are

trying to emphasize the texture of a subject. If, however, you are simply trying to record features in a scene, then front lighting provides bright illumination.

### ▌Overhead and side lighting

Overhead or side lighting is ideal for emphasizing texture or form. Lighting coming from above or to the side of the subject creates intense shadows that punctuate, for example, the undulations in a ploughed field or the bark of a tree, or helps to distinguish between the sides of an old barn or building.

### ▌Back lighting

You can use back lighting to exploit differences in surface reflectivity. For example, water, when backlit, appears wet and liquid, adding life and visual energy to photographs. However, when lit from directly above, water takes on the appearance of a solid mass.

For more creative endeavours, back lighting, when metered correctly (see page 53), can be used to produce a golden halo effect. This can

**Back lighting**

Silhouettes are a natural result of back lighting, and can form powerful graphic images when photographed well. The lack of colour and detail in silhouettes bring shape to the fore, which can be used to create evocative and emotive images.

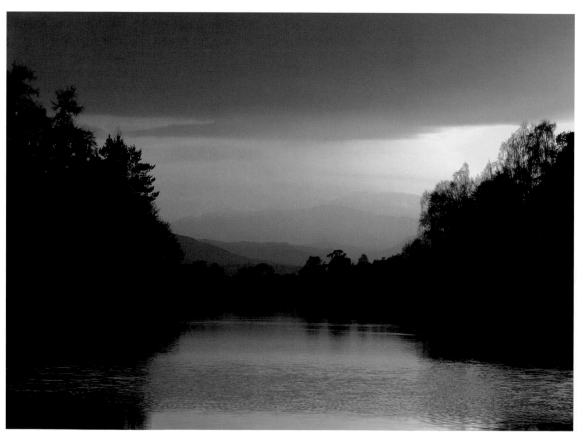

▲ Cool tones

The cool blue cast to this image of a waterfall in France enhances the photograph. It was created by a combination of the time of day (mid-afternoon), the weather (cloudy) and the position of the subject (in shade).

be exploited to great visual effect when recording portraits of animals, or when creating strong graphic statements by rendering the subject as a silhouette.

When using back lighting, you should be aware that the problem of lens flare can occur. This is caused by light falling directly onto the lens. A lens hood will help to avoid the image-degrading effects of flare.

## The colour temperature of light

The colour of light is often referred to in terms of its temperature. For example, blue light is described as being cool and is a colour that we associate with cold subjects, such as ice-covered landscapes or large bodies of water. Conversely, red light is considered to be warm and is associated with subjects such as fire or the warm hues of autumn foliage.

The human eye compensates for variances in colour temperature, and we find one temperature of light indistinguishable from another. For example, the light from a household light bulb appears white to us, even though its actual colour temperature is a very warm orange – which is how it would appear if it were photographed using daylight film.

Film and digital sensors record colour temperatures as they are and not how they appear to the human eye. Therefore, you must learn to identify the temperature of sunlight at different times of the day and how to compensate for it using colour correction filters (see page 33) or the white balance control on a digital camera (see page 44).

Light temperature is measured using a scale known as degrees Kelvin (K). Sunlight on a clear summer's day around noon, for example, is approximately 5,500K. On the same summer day, the temperature of light around sunset drops to roughly 2,000K – far warmer than the blue light apparent during the middle of the

▲ Warm tones

This autumnal scene benefits from the warm glow of evening light, which helps to enrich the colour of the soon-to-fall leaves and contrasts nicely with the shimmer of blue water.

| COLOUR TEMPERATURE IN VARIOUS CONDITIONS | |
| --- | --- |
| Light source | Colour temperature |
| Subject in shade on a sunny day | 8,000K |
| Heavily overcast conditions – thick cloud cover | 7,000K |
| Lightly overcast conditions – light covering of cloud | 6,000K |
| Summer sunlight | 5,500K |
| Early morning/late afternoon sun on a clear day | 3,500K |
| Direct, electronic flash light | 3,400K |
| Sunset on a clear day | 2,000K |

a       b

I often use a white balance setting other than the one that has been recommended by the camera. For example, if the subject is lit by bright sunlight I may set WB to 'cloudy' rather than 'direct sunlight' to create an image with a warm feel, much as I would use an 81 series filter with daylight film.

# Mastering exposure

Exposure is a subject that often haunts and mystifies photographers. The matter tends to be shrouded in guruism and complicated by technical jargon. And yet it is a subject that can be easily mastered once the basis for calculation is understood.

## Understanding stops

A stop is a unit of measurement that refers to light in the context of the three main exposure controls: shutter speed, aperture and ISO or ISO-E rating. For example, an ISO 100 film is less sensitive by 1 stop than an ISO 200 film; to reduce shutter speed from 1/250 sec to 1/125 is to increase the length of time the shutter is open by 1 stop; and to increase the aperture from f/8 to f/5.6 is to increase the amount of light entering the camera by 1 stop.

Stops make it easy to apply adjustments in exposure settings in relation to the law of reciprocity, i.e. a change in one setting must be matched by an equal and opposite change in another. If you reduce the amount of time the shutter is open by 1 stop, you must also increase the quantity of light falling on the film/sensor

### Colour casts

Artificial light often has a strong orange cast caused by its low Kelvin value. This is why photographs taken indoors often look unnaturally orange (image a). Digital cameras help you to adjust for the colour temperature of light via the white balance control, producing more natural-looking results (image b).

day. The table on page 43 lists typical colour temperatures for a number of settings.

## White balance

Digital cameras have a function known as the white balance or WB control. This allows the photographer to set the colour temperature of the sensor to reproduce the light in a scene as neutral white, irrespective of the conditions. To achieve the same result with film, you would need a series of colour correction filters to cover any eventuality – an impractical solution.

Some of the WB settings are typically pre-programmed. The more common of these are listed in the table below, along with their relative colour temperature equivalents. More advanced digital cameras have a facility that enables matching of the exact colour temperature of a scene at the point of shooting.

### Exposure compensation chart

This chart will provide you with some useful guidelines for setting exposure compensation in situations with non-middle-tone colours using a reflected light meter.

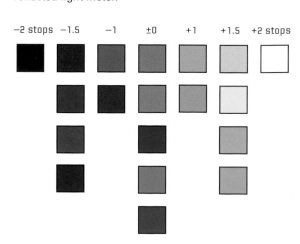

| WHITE BALANCE SETTINGS | | |
|---|---|---|
| **WB setting** | **Approximate colour temperature** | **Light source** |
| Incandescent | 3,000K | Household light bulb – a similar setting to tungsten balanced film |
| Fluorescent | 4,200K | Fluorescent strip lighting, often found in offices |
| Direct sunlight | 5,200K | Noon sunlight on a cloudless day – a similar setting to daylight-balanced film |
| Flash | 5,400K | Electronic flash unit |
| Cloudy | 6,000K | Overcast day |
| Shade | 8,000K | Outdoor subject in shade |

(using the aperture) by 1 stop to retain parity. Alternatively, you might increase the sensitivity of the film/sensor by the same amount. As well as whole stops, many cameras allow adjustments in either one-third or half-stops, or both. However, the same principle applies.

## Through-the-lens (TTL) light meters and exposure

The key to mastering exposure lies in understanding exactly how a camera's TTL-light meter operates.

TTL meters are reflected light meters – that is, they measure the amount of light reflecting off a subject. They differ from handheld ambient light meters, which measure the amount of light falling on a subject (see page 46).

TTL-light meters see the world only in shades of grey, and this is their primary disadvantage. They are unable to detect the tone of the subject that you are photographing. In other words, the meter is unaware whether the subject's tone is black, white, dark grey, light grey or anything in between. To compensate for this, manufacturers agree on an industry standard that all light meters are set to: middle-tone, 18 per cent grey. This means that all light meters used for photographic purposes assume the tone of the subject to be middle-tone, 18 per cent grey. If you have ever heard of the Kodak Grey Card, this is where the term originates.

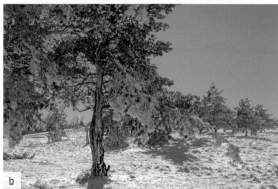

**Metering problems**
Here, the predominantly white landscape has fooled the camera's meter into underexposing the scene (image a). Because white is between 2 and 2.5 stops lighter than middle tone, I set an exposure compensation value of +2.5 stops and reshot the image, thereby producing an accurately exposed image (image b).

When a TTL-light meter gives an exposure reading, it gives a reading for a subject that is middle-tone grey, irrespective of its actual tone. This means that meter readings for subjects that are brighter than middle-tone, such as white snow, will be underexposed (to make them darker and closer to medium grey). On the other hand, meter readings for

**Exposure effects**
There is no such thing as a correct exposure. Here, I purposely underexposed the foreground to create a silhouette of the rocky outcrop and the small chapel. Exposures should always be faithful to the effect that you are trying to create.

subjects that are darker than middle-tone will be overexposed to render the subject lighter (again, closer to the medium grey that is assumed by the camera).

Once you know this, understanding meter readings becomes much simpler: you begin to realize why snow, for example, when photographed at the camera's automatic exposure setting, always appears grey on the resulting image. It's because the camera sees it as grey – 18 per cent, middle-tone grey, to be exact.

As the photographer, you must determine whether the subject being photographed is middle-tone, brighter than middle-tone or darker than middle-tone. If it's middle-tone, the camera in automatic mode will set a technically accurate exposure, or indicate such via the manual exposure graph in the viewfinder when set to manual exposure mode. However, if the subject is lighter or darker than middle-tone, you have to tell the camera this by using the exposure compensation function.

## Incident light meters

As an alternative to measuring the quantity of light reflecting off a subject, an incident light meter measures the amount of light falling on a subject – the ambient light. An incident light meter uses a white diffuser to average the total amount of light falling on it before the light level is measured by the meter's cell underneath the diffuser.

Ideally, the meter should be placed close to the subject, pointing towards the camera. The advantage of this type of metering is that contrasting areas of light and dark have no influence over the meter reading and therefore it gives accurate results in most lighting conditions. However, an incident light meter is limited in that it gives no selective information, which removes a level of control over the creative possibilities of a potential image.

## Defining tonality

This leads to the tricky bit: what is and isn't middle-tone, and by how much does the tone vary? The chart on page 44 can be used as a guide when you're in the field. Here are some pointers in the meantime.

Many subjects in nature are middle-tone, including lawn-green grass, blue sky on a sunny day between 11:00am and noon, and poppy red. Subjects that are lighter than middle-tone include daffodils, dandelions and rapeseed, all of which are around 1.5 stops brighter than middle-tone. Snow and swans' feathers are around 2 stops brighter, whereas blue sky in the

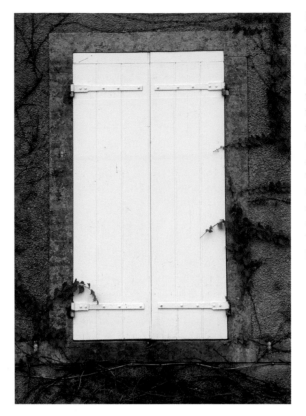

early morning (around 9:00am) is around 1 stop brighter than middle-tone. Conversely, conifer green is around 1.3 stops darker than middle-tone and the night sky around 2 stops darker.

When you are starting out, it is useful to carry a grey card with you to help assess the relative brightness of the tones in a scene. Hold the card up against the subject and determine whether the tones are similar, brighter or darker. Once you have assessed the tonality of the subject, to gain a technically accurate exposure simply dial in the appropriate amount of exposure compensation (or, in manual mode, over- or underexpose by the right amount) before taking the picture.

## Taking a meter reading

There are two ways to take a meter reading with a reflected light meter. One is to take a meter

### Spot meter reading

To photograph this predominantly white scene, I took a spot meter reading from the middle-tone stone to one side of the shutters and locked the exposure value given by the camera. An alternative method would have been to meter the white shutters and set +2 stops' exposure compensation. The result would have been identical.

### ▶ Wide aperture

To obscure background detail and isolate the statue, I set a wide aperture (f/5.6) to limit the extent of depth of field.

### ◀ Incident light meter

An incident light meter can produce highly accurate results in the right conditions

reading from the subject directly and then apply the appropriate amount of exposure compensation. Alternatively, you can take a meter reading of a middle-tone subject that is in the same light as your subject, lock the exposure using the AE-Lock function on the camera (or set the exposure in manual mode) and recompose the picture before pressing the shutter. Following the second example, it is vital that the middle-tone subject you meter from is in the same lighting conditions as the subject, or the exposure will vary because of the difference in the intensity of illumination.

| EV 10 EQUIVALENCY | |
|---|---|
| Lens aperture | Shutter speed |
| f/2 | 1/250 sec |
| f/2.8 | 1/125 sec |
| f/4 | 1/60 sec |
| f/5.6 | 1/30 sec |
| f/8 | 1/15 sec |
| f/11 | 1/8 sec |
| f/16 | 1/4 sec |
| f/22 | 1/2 sec |
| f/32 | 1 sec |

## Exposure values

Rather than a combination of lens aperture and shutter speed, some light meters generate a number for exposure, known as an exposure value (EV). This can then be used in conjunction with an EV table (as shown below left) to determine the various lens aperture/shutter speed combinations that can be used for the given meter reading.

For example, EV10 is equivalent to the lens aperture/shutter speed combinations as shown left.

## The two main exposure controls

The two main camera controls used in setting exposure are the lens aperture and the shutter speed. How you combine these two controls greatly influences the appearance of the final image, and it is important to understand how each affects photographic composition.

## Lens aperture

The size of the lens aperture controls the quantity of light reaching the film/sensor, working in much the same way as the pupils of our eyes. For example, in very bright conditions our pupils contract, as less light is needed for us to see what we're looking at. Conversely, in very dark conditions our pupils grow larger because more light is required to distinguish the same detail. Changing the size of the lens aperture, then, increases or decreases the amount of light reaching the film/sensor.

All camera lenses use the same scale of measurement, known as f/stops. F/stop numbers are marked on the aperture ring on the lens and are displayed on the LCD panels of modern cameras. The actual range of f/stops

▼ **Narrow aperture**
For this image, I wanted depth of field to extend from the close foreground all the way through to infinity. I set a narrow aperture (f/22) to maximize the zone of acceptable sharpness.

| F/STOP INDEX | | | | | | | | | | | | |
|---|---|---|---|---|---|---|---|---|---|---|---|---|
| f/1 | f/1.4 | f/2 | f/2.8 | f/4 | f/5.6 | f/8 | f/11 | f/16 | f/22 | f/32 | f/45 | f/64 |

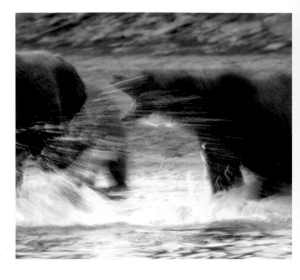

varies with the lens used, but they always form part of the same scale, illustrated in the table above. Although aperture size can extend from as large as around f/1 to as small as f/64, most lenses used today start at around f/2.8, decreasing in size to something like f/32.

Each f/stop number represents the ratio of the focal length of the lens to the diameter of the lens diaphragm opening and, in practical terms, can be thought of as units of measurement. The larger the f/stop number, the smaller the lens aperture. Increasing the aperture by one full stop doubles the amount of light reaching the film. Reducing the aperture by one full stop halves the amount of light reaching the film.

I am often asked why it is that the larger the f/stop number, the smaller the aperture it relates to. It helps to think of f/stops as fractions. For example, 1/22nd is smaller than 1/16th, just as f/22 is smaller than f/16.

The most obvious consequence of adjusting lens aperture is to affect depth of field. The larger the aperture, the less depth of field you have to work with. As aperture size decreases so the extent of depth of field increases. That is, the smaller the aperture, the greater the

**Visual energy**
A slow shutter speed (1/20 sec) has helped to blur the motion of these bears. Motion blur creates a sense of movement and gives an image visual energy.

depth of field. Depth of field influences the appearance of objects in a scene and whether subjects distant from the point of focus, such as foreground and background detail, appear sharp (wide depth of field) or blurred (shallow depth of field). See also pages 61–63.

## ▌Shutter speed
Shutter speed determines the length of time the film/sensor is exposed to light. It is measured in whole seconds and fractions of

**Freezing motion**
To freeze the movement of this flock of flamingos flying in formation, I set a fast shutter speed of 1/1000 sec. While the image lacks the visual energy of the photograph above, here a fast shutter speed has helped depict a behavioural aspect of the birds.

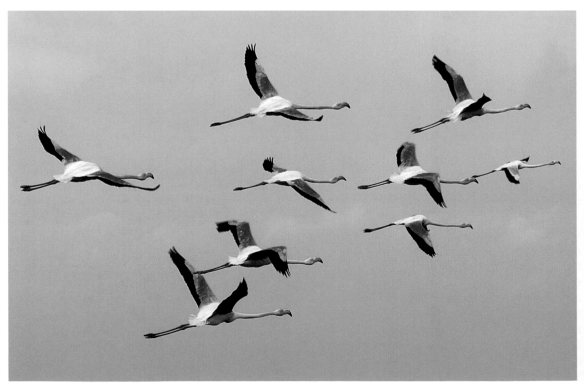

seconds. The pre-set shutter speeds available on most cameras vary between a few seconds to as short as 1/1000 sec. However, some more sophisticated models provide speeds as slow as 30 sec and as fast as the current champion at 1/16,000 sec. There is also a setting known as the Bulb setting (sometime referred to as the Time or T setting). When shutter speed is set to Bulb, the shutter remains open so long as the shutter release is fully depressed, enabling exposure times to extend beyond the slowest pre-set camera setting, up to several minutes, hours or even days.

As with lens aperture, a full one-stop change in shutter speed will either double or halve the length of time of the exposure. For example, increasing the shutter speed from 1/250 sec to 1/500 sec will halve exposure times. Correspondingly, decreasing the shutter speed from 1/500 sec to 1/250 sec will double exposure times.

Shutter speed, relative to the speed of the subject, determines how movement is depicted. Fast shutter speeds will freeze motion, producing images of subjects with well-defined, sharp edges. Conversely, slow shutter speeds can produce pictures showing artistic blur, where edges and shapes become more abstract, creating a sense of visual energy and motion.

## Exposure control: sensitivity

The sensitivity of film (also referred to as film speed) is a measure of how quickly that film reacts to light. It is depicted by its ISO (International Standards Organization) rating. A film with a rating of ISO 100 or below reacts more slowly, meaning that more light is needed for a longer period of time for an image to form. These films are sometimes referred to as slow films.

Every subsequent increase in the sensitivity, or speed, of the film (e.g. ISO 100, ISO 200, ISO 400, ISO 800) reduces the quantity of light or the length of time of the exposure needed for an image to form. Therefore, the ISO rating of the film influences exposure by determining the film's sensitivity to light.

### Up-rating and down-rating film speed

All films have a pre-set ISO rating set by the manufacturer at which they perform to their optimum standard. However, the given rating of a film can be changed by manually setting the film speed indicator on the camera. When the base ISO rating is set at a higher sensitivity level (e.g. an ISO 100 film is rated at ISO 200), this is known as up-rating, or pushing film speed. When the opposite applies and the film speed

**Shutter speed**
I wanted to set a relatively slow shutter speed for this image of two young skaters, but the high level of light precluded this. I reduced the sensitivity of the digital sensor to its slowest rating (ISO-E 100) to achieve the necessary shutter speed.

is manually set at a lower rating than the pre-set ISO, it is referred to as down-rating, or pulling the film speed.

The purpose of up- or down-rating film is to gain extra stops of light or to lose stops of light when levels of illumination are either too low or too high, respectively, to attain the shutter speed/lens aperture combination you need to create the compositional effect you desire.

### How to up-rate and down-rate film

By up- or down-rating film, you are telling the camera to act as if the film is more or less sensitive to light than it actually is. For example, you may take an ISO 100 film and rate it at ISO 200 – 1 stop more sensitive (faster) than the pre-set rating given by the manufacturer.

First, you need to switch off any automatic DX coding function on the camera. You will be able to find instructions for this in your user manual. Then you need to set the up- or down-rated film speed manually via the appropriate dial.

Now when the camera makes a meter reading it will assume the revised, manually set ISO rating and provide an adjusted exposure value accordingly.

Some films react better to up- and down-rating than others. In some cases, the so-called professional films, such as Fuji Provia 100F and Fuji Velvia, perform better when re-rated by 1 stop than other films of the equivalent pre-set ISO rating. In all cases, up- and down-rating film affects the graininess of the final image (see page 20).

Whichever film type you decide to work with, I recommend re-rating films by no more

## LENS APERTURE/SHUTTER SPEED COMBINATIONS

| Lens aperture | Shutter speed (seconds) | Exposure Value (EV) |
|---|---|---|
| f/4 | 1/50 | 13 |
| f/5.6 | 1/250 | 13 |
| f/8 | 1/125 | 13 |
| f/11 | 1/60 | 13 |
| f/16 | 1/30 | 13 |

## LENS APERTURE/SHUTTER SPEED/ISO COMBINATIONS

| Lens aperture | Shutter speed (seconds) | ISO/ISO-E rating | Exposure Value (EV) |
|---|---|---|---|
| f/4 | 1/250 | 200 | 11 |
| f/4 | 1/125 | 100 | 11 |
| f/4 | 1/500 | 400 | 11 |
| f/2.8 | 1/250 | 100 | 11 |
| f/5.6 | 1/250 | 400 | 11 |

three different exposure controls and be able to maximize their creative effects while working within their limitations.

When too little light reaches the film/sensor, underexposure results in dull images punctuated by large, dark or black patches. To rectify this, you can either increase the quantity of light reaching the film/sensor by making larger the lens aperture or set a slower shutter speed, increasing the length of time of the exposure.

An alternative method, and one that is particularly handy given the flexibility of digital cameras, is to make the film/sensor more sensitive by increasing its ISO or ISO-E rating, which reduces the level of illumination needed to record an acceptable image.

When too much light falls on the film/sensor, you will obtain an overexposed image with burned-out highlights that are lacking in detail. The level of illumination must be reduced; this can be achieved by making the lens aperture smaller or by setting a faster shutter speed. Alternatively, using the ISO/ISO-E control, the sensitivity of the film/sensor can be reduced by down-grading (film) or selecting a slower rating (digital) – always remembering that the law of reciprocity dictates that any change in one exposure control necessitates an equal and opposite change in another.

than 1 stop higher or lower than their pre-set rating. It is also worth noting that the revised ISO rating must be applied to the entire film strip. You should always mark the film canister as a reminder to advise your processing lab of the change, or you will end up with a set of under- or overexposed images.

### ISO-E (equivalency)

Using a digital camera, the sensitivity of the sensor is measured in the same way as it is for film, and is referred to as its ISO-E (equivalency). For example, a sensor that is set to an ISO-E of 200 reacts to light in a similar way to a film of the same ISO rating (in this example, ISO 200).

The advantage of the digital format is that a different ISO-E rating can be set for each exposure, thus negating any need for up- or down-rating as it applies to film.

To increase the sensitivity of the sensor, a digital camera increases the level of amplification of the signal produced by the sensor, which can increase levels of digital noise, as described on page 23.

## Using the three exposure controls together

In order to manage exposure effectively, you must understand the relationship between the

### Managing light

Managing light using all three available exposure controls is the secret to creating images that accurately reflect the scene as you saw it. Exposure is always a balance between image quality, how we depict motion and the extent of depth of field.

## The law of reciprocity

To guide you through the law of reciprocity, let's use the following example.

Assume a correct exposure setting of 1/250 sec at f/11. If you decide to increase the shutter speed to, say, 1/500 sec, you are halving the length of time of the exposure. In order to retain an accurate exposure, you must make a reciprocal change in aperture, in this case widening the aperture to f/8 to double the quantity of light reaching the film/sensor.

Equally, if you choose to narrow the aperture from f/11 to, say, f/16 to gain, for example, additional depth of field, you halve the quantity of light reaching the film. This necessitates a reciprocal adjustment in shutter speed – in this example, from 1/250 sec to 1/125 sec (lengthening the duration of the exposure).

As both of these examples show, the law of reciprocity dictates that multiple combinations of lens aperture/film speed settings allow exactly the same level of illumination to fall on the film/sensor so long as any change in one setting is compensated for by an equal and opposite change in the other. This is represented in the table reproduced to the left, where each of the lens aperture/shutter speed combinations shown result in exactly the same exposure value.

Another option is to replace a reciprocal change in lens aperture or shutter speed by adjusting the sensitivity of the film/sensor, as described above. The table reproduced left indicates how this would work in the field.

## Law of reciprocity failure

When film is exposed at shutter speeds exceeding around 1 sec, reciprocity law fails. This is because the longer film is exposed to light, the less sensitive it becomes. Therefore, for exposures of 1 sec or longer, you must compensate for reciprocity law failure by increasing the exposure above and beyond normal reciprocity.

Because individual films react differently, manufacturers provide an indication of the effects of reciprocity law failure for each of their film products, some of which are shown on page 52. However, to be certain of attaining an accurate exposure in the field, it is sensible to bracket images (see pages 126–128).

Digital sensors are unaffected by reciprocity law failure and require no compensation when exposures exceed 1 sec.

**Low light**
In low-light conditions, film suffers from a failure in the law of reciprocity. You must adjust the exposure settings accordingly.

## Countering the effects of slow shutter speeds

Whether on purpose or through necessity, several factors may dictate the need to set long-time exposures, where the shutter speed exceeds 1 sec, so inducing law of reciprocity failure. These conditions include low light, using slow film or shooting at small apertures to gain additional depth of field. The tables shown right indicate the amount of exposure compensation required for some popular film types.

Another effect of long-time exposures when using colour film is colour shifts. Colour shifts are caused because the separate layers of emulsion react differently to reciprocity failure. Because of this, the use of colour correction filters is advised with recommended filters listed in the tables reproduced below right. (NB, digital sensors are unaffected by colour shifts in the way that film is.)

All of the tables reproduced in this section show the manufacturers' own recommended guidelines. For absolute accuracy, I suggest running your own tests.

## Exposure in difficult lighting conditions

The exposure techniques discussed above can be applied in most conditions and for most subjects. However, there will be occasions when the complexity of the interaction between

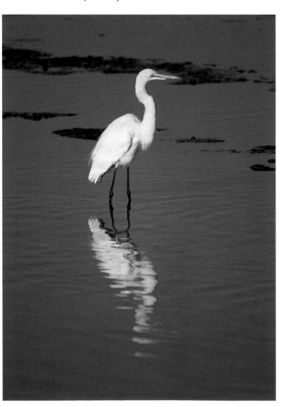

### EXPOSURE COMPENSATION

| Fuji | 1 sec | 4 sec | 16 sec | 64 sec |
| --- | --- | --- | --- | --- |
| Fuji Velvia 100 | None | None | None | None |
| Fuji Provia 100F (RDP III) | None | None | None | None |
| Fuji Astia 100 (RAP) | None | None | None | +1/3 stop |
| Fuji Provia 400F (RHP III) | None | None | None | +2/3 stop |
| Fuji Sensia 100 (RA) | None | None | None | +2/3 stop |
| Fuji Sensia 200 (RM) | None | None | None | +2/3 stop |

| Kodak | 1 sec | 10 sec | 100 sec |
| --- | --- | --- | --- |
| Ektachrome E100VS (Pro) | None | None | None |
| Ektachrome E100SW (pro) | None | None | Not advised |
| Kodachrome 64 | Not advised | Not advised | Not advised |
| Kodachrome 200 | +1/2 stop | Not advised | Not advised |
| ELITE chrome 400 (EL) | 1/3–1/2 stop | 1/2 stop | Not advised |
| PORTRA (Pro) 160NC/160V 400NC/400VC/400UC | None | None | Not advised |
| SUPRA (Pro) 100/400/800 | Not advised | Not advised | Not advised |

### CORRECTING COLOUR SHIFTS

| Fuji | 1 sec | 4 sec | 16 sec | 64 sec |
| --- | --- | --- | --- | --- |
| Fuji Velvia 100 | None | None | None | None |
| Fuji Provia 100F (RDP III) | None | None | None | None |
| Fuji Astia 100 (RAP) | None | None | None | None |
| Fuji Provia 400F (RHP III) | None | None | None | 5G |
| Fuji Sensia 100 (RA) | None | None | None | None |
| Fuji Sensia 200 (RM) | None | None | None | 5G |

| Kodak | 1 sec | 10 sec | 100 sec |
| --- | --- | --- | --- |
| Ektachrome E100VS (Pro) | None | None | None |
| Ektachrome E100SW (Pro) | None | None | 075Y |
| Kodachrome 64 | Not advised | Not advised | Not advised |
| Kodachrome 200 | 10Y | Not advised | Not advised |
| ELITE chrome 400 (EL) | 05R | 10R | Not advised |
| PORTRA (Pro) 160NC/160VC/ 400NC/400VC/400UC | None | None | Not advised |
| SUPRA (Pro) 100/400/800 | Not advised | Not advised | Not advised |

### The sunny f/16 rule

In bright conditions, making the most of the simple and effective 'sunny f/16' rule can make calculating accurate exposures an easier task.

or water, under very bright conditions and when the subject fills a large area of the picture space requires a slight modification of the sunny f/16 rule to avoid burned-out highlights.

The sunny f/22 rule follows the f/16 version except that lens aperture is set to f/22 to retain detail. Like the sunny f/16 rule, once an EV has been determined, any equivalent combination of settings can be set for the actual exposure.

## Photographing backlit subjects

One of the more complicated situations to meter is when the subject is backlit and you are shooting into the light. In this instance, bright light from behind the subject, which by definition is in shadow, typically results in an underexposed image where subject detail is lost or greatly obscured.

There are several solutions to this challenge. Repositioning the camera or using a longer focal length lens so that the subject fills the picture space will block background illumination. Alternatively, you can use a spot meter (which has a very narrow angle of view) to meter only the surface area in shadow – background light will have no influence over the meter reading. If your camera has no spot meter facility, you can improvise by attaching a long telephoto lens in conjunction with centre-weighted metering.

Another option is to use an incident light meter by holding the meter above your head and in front of you, with the invercone (white sphere) facing behind you, away from the subject.

## Creating silhouettes

Silhouettes can create evocative images that make powerful graphic statements. The technique for rendering a subject as a silhou-

illumination and subject require a more considered approach to exposure settings in order to attain faithful and artistic results. The following section in this chapter will help to demystify some of the more advanced exposure techniques and enable you to make the most from any shooting opportunity.

## The sunny f/16 rule

Very light- and very dark-toned subjects, such as sand or dark-coloured fur, can fool your camera's meter into indicating an incorrect exposure when photographed in direct sunlight in the middle of the day. Although you may apply exposure compensation in line with the guidelines given earlier, it will prove ineffective if the original meter reading is incorrect.

Under these conditions, a simple, effective and uncannily accurate technique to adopt is known as the 'sunny f/16 rule'. This manual technique works by setting lens aperture to f/16 and shutter speed to the setting closest to that of the ISO rating of the film you're using (or ISO-E value for digital). For example, using an ISO 100 film would mean setting shutter speed to 1/100 sec (or 1/125 sec, if your camera doesn't allow 1/3-stop adjustments).

Once you have this base exposure, any equivalent combination can be used to achieve the same exposure value (see the EV chart on page 47). For instance, taking the above example, an exposure of 1/200 sec at f/11 or 1/50 sec at f/22 would result in identical levels of illumination. I know it sounds too simple to be true, but often the simple ideas are the best ones.

## The sunny f/22 rule

Photographing pure white or highly reflective, shiny subjects, such as snow, white feathers,

| -2 | -1.5 | -1 | -.5 | ±0 | +1.5 | +1 | +1.5 | +2 |
|---|---|---|---|---|---|---|---|---|

### Grey scale

The grey scale is a graphic representation of brightness levels (contrast). It can be used to assess the SBR of a scene.

### Low-light metering

Metering in low-light conditions can be tricky. Here I metered from the brightly lit walls of the chateau in the left of the frame and calculated the appropriate exposure from the given EV. Even so, I bracketed the exposure between +1 and -1-stop in half-stop increments to make sure I had the image I wanted.

ette is opposite to that described on page 53 for photographing backlit subjects. When creating a silhouette, the aim is to remove all detail in the subject itself. Do this by metering the bright area of the scene behind the subject, but exclude the light source itself (remembering to apply any relevant exposure compensation). The technique will be successful so long as the brightness of the area of shadow falls outside the latitude of the film/sensor.

## Metering in low light

I have already discussed the problems of reciprocity law failure (film) and noise (digital) encountered when setting long-time (more than 1 sec) exposures, which are often necessary in conditions of low light (see page 51). Another possible problem when photographing in low light is encountered when the level of illumination becomes so low that it is beyond the sensitivity range of the meter. In this instance, the TTL meter in the camera will indicate that it is incapable of providing a meter reading.

There are two solutions, one of which involves the trusty incident light meter. The invercone on an incident light meter absorbs approximately 80 per cent of the light falling on it. By removing the invercone, the absorbed light instead reaches the metering cell, which may prove sufficient to bring the sensitivity of

the meter back within range. If so, an incident light reading manually adjusted by a multiplication factor of 20 per cent will give you an EV for a middle-tone subject, since the 20 per cent calculation replicates the use of the removed invercone.

Without an incident light meter, the alternative is to rely on your experience and a little guesswork. Find an area of the scene that is bright enough to meter and take a meter reading using the spot metering function on the camera. Then, using the grey scale (shown left), assess the number of stops' difference between the metered subject and the actual subject and count down in stops from the given exposure setting.

For example, if the metered subject requires an effective exposure of 1/30 sec at f/4 and the actual subject is estimated to be 7 stops darker, the actual exposure would be 4 sec at f/4 (or any equivalent combination) plus (in this example) an allowance for reciprocity law failure if film is used.

When using the latter technique, I recommend that you always bracket your exposures (see pages 126–128), or use the histogram on a digital camera, to ensure that an accurate exposure is attained.

## Coping with contrast: assessing SBR

The difference, represented in stops, between the darkest and lightest areas of a scene is called the subject brightness range, or SBR. It is essential to determine an SBR value when photographing subjects where there is a high

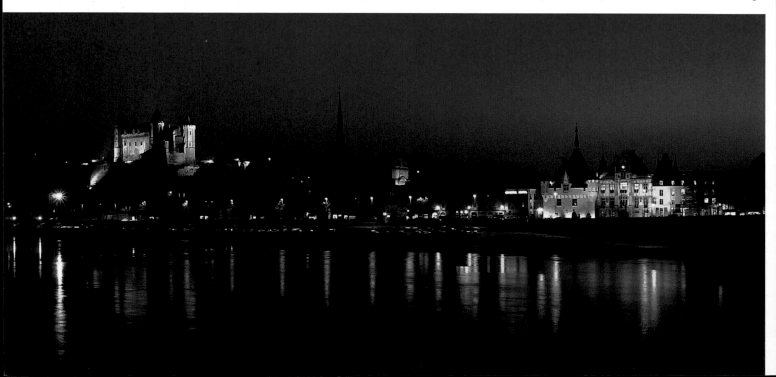

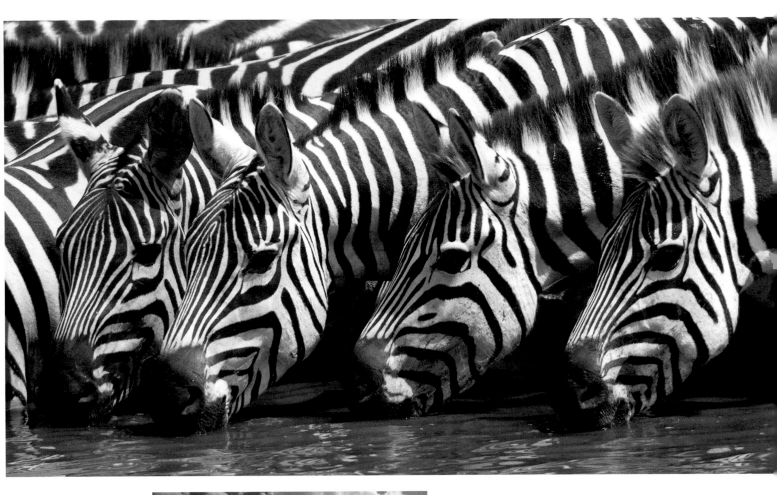

### ▲ High contrast

When photographing a high-contrast subject, such as these zebras, it is often best to do so in overcast conditions, when diffused lighting will reduce the overall SBR. If you have to photograph under a harsh, bright light and the SBR exceeds the latitude of the film or dynamic range of the sensor, you will need to compromise.

### ▶ Dynamic range

For this landscape, where the SBR exceeded the dynamic range of the sensor in my camera, I used an NDG filter to even the tones and reduce the SBR to a level within range.

level of contrast that may extend beyond the latitude of the film/sensor used, so causing areas of detailless black or burned-out highlights to appear on the recorded image.

The simplest method of calculating SBR is to use a variation of the Zone System. This was devised by Ansel Adams (see page 41) and has been the cornerstone of photographic exposure ever since. The grey scale, reproduced on page 54, is a graphical representation of brightness levels. When inventing the Zone System, Adams divided the scale into nine distinct, equal segments. This was later extended to eleven zones.

Each segment has a numeric identifier, which aids assessing SBR, from 1 (pure black) to 9 (pure white). Starting from Zone 1, the centre of each segment is exactly twice as bright as the previous segment and is equivalent to a 1-stop difference in exposure value. The centre segment (Zone 5) is middle-tone (18 per cent) grey – the tone all photographic light meters are calibrated to reproduce.

To assess SBR, each tone in the scene being photographed must be assigned a value based on the grey scale. Once all tonal variations have been given a valid number, SBR can be calcu-

lated by subtracting the lowest value from the highest, the sum being SBR given in stops.

For example, if the darkest area of the scene falls into Zone 2 and the brightest area of the scene falls into Zone 7, then the SBR is 5 stops (7 - 2 = 5).

Calculating SBR enables pre-visualization of the final image, in terms of exposure, ensuring that any necessary adjustments can be made in-camera to achieve an SBR within the latitude of the film/sensor used.

## Neutral density graduated filters

NDG filters are used frequently in landscape photography, where the SBR between the sky and the land is often outside the latitude of

the film/sensor used, causing detail to be lost in either the shadow or the highlight areas of the picture space. For example, when photographing a scene that contains both a bright sky and shaded foreground, if you meter for the sky the foreground will be underexposed, whereas if you meter for the foreground the sky will be overexposed.

NDG filters overcome this anomaly by blocking light from the sky without changing its natural colour. In so doing, the tonality of the sky can be equalized to match the foreground, bringing the SBR within the latitude of the film/sensor used. Different strength filters are available to be used with variations in SBR, as shown in the table left.

The following steps describe the technique for selecting and using a NDG filter:

1 _ Set the camera to manual metering mode and select your working aperture.

2 _ Take a meter reading of the foreground (shaded area) and note the exposure value (EV) or shutter speed.

3 _ Take a meter reading of the brightest area of the sky and similarly note the EV or shutter speed.

| NDG FILTER STRENGTHS | | |
|---|---|---|
| Filter density | Filter factor | Light blocked (stops) |
| 0.1 | x 1.25 | 1/3 |
| 0.2 | x 1.5 | 2/3 |
| 0.3 | x 2 | 1 |
| 0.6 | x 4 | 2 |
| 0.9 | x 8 | 3 |
| 1.2 | x 16 | 4 |

### Exposure choice

The extent of the SBR in this scene meant that I needed to decide between retaining detail in the highlights or in the shadow areas. I chose the highlights and exposed accordingly. Some of the shadow areas show no detail, but none of the highlights are burned-out.

4 _ Subtract the first EV from the second or count down in number of stops from the fastest shutter speed to the slowest to indicate the SBR. For example, if the first EV = 2 and the second EV = 5 then the SBR = 3 stops. Alternatively, if the fastest shutter speed = 1/250 sec and the slowest equals 1/30 sec, then the SBR also equals 3 stops.

5 _ In this example, the required NDG would be one with a density of 0.9 (i.e. 3 stops), as per the table on page 56.

6 _ Set the exposure for the foreground (the shaded area) and then slide the NDG filter into the holder until the dark area of the filter covers the appropriate area of sky, checking through the viewfinder for exact positioning.

7 _ With the filter in place and positioned correctly, take the picture. Note that the camera will be indicating an incorrect exposure in the analogue display in the viewfinder. This is normal and can be ignored.

## Filters and light absorption

Some filters absorb light and this must be taken into account when assessing exposure values with any tool other than a TTL meter. Typically, the darker the filter, the more light is lost. Because TTL meters assess light actually entering via the lens, they automatically take into account the effects of any attached filter.

When using a non-TTL meter to calculate exposure, however, some compensation may need to be applied, as indicated in the table shown right.

### Polarizing filters

Polarizing filters stop polarized light from entering the lens. The position of the filter determines exactly how much light is blocked, which affects the amount of exposure compensation required.

Linear and circular versions are available. TTL meters automatically compensate for the loss in light caused by a circular polarizer. However, the design of linear-type polarizers makes TTL meters less effective and unreliable; you should be prepared to use manually adjusted exposure settings in this instance. The table on page 58 can be used as a guide to the level of exposure compensation required. Even so, I recommend any approximations to be backed up by bracketing exposures.

### BLACK-AND-WHITE PHOTOGRAPHY — FILTER TYPE [FACTOR]

| Filter | Factor |
|---|---|
| Yellow (x2) | +1 |
| Yellow/green (x4) | +2 |
| Green (x6) | +2.5 |
| Orange (x4) | +2 |
| Red (x8) | +3 |
| Blue (x4) | +2 |

### COLOUR PHOTOGRAPHY — FILTER TYPE

| | | | | |
|---|---|---|---|---|
| 81 series | 81A | 81B | 81C | 81D |
| | +1/3 | +1/3 | +1/3 | +2/3 |
| 82 series | 82A | 82B | 82C | 82D |
| | +1/3 | +1/3 | +2/3 | +2/3 |
| 80 series | 80A | 80B | 80C | 80D |
| | +2 | +1.6 | +1 | +2/3 |
| 85 series | 85 | 85B | 85C | |
| | +2/3 | +2/3 | +1/3 | |
| Ultraviolet | ±0 | | | |
| | | | | |
| Red-enhancing | +1 | | | |
| | | | | |
| Neutral density | (see separate table on page 56) | | | |
| | | | | |
| Skylight | ±0 | | | |
| | | | | |
| Polarizing | (see separate table on page 58) | | | |

### COLOUR PHOTOGRAPHY — COLOUR CORRECTION FILTERS

| Colour | Density | | | | | | | |
|---|---|---|---|---|---|---|---|---|
| | CC5 | CC10 | CC15 | CC20 | CC25 | CC30 | CC40 | CC50 |
| Yellow | ±0 | +1/3 | +1/3 | +1/3 | ±0 | +1/3 | +1/3 | +2/3 |
| Magenta | +1/3 | +1/3 | +1/3 | +1/3 | ±0 | +2/3 | +2/3 | +2/3 |
| Cyan | +1/3 | +1/3 | +1/3 | +1/3 | ±0 | +2/3 | +2/3 | +1.6 |
| Red | +1/3 | +1/3 | +1/3 | +1/3 | ±0 | +2/3 | +2/3 | +1 |
| Green | +1/3 | +1/3 | +1/3 | +1/3 | ±0 | +2/3 | +2/3 | +1 |
| Blue | +1/3 | +1/3 | +1/3 | +2/3 | ±0 | +2/3 | +1 | +1.3 |

| COLOUR PHOTOGRAPHY: POLARIZERS | |
| --- | --- |
| Polarization | Exposure compensation (stops) |
| 1/4 | +1 |
| 1/2 | +1.5 |
| 3/4 | +2 |
| Full | +2.5 |

## Exposure in macro photography

In macro and close-up photography, extenders, either in the form of extension tubes or bellows, are often used to enable close working distances and high subject magnifications. Extenders reduce the level of illumination, which affects exposure. As the length of the extender increases, the greater is the loss of light. Think of a tunnel; the further into the tunnel you travel, the less light there is.

As with filters, a TTL meter reading with extenders attached will be accurate, as the meter automatically accounts for any loss of light caused by the extender. However, not all extenders enable auto TTL metering and it may be necessary to manually assess exposure.

In this case, you will need to calculate the extension/compensation factor for each piece of macro/close-up equipment you are using. This can be done by repeating the following test:

1 _ Attach your camera to a tripod and set the focus at infinity (∞). Meter a flat surface, such as an internal wall, in conditions of even, consistent lighting. Make a note of the EV or exposure settings.

2 _ Keeping the camera-to-subject distance constant, add the relevant extender.

3 _ Next, take a revised meter reading and record the change in EV or exposure settings.

4 _ The difference between your first and second exposure is the compensation factor for that extender.

For example, say your first meter reading was 1/250 sec at f/5.6 and your second meter reading was 1/125 sec at f/5.6. The difference between the two readings (and, therefore, the compensation factor of the extender, which can be applied any time it is used) is 1 stop.

Repeat the process to calculate the exposure compensation factor for other extenders.

The same issues apply when the lens is set to the minimum focusing distance. By extending the distance between the front of the lens and the focal plane, illumination is reduced. Therefore, to calculate the compensation factor for your lens you need to run another test:

1 _ Attach your camera to a tripod and set the focus at infinity (∞). Meter a flat surface, such as an internal wall, in conditions of even, consistent lighting. Make a note of the EV or exposure settings.

2 _ Keeping the camera-to-subject distance constant, set the lens to its closest focusing distance.

3 _ Next, take a revised meter reading and record the change in EV or exposure settings.

4 _ The difference between your first and your second exposure is the compensation factor for that lens at its closest focusing distance.

To use your lens at its closest focusing distance in conjunction with an extender, calculate the exposure compensation factor by adding the two values. For example, if the compensation factor for the extender is 1 stop and the compensation factor for the lens is half a stop, the total compensation factor will be 1.5 stops.

When you have completed calculating the exposure compensation factor for all of your extenders and lenses, keep an exposure compensation record card and use it on subsequent shoots.

**Enhancing colours**
A polarizing filter has helped to enhance the colours of this twin rainbow at the Victoria Falls in Zambia. Polarizing filters are an essential tool in a landscape photographer's kit bag.

## Calculating flash exposure

Calculating flash exposure can appear to be quite a complex process, but it is necessary to master the principles in order to become a successful photographer.

### The role of the shutter

Shutter speed plays no influential role in flash exposure, other than to affect the area of the scene not lit by the flash illumination, which will be governed by shutter speed in the normal way. The relevance of shutter speed in flash exposure is related directly to the flash synchronization speed.

Flash synchronization is specific to cameras with a focal-plane shutter, consisting of two shutter curtains – one to begin exposure and one to end it – that travel horizontally or vertically over the film/sensor aperture. At very fast shutter speeds, the second curtain begins to close the exposure before the first curtain has travelled fully across the frame, creating a slit of light through which exposure is attained. This is how shutter speeds of thousandths of seconds are achieved.

In flash exposure, the duration of illumination determines the effective shutter speed. To the naked eye, flash duration can seem a relatively long time. In reality, however, flash exposure may last no longer than 1/10,000 sec. At such high speeds, if the shutter speed set on the camera is too fast – that is, beyond the pre-set flash synchronization speed – then the only part of the film/sensor that records light is that part visible through the tiny slit between the two shutter curtains as they open and close, respectively.

### The role of lens aperture

Lens aperture plays a very influential part in flash exposure. Together with flash duration and flash-to-subject distance, it is a primary controlling factor in flash exposure.

Using lens aperture, exposure can be controlled in two ways: by maintaining a fixed lens aperture and altering the power output of the flash unit, or by altering the lens aperture and keeping the power output fixed. Which option you decide to use will be governed by two factors: flash-to-subject distance and depth of field.

The further from the subject the flash is, the less illumination the subject receives, which reduces flexibility when setting lens aperture. If smaller apertures are essential to the composition (see depth of field, page 48), the flash must be moved closer to the subject.

Automatic flash units measure the level of light falling on the subject and cut flash output once the exposure has reached its optimum level. However, as with any metering system, the flash sensor is calibrated to give a technically accurate exposure for a middle-tone subject. If your subject is lighter than or darker than middle tone, the flash-calculated exposure will need adjusting as for a normal exposure (see pages 45–46). With an automatic flash, this is done by adjusting lens aperture from the suggested setting – opening it for lighter than middle-tone subjects and closing it for darker than middle-tone subjects. With dedicated flash units, a level of exposure compensation can be set on the flash unit (plus for lighter than middle-tone subjects and minus for darker than middle-tone subjects).

### Manual flash exposure

Because flash exposure calculations are based on flash-to-subject distance, knowing the range of the flash unit is critical.

In order to calculate the range of a flash unit, you will need to know its guide number (GN). This is given by the manufacturer and

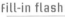

### Fill-in flash

Fill-in flash can be used to help balance differing levels of illumination. Here, a small off-camera flash fitted with a diffuser has helped to brighten the fox's face.

refers to the amount of light generated by the flash unit at a given ISO/ISO-E rating. With the guide number and the base ISO/ISO-E rating, it is possible to calculate the GN for different ISO/ISO-E ratings. The easiest method is to work in stops using the f/stop series of numbers. For example, if the flash unit has a GN of 80 at ISO/ISO-E 100, to calculate the GN at, say, ISO/ISO-E 50, first calculate the difference in stops in ISO/ISO-E rating.

ISO/ISO-E 50 is 1 stop slower than ISO/ISO-E 100. For the purpose of calculation, drop the zero from the original GN (80), giving you 8. Then apply this to the f/stop scale, i.e. f/8. Open up one stop from f/8 (equivalent to the difference between ISO/ISO-E 100 and ISO/ISO-E 50), giving f/5.6. Multiply by the zero dropped earlier in the calculation, and the result is a guide number of 56.

Next, to calculate flash-to-subject distance, use the following formula:

> Flash shooting distance = guide number (GN) ÷ f/stop (lens aperture)

For example, working with the example above, take the GN of 56 and apply a lens aperture of, say, f/16. Flash shooting distance will be 3.5m (11ft):

> 56 (GN) ÷ 16 (f/stop) = 3.5 meters (flash shooting distance)

Using this calculation, you can determine where to position the flash unit based on your preferred exposure settings. For instance, taking the above example a step further, assume an aperture of f/8 is preferred:

> 56 (GN) ÷ 8 (f/stop) = 7 meters (flash shooting distance)

For occasions when it is impossible to alter flash-to-subject distance, it may be necessary to adjust the lens aperture instead. This can be achieved using a slight variation of the above formula.

> Lens aperture = guide number (GN) ÷ flash-to-subject distance

Using again the above example, assuming the flash-to-subject distance is fixed at, say, 5 meters, the calculation would be:

> 56 (GN) ÷ 5 (meters) = f/11

## Manually calculating flash exposure for bounced flash

Manual flash exposure calculations for bounced flash follow the same rules as applied in the above examples. However, the exposure must be based on the total distance the flash has travelled, i.e. the distance between the flash head and the reflective surface plus the distance between the reflective surface and the subject. In addition, absorption and scatter must be taken into account.

Expanding on our earlier example, the original flash-to-subject distance is 5 meters. However, you decide to bounce the flash off a reflector that is 3 meters from the flash unit and 4 meters from the subject. The total flash-to-subject distance is now 7 meters, giving the following calculation:

> 56 (GN) ÷ 7 (meters) = f/8

Allowing for light loss and scatter, apply a compensation factor of +1 stop, giving a working aperture of f/5.6.

## Manually calculating flash exposure with diffusers

A diffuser causes light loss through absorption. To assess the level of absorption of a diffuser, run the following test:

1 _ Set your camera with flash attached on a tripod and compose your subject.

2 _ Take a picture using the manual exposure calculation method described above. This will give you your base exposure.

3 _ Now attach your diffuser and take several more images, opening up the aperture by half a stop each time. Make a note of the aperture settings for each frame number.

4 _ Once the images are processed, review them to see which one is correctly exposed. Refer to your notes to find the lens aperture setting for that image and then deduct the difference in stops from your base setting. This tells you the absorption value of the diffuser material in f/stops.

For example, with a base exposure of f/11 with a flash-to-subject distance of 5 meters, if the most accurate test shot was exposed at an aperture of f/5.6 then the diffuser material is absorbing 2 stops of light (i.e. the difference in stops between f/11 and f/5.6).

**Hyperfocal distance**
To ensure that all the boats in this scene appeared sharp, I needed to manage depth of field. I focused on the second boat in from the foreground and set a narrow aperture (f/22) to make the most of the hyperfocal distance.

## ■ Exposure calculation for fill-in flash

If you look at any scene, you will notice the variation in brightness between the lightest and darkest (shadow) areas. The purpose of fill-in flash is to add illumination into areas of shadow that would otherwise appear underexposed or featureless, and lacking in detail.

Some of the sophisticated modern cameras and flash units have pre-set functions for balancing fill-in flash with ambient light (auto-balanced fill flash). Others rely on less sophisticated technology. However, all are trying to achieve the same thing – even lighting throughout the scene, which, more often than not, results in a flat image lacking in contrast.

To achieve a more natural image and maintain a level of contrast that is within the film/sensor's dynamic range (latitude) yet sufficient to maintain form (contrast), it is usually necessary to apply flash exposure compensation to reduce the quantity of light emitted by the flash unit to a level just enough to raise illumination in the shadow areas without overdoing it.

In nature photography, a classic guide is to set flash exposure compensation to around -1.5 to 1.7 stops. If photographing people outdoors using fill-in flash then you may want to reduce the level of compensation to around -1 stop.

# FOCUS

Focus is another of photography's fundamental principles, and depth of the field is a particular consideration in landscape and nature photography. Learning to use your camera's autofocus and manual focus modes will be an important part of honing your photography skills.

## The point of focus and depth of field

There is only one point of focus: the focus distance. This is the distance between the subject and the focal plane. Any subject exactly at that distance is in focus while everything else is, technically, out of focus. However, because of the limitations of human eyesight, objects that are technically out of focus may seem to be sharp. For example, if you observe a 10x8in print made from a 35mm negative or transparency, you will be unable to distinguish two adjacent points less than 0.03mm in size and, therefore, they will appear sharp. This is known as the circle of confusion and is what determines depth of field.

Photographically, three things control depth of field: lens aperture, focal length, and camera-

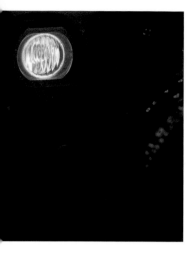

**Depth of field preview**
Some cameras have a depth of field preview button to help assess the extent of depth of field.

**Retaining detail**
It was important in this scene to ensure that both the foreground and background detail were sharp. I used the depth of field preview button on my Nikon D2X to help me select the appropriate lens aperture (f/16).

to-subject distance. While all three can be managed separately, they are interdependent, and each has an effect on the captured image.

### Lens aperture
Selecting small apertures increases depth of field. Smaller apertures pass less light, which produces smaller circles of confusion. Because any point smaller than around 0.03mm appears sharp, the smaller the circle of confusion, the sharper the image appears.

### Focal length
Depth of field is inversely proportional to focal length. For example, a short focal length lens, such as a 24mm wide-angle lens, will produce greater depth of field than a long focal length lens, e.g. a 200mm telephoto lens.

### Camera-to-subject distance
The greater the camera-to-subject distance, the deeper the depth of field. Depth of field will be greater when subjects are distant from the camera and at its narrowest when photographing subjects close-up. This is one of the many challenges for the macro photographer (see page 118) and for the landscape photographer trying to include foreground interest to create a sense of depth.

## Understanding depth of field
Depth of field is not an exact science. It is defined as the zone of 'acceptable' sharpness, and what is acceptable to one person will be unacceptable to another. A number of external factors come into play, including print size, viewing distance, and the viewer's eyesight. For consistency, most theoretical depth of field

calculations are based on a 10x8in print viewed from a distance of at least 12in (30cm). The most accurate means of measurement is the practical one: depth of field preview.

### Depth of field preview
Some cameras have a depth of field preview function. This is a small button or lever that manually closes down the lens diaphragm to the shooting aperture so you can see the effects of stopping down through the viewfinder.

This can be the most accurate means of assessing depth of field, but also the most difficult, because the reduced amount of light reaching the viewfinder makes it difficult to see the scene you're photographing. The technique requires practice but is worth pursuing.

### Depth of field lens scale
Prime lenses typically have a depth of field scale etched on to the lens barrel that indicates depth of field for each lens aperture at different focusing distances. The principle is sound and can be effective in practice while never being absolute. Fewer lenses are made with this scale and it is absent from all zoom lenses.

**Depth of field scale**
Prime lenses often have a depth of field scale on the lens barrel. While the scale can only be used as a guide, it is helpful in assessing depth of field.

### Depth of field charts
Depth of field charts enable calculation of depth of field for any focal length and lens aperture setting. Often, the instruction manual that comes with the lens will include charts specific to that lens. Alternatively, there are several websites that provide depth of field calculators, where you set the parameters and they tell you the result.

## Hyperfocal distance
The hyperfocal distance is the point of focus that gives the maximum depth of field for a given combination of lens aperture, focal length and

**Continuous AF**
To photograph this Griffon vulture soaring high above the Gorge du Verdon in France, I selected continuous AF mode on my Nikon D2H camera and allowed the AF system to track the bird's movement, keeping it in focus.

camera-to-subject distance. It is based on the theory that two-thirds of depth of field is always behind the point of focus and one-third in front.

By assessing where depth of field begins (i.e. the hyperfocal distance) with the lens focused on infinity and then refocusing on the hyperfocal distance, depth of field increases to halfway between the camera and the hyperfocal distance to infinity.

For example, with the camera focused on infinity, assume that depth of field extends from 10m to infinity. This would make the hyperfocal distance 10m. If you adjust the focus distance on the lens to 10m, depth of field will now extend from half of the hyperfocal distance (5m, in this example) to infinity.

## Making the most of autofocus
The invention of autofocus (AF) systems opened new opportunities for photographers, particularly those interested in wildlife. While all AF systems have their limitations, often it is an incomplete understanding of how the system operates rather than the system itself that is the cause of inferior results. Learning exactly how the system in your own camera operates will greatly improve your levels of consistency and quality.

Most cameras have two types of AF system. One is called Single AF or Single Servo AF, while the other is referred to as Continuous AF (or AI-servo on a Canon camera). The two modes work very differently and will suit different subjects.

### Single AF mode
Single AF mode is ideal for subjects that are relatively static, such as landscapes and outdoor portraits. When the camera is set to single AF mode, the AF system will detect and set focus distance and then lock it while AF is active. (AF remains active so long as the shutter release is pressed part-way or the AF-Lock button is pressed fully.)

If the subject moves away from the point of focus, focus distance will remain unchanged so long as AF remains active, leading to out-of-focus pictures. In order to refocus on the subject, AF must be deactivated (usually by releasing the shutter button or AF-Lock button) and reset.

In this mode, the camera gives priority to focus and the shutter is deactivated until the subject is in focus. This minimizes the chance of out-of-focus pictures being taken.

### Continuous AF mode
Continuous AF mode is the ideal setting for photographing moving subjects, such as wildlife. In continuous AF mode, after detecting and setting focus distance the camera leaves it unlocked while AF is active (unless the AF-Lock button is pressed). Should the subject move away from the original point of focus, the camera uses its AF target sensors to track its movement and continually resets focus distance to keep the subject in focus.

In this mode, priority is typically given to the shutter and pictures can be taken whether or not the

**Single AF**
Continuous AF is unnecessary for static subjects, such as this honey shop in France. I selected single AF and took the picture once the camera had locked focus on, in this instance, the clock face.

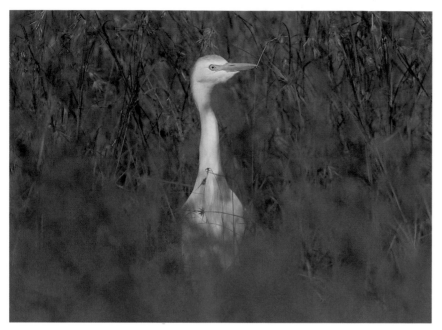

Single Area mode typically uses the central target sensor to attain focus. It is suitable for static subjects or scenes that have several disparate objects within the frame as it enables selective focusing on very small areas of the picture space.

When the subject is moving, however, Wide-area AF mode activates all (or a selected combination) of sensors, enabling the camera to maintain an accurate focus distance more easily. This mode is particularly useful for subjects that are moving erratically throughout the frame, when it is difficult for the photographer to predict where the subject will be at any given moment.

## Manual focus mode

Although the majority of modern cameras are AF-enabled, manual focus still has an important part to play in practical photography. AF systems have their limitations, most notably because they need a certain level of brightness and a clear line of sight to operate effectively. Both of these conditions lead to the lens 'hunting'. This means that it continually searches to attain focus, shifting between the closest focusing distance and infinity without ever locking on to the subject. This is a particularly annoying trait that leads to many missed opportunities. In such cases, manual focus mode is a better option.

**Manual focus**

Dense foliage can cause many AF systems to become unreliable. To photograph this image I switched the camera to manual focus mode and manually focused the lens on the bird's eye.

subject is in focus. Most cameras allow this priority setting to be changed to focus priority via the menu settings, and it is advisable – there is little value in an out-of-focus picture.

### AF area modes

As well as two AF modes, cameras generally are designed with at least two Area modes that determine which AF target sensors are used in detecting focus.

**Focus point**

This was another tricky scene where manual focus proved a better option than AF. In AF mode, the delicate nature of the subject swaying in the breeze left the camera 'hunting' for a focus point. I switched to manual and focused by hand.

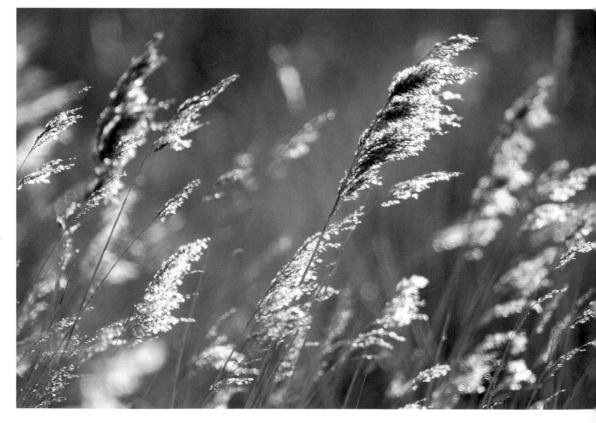

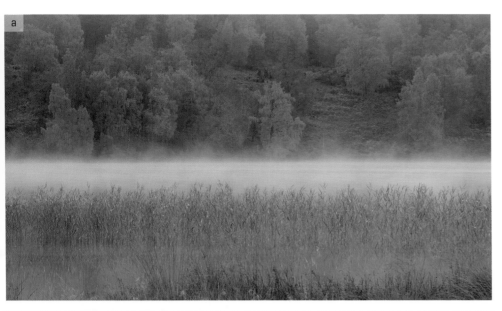

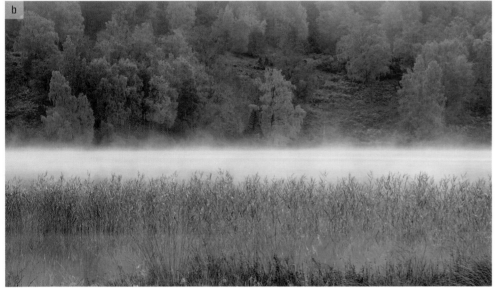

the tonal range. Conversely, when flat lighting causes images to lack contrast, tone can be increased to stretch the tonal range and improve the overall exposure.

When you are assessing tonality, the digital histogram is a useful tool. For example if the histogram displays excess contrast, this indicates that the exposure would benefit from a reduction in contrast (tone). The histogram may however show the opposite – a lifeless image lacking in tonal range – suggesting an increase in contrast to add a dimensional element to the image.

## Saturation

Saturation refers to the vividness with which colours are reproduced. Nature pictures often benefit from increased saturation to bring out the power of colours such as green and red. This is why many film users prefer to use Fuji Velvia, a highly saturated film.

Be careful to avoid overdoing saturation, however, particularly when you are photographing wildlife, as too much saturation can give animals an unnatural look.

## Hue

Digital cameras produce colour by mixing quantities of the three colours red, green and blue (RGB). The final colour depends on the quantity of each colour put into the mix, but ultimately all colours of the visible spectrum can be produced in this way.

You can change the colour cast by adjusting the hue control on a digital camera. For example, by increasing the level of red used, a yellow cast causes reds to appear closer to orange. Reducing the level of red results in a stronger blue cast, making reds appear more purple.

The value of this control in the field is limited, except in very specialist circumstances. However, it can be useful when trying to perfect colour reproduction of subjects such as flowers.

**Tone setting**

The lighting conditions and weather meant that this scene was lacking in contrast (image a). I increased the tone setting on my digital camera from normal to high to increase the SBR (contrast), as shown in image b.

# Digital shooting parameters

A distinct advantage of digital cameras is the ability to control in-camera some of the functions previously possible only in the wet darkroom. Once these parameters are understood and applied correctly, it is more likely that the resulting image is closer to the reality perceived at the time of shooting.

## Tone

The tone control adjusts the level of contrast in the picture during processing. In contrast-rich scenes where the range of tones (SBR; see pages 54–56) falls outside the latitude of the sensor, tone can be reduced to decrease

## Sharpening

In-camera sharpening controls the appearance of borders between light and dark areas of the picture. Textures, such as animal fur, often benefit from increased sharpening, although too much can kill a picture.

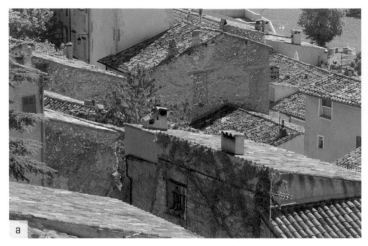

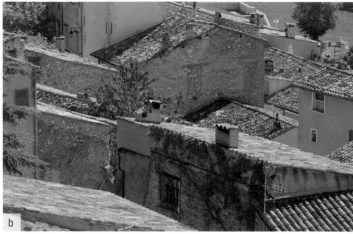

### Colour saturation

To improve the vividness of the colours in this rustic scene and get an image closer to that taken with a film camera using Fuji Velvia, I increased the level of saturation (image a) from the camera's auto-setting (image b).

Commercially, photographic libraries prefer to obtain images that are unsharpened, as excessive enlargement can result in artefacts and poor image quality.

## How in-camera processing works

Digital cameras process images differently depending on the image file setting. When saving files as JPEGs or TIFFs, the camera applies the shooting parameters in-camera and they are then saved on the memory card as processed files. Any additional on-computer processing is applied to the already processed pixels.

In RAW mode, the camera appends an instruction sheet containing all the shooting parameter settings to the image but leaves the pixels unprocessed. When the image is opened via a computer, the parameters are applied and they are saved only when the file is saved on the computer as a JPEG or TIFF. The advantage of this is that any image processing is applied to the original, non-processed pixels, thereby increasing image quality.

## Drive modes

Most modern cameras have dispensed with the film wind-on lever and now use an automatic advance. Typically, these provide three speeds, including single-frame, low-speed continuous (between 3 and 5 frames per second, or fps) and high-speed continuous (8-plus fps).

For static subjects, single-frame advance will ensure you don't snap several shots of the same image, wasting film and editing time. Of the two continuous modes, there is rarely a need to select high-speed advance except when trying to capture images of very fast-moving subjects.

Before beginning a new session and when shooting in continuous mode, always check the frame count of the film or available space on the memory card to ensure you don't end up missing shots part-way through an image sequence. If the film is more than two-thirds used or there is capacity for fewer than 20 images on the memory card, load a new film roll or download images from the card to free up some capacity.

### Sharpening

Digital images straight from the camera can appear flat (image a) when compared to film. To increase the appearance of texture in this woodchuck's fur, I set the level of sharpening to medium-high (image b).

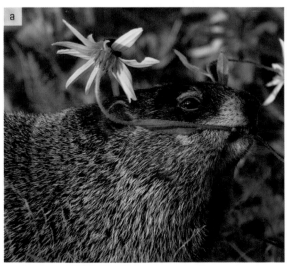

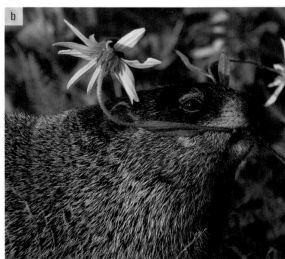

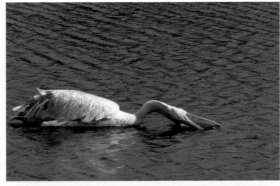

## frames per second

Professional specification digital cameras can now expose around 8 frames per second, as good as the best film cameras. This sequence of images was photographed with the camera set to a moderate 5 frames per second.

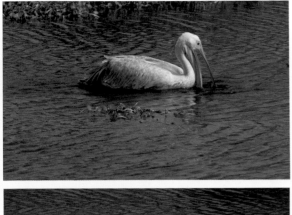

## Burst depth

In digital photography, burst rate refers to the number of images that can be exposed in any single pressing of the shutter release button. It is limited by the size of the internal memory buffer, the type of processor installed, the memory card used and the image file setting (i.e. JPEG, TIFF or RAW).

In addition, the amount and type of in-camera processing set will affect the burst depth. For example, in some cameras selecting image compression will slow burst depth (although not in all camera models) and setting the noise reduction function to 'on' will also down the burst depth.

In wildlife photography, in particular, burst rate can be critical, especially when photographing fast-moving subjects, or when shooting sequences of images. Early digital cameras, such as the Nikon D100, were restricted with burst depths of less than five images. However, advances in technology mean that current models have largely overcome these shortcomings, providing burst depths of tens and even hundreds of images, even when shooting in RAW mode.

Because the write speed of the memory card used will influence burst depth, some manufacturers have developed technologies to maximize the transfer rate of data between the camera's processor and the memory card, such as Lexar's Write Acceleration technology. However, not all digital cameras support these formats and it is important to check the compatibility of any memory card with your camera. Of course, film also has an equivalent burst depth, being either 24 or 36 frames, depending on the length of the roll of film. So burst depth is not a phenomenon that is new to digital photography.

**W**hat makes a compelling photograph? A picture admired by some may be deemed bland by others; the abstract nature of one photographer's imagination may be considered poor technique by another. Such is the nature of art. However, for any image to compel it must transcend the mere two-dimensional record of location or species.

Photography is a form of communication, and good photographs tell interesting stories. When you look through the viewfinder of a camera you are making choices: you decide on perspective, isolate subjects that are interesting and exclude others that aren't. In this chapter, we consider what makes a good composition and how to communicate your intentions to the viewers of your images.

## Visual communication

Photography is the art of exclusion. While a painter can decide which elements within a scene to include on his or her canvas, the photographer has no such luxury. Instead, we must determine which pictorial elements are relevant to our story and which detract from it, finding a means to exclude the latter from the picture space. By limiting what the viewer sees, you are telling them what for you is important or interesting about the scene. The resulting photograph is as much a reflection of you as it is the subject.

In the field, your emotions are formed by a culmination of input from your five senses – the sights around you, the sound of birds singing, the smells that float on warm currents of air, the feel of the wind in your face and of the earth underfoot, and the taste of wildness. All this information is absorbed and assimilated by the brain to form experiences and memories. A photograph, however, can convey only vision. The information from your other four senses is lost and unavailable to whoever views your pictures. Unless this information is recreated by your artistry and captured by your mastery of technology, your images will never truly communicate the emotions that compelled you to take the picture.

The purpose of a photograph is to communicate and, in so doing, to elicit an emotional response from the viewer. The more intense our feelings, the more compelling the image; this is what sets great photographs apart from other images.

Emotions take on many guises: happiness, humour, fear, sorrow, calmness, anger, to mention just a few. Our role as photographers is to decide what emotions we wish to communicate in our images and to use the tools at our disposal – cameras, lenses, and compositional guidelines – to convey that message as strongly as possible.

Think about the great pictures of our time. Images from the war in Vietnam, for example, were the genesis of a movement that ultimately led to peace. A great photograph truly speaks a thousand words, and in a language unrestricted by the limitations of an alphabet. What stories do you want your pictures to tell? A few possible themes are explored in this section.

▶ **Captioning**
Before you press the shutter ask yourself, 'How would I caption this image?' Only when you have an interesting caption should you press the shutter.

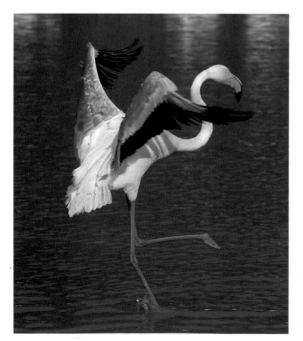

◀ **Communication**
Photography is a means of communication. If our pictures have nothing interesting to say then no one will look too long or too hard at them. Always keep an eye open for interesting or unusual behaviour, such as this flamingo settling down after landing from a short flight.

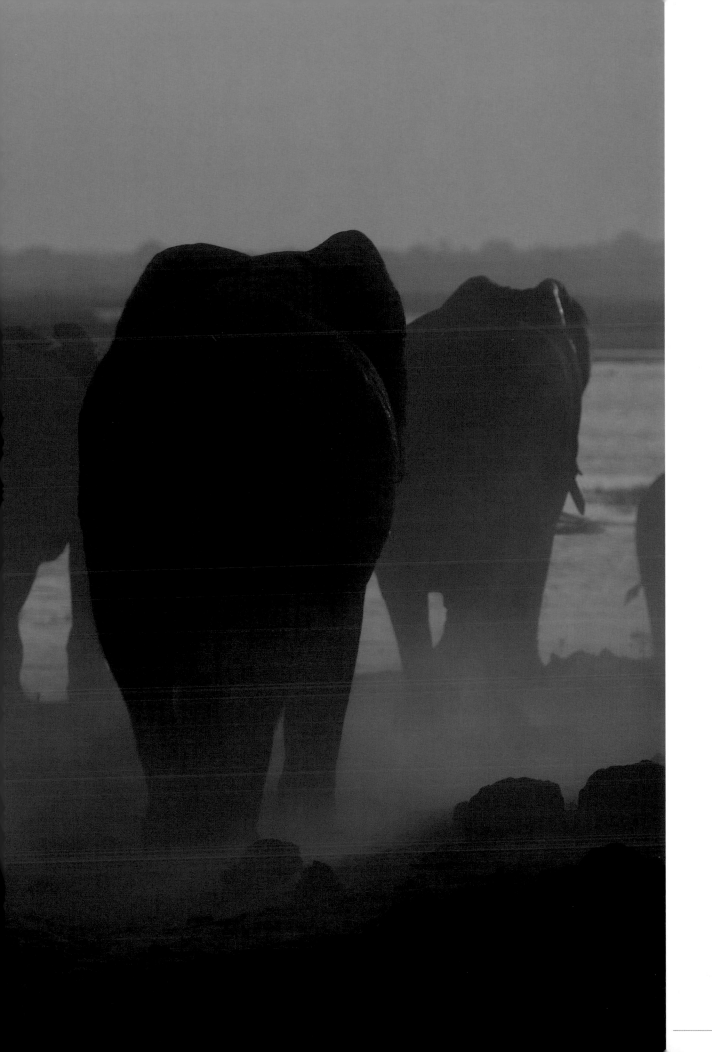

## A sense of place

By including the environment within the picture, the feeling of space changes the compositional tone of the image, altering the perspective to achieve a sense of place. Images communicate an idea of the subject's habitat, where and how it lives and a greater appreciation of its role in the ecology of the region.

## Mood and emotion

Clever use of light and careful composition can elicit emotional responses ranging from excitement to fear. In the landscape, colours can influence whether we feel warm or cold, and lines and shapes affect our sense of balance. Waiting for the right moment to press the shutter when photographing wildlife can turn an ordinary scene into a moment of humour, empathy, anger, or sorrow.

## Animal interaction

When two or more animals appear together in a scene, how they are composed often communicates a broader understanding of the relationship they share and the environment they exist in. Two stags rutting, for example, informs us of the competition for hierarchical superiority over a herd, while lion cubs playing tells us of young life inside a pride.

## Animal behaviour

Photography has been a vital component in our understanding of ecology and the environment. By recording images of behavioural traits in wildlife, we gain a greater appreciation of our relationship with animals and their relationship with the environment.

## Life and regeneration

Nature is a cycle, leading from birth through death to regeneration. We are bombarded with nature's reminders of this cycle: the shoot of a newly forming tree breaking through a leafy forest floor; the decaying bones of an animal perished in desert heat; spring bear cubs riding on their mother's back.

## Seasons

Our environment is in constant change, and never more so than with each passing season. Stand in the same spot from spring to winter and the landscape will form and reform around you.

**a) Life and regeneration**
Two cheetahs stalk a Thomson's gazelle among the zebra in a typical African hunting scene.

**b) Behaviour**
The camera can be used to visualize the behaviour and habits of the subject, helping to explain the many facets of a species' life.

**c) Humour**
The purpose of photography is to elicit an emotional response. Humour, because it makes us feel happy, is always a crowd-pleaser.

**d) Interaction**
Placing two or more animals in a scene thoughtfully can help us define the relationship between disparate subjects.

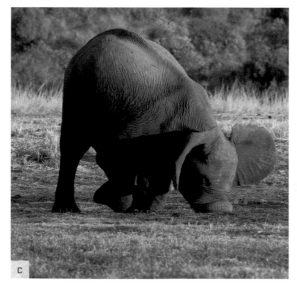

Spring is the season of rebirth, as life renews after the cold decline of winter and newborn cubs emerge from their dens. Summer is the season of radiance, with flowers in full bloom and trees heavily laden with leaves. Autumn is the season of change, as green turns to shades of ochre, orange, red and gold. Winter is the season of coldness and stillness, complete with captivating icy landscapes.

## People in the landscape

We often think of people as mutually exclusive to the land, and yet we are an intrinsic part of nature. Close to, the camera reveals the emotional influence of the environment over us.

At a distance, humanity is placed in the environment and we are exposed to a sense of scale.

## Photojournalism

The essence of 'a picture speaks a thousand words' is seen nowhere more than in photojournalism – the use of images to unravel hidden stories. Often, we associate photojournalism with war and the third world at the expense of the world immediately around us. You need look no further than your own back yard for interesting and motivating themes.

# Composition

Compelling photographs share a common form. They have a clear point of interest, which is emphasized by harmonious sub-elements. They are also emotionally compelling. All the components in a successful photograph work together towards a common goal: clarity of vision. Composition is the glue that holds together all the pictorial elements that, as photographers, we have deemed important enough not to exclude from the picture space. Composition is a multi-faceted element of photography. How you hold the camera, where in the frame you position the main subject, the perspective you choose, as well as the all-important elements of design, all affect how an image is perceived.

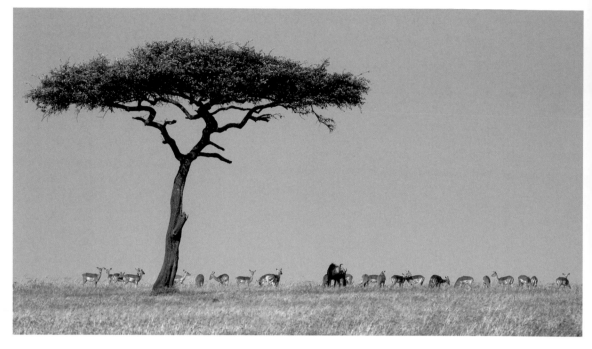

**landscape format**
When framed in the horizontal (landscape) format, images take on a greater sense of space. Here, the height of the tree is secondary to the line of impala on the horizon.

## Defining the picture space

With any photograph, the picture space is defined by your viewfinder initially and later by how you crop the image during the editing and printing process. The photographer can control the picture space by deciding firstly on its orientation – vertical (portrait) or horizontal (landscape) – and secondly its shape (rectangular, square or panoramic).

**Portrait format**

In the vertical (portrait) format, the emphasis is on height. By positioning the zebra in the bottom of the frame and turning the camera for a vertical frame I have created a sense of scale.

### Orientation

There is no right or wrong way to position the camera, but your decision will dictate which of the elements in the picture space receives the most emphasis.

Height and depth are accentuated when the camera is positioned in the vertical format. This helps to highlight, for example, the powerful presence of tall trees, or creates depth by leading the eye from foreground to background.

Positioned horizontally, greater emphasis is given to space. This may help to show an animal in the context of its environment by extending the area of inclusion to include complementary pictorial elements.

It is wise to shoot a scene in both formats if possible, particularly if you are considering selling your images. While we tend to shoot instinctively in the horizontal format, the typical format of books and magazines is vertical. How well your images fit may determine the extent of your sales.

### Format

The shape of the image (height to width proportion) strongly influences composition. The most common format shape is rectangular, such as the 2:3 ratio of 35mm film, which lends itself to the power of line to define space and height within the picture space.

A square format alleviates the need to decide between horizontal and vertical orientation but lacks the power of the rectangular format. However, it is often easier to crop a square image to achieve the desired proportions.

Compare these two images and note the one you prefer. In my mind, the rectangular format of image a helps to define a sense of space that is lacking in the square format image b, which seems to contain space.

## Perspective

As the photographer, it is down to you to define perspective and, in so doing, dictate the visual statement made by your images. Additionally, camera-to-subject distance, your choice of lens, and the angle of view between camera and subject all influence the relationship between the subject and other pictorial elements within the frame.

## Subject size

The size of the subject within the photographic frame can be altered in one of two ways. You can increase or decrease the camera-to-subject distance while maintaining the focal length to make the subject appear smaller or larger, respectively.

Alternatively, you can maintain camera-to-subject distance and change focal length to alter the subject magnification. Because actual levels of magnification are tiny, it is helpful to think in terms of human vision. The standard 50mm lens is so called because it has an angle of view similar to that of human eyesight. If we consider a 50mm standard lens to have a reproduction value of 1 (that is, equal to human vision), a 100mm telephoto lens will make your subject appear twice as close, and a 24mm wide-angle lens approximately twice as far away (or half as close).

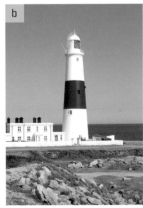
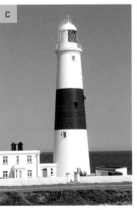

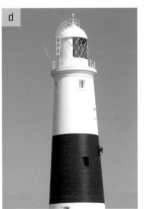

This series of images shows the effects of changing focal length lenses while maintaining camera-to-subject distance; a: 28mm, b: 35mm, c: 50mm, d: 85mm, e: 120mm, f: 200mm, g: 300mm, h: 400mm.

## Spatial relationships

By changing the camera-to-subject distance while altering focal length to keep image size constant, you can affect spatial relationships; that is, how the subject impacts on its surroundings.

For example, photographing a subject from 20m (65ft) away with a 200mm lens gives about the same subject magnification compared to using a 50mm lens when the subject is 5m (16ft) away. However, in relation to its surroundings, the two images will appear to be very different: the latter approach creates a sense of place, whereas the former method places a greater emphasis on the subject by isolating it from its environment.

Telephoto lenses have the optical effect of compressing space, making objects in an image appear closer together than they actually are. Photographing a wood or forest from ground level with a telephoto lens, for example, can make the trees appear as if they are planted in a single row.

Wide-angle lenses have the opposite effect, expanding the appearance of space between objects on different planes, making them

### ▼ Compressing perspective
Telephoto lenses have the effect of compressing space between distant objects, thereby making them appear closer together. Here the giraffe appears to be standing under the tree and yet, in reality, it was about 15m (50ft) further back.

appear further away and smaller in relation to the subject. In so doing, a wide-angle lens helps to create a sense of depth.

## Angle of view
The angle of the camera relative to the subject also affects how the viewer perceives their relationship with the subject. For example, an animal photographed from above will appear subordinate to the viewer, as if the photographer is controlling it. This apparent control of human over animal can cause the subject to appear captive, even if the photograph has been taken in the wild.

### ▲ Camera-to-subject distance
In each of these four images, the bale of hay remains roughly the same size. However, by altering camera-to-subject distance, the relationship between the subject and the surrounding area greatly changes in each image.

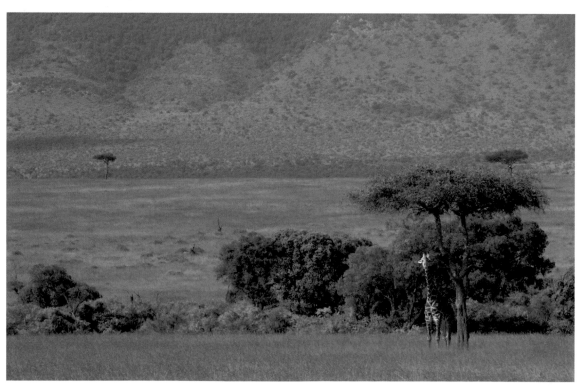

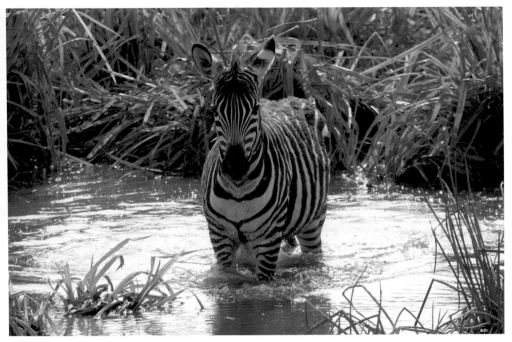

## ▲ Eye level
Photographing wildlife from above eye level rarely results in an appealing image. It creates a sense of superiority over the subject that doesn't suit the subject matter.

Wildlife photographed at eye level, however, will create more of a sense of equality. The resulting picture will be far more intimate because it removes the sense of familiarity the viewers have with their own environment and places them in the scene with the animal.

Shot from below, the subject gains control over the picture space, making the viewer feel vulnerable. This composition has an opposite impact on our emotions towards the subject than when photographed from above.

There is no right and wrong way to angle the camera. It is a question of considering that the position we choose alters the emotional response the viewer has to the image.

## ▲ Subject placement
By placing the subject in the middle of the image space, emphasis is given to the subject rather than to the surroundings. This is a useful strategy for photographing people, who will generally be more emotionally compelling than the environs in which they are sitting.

## Positioning the subject
Where the subject is positioned in the picture frame determines its visual weight. For example, if it is positioned centrally, the subject becomes isolated from its surroundings and emphasis is weighted towards the subject alone. Such central compositions are particularly effective when photographing wildlife. By directly engaging the viewer and focusing attention on the animal, the image becomes more intimate and intense.

Conversely, positioning the subject off-centre places greater emphasis on the surrounding environs, adding visual weight to space and depth. Off-centre compositions can be used to exploit wide vistas of beautiful and dramatic landscapes or, in wildlife photography, can be used to show the subject in relation to its habitat, so creating a sense of place.

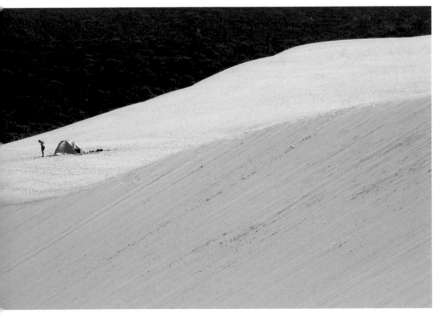

## ◀ A sense of place
In this image, by positioning the camper away from the centre of the frame, I have made the surrounding environment a greater part of the picture. This helps to create a stronger sense of place. Had I positioned the figure centrally, he would have seemed isolated from his surroundings.

## ▲ (left) Line

Line is the most basic of design elements and can have a profound effect on how we interpret an image. Here the vertical lines of the pillars provide us with the sense of height, while the diagonal line of the hand rail creates visual energy, making the composition more dynamic.

## ▲ (right) Circles

Circles and spheres are one of the most powerful graphic components. They contain their energy within, drawing attention to themselves. In this image of rippling water, circles have been used in isolation to add extra weight to their compositional strength.

## ▮ Isolating the subject

The pictorial power and intimacy imposed by a subject that is isolated from its environment can be achieved in additional ways. For example, a very narrow depth of field obscures foreground and background detail, leaving the eye with only the subject on which to focus. Also, framing the subject within natural borders helps the subject to stand apart distinctly from the space around it.

## ▮ The golden mean

The golden mean (which is often referred to incorrectly as the rule of thirds) is a very useful compositional aid to photographers. The idea of the golden mean was utilized extensively in classical architectural design and sculpture by the ancient Greeks, who borrowed it from the even more ancient Egyptians.

The golden mean is a quadratic equation that equates to a ratio of 8:5, which was considered the perfect spatial proportion for composition and design. In terms of a 35mm photographic frame, it produces a grid like the one shown right. Accordingly, the principal subject of an image should be positioned at one of the intersections for maximum impact.

The rule of thirds is a simplified version of the golden mean that has become commonly used because of its practicality. In either case, the effect is to create the possibility for an asymmetric composition of aesthetically powerful proportions by fashioning new centres of interest.

## ▮ Symmetry and asymmetry

A balanced, symmetrical composition elicits a feeling of stability and stasis. Pictures that contain subjects symmetrically positioned often lack visual energy, their strength lying in their formal organization of pictorial elements.

Asymmetric design, on the other hand, opens greater compositional opportunities. With the visual weight off-centre, tensions and

### The golden mean

### The rule of thirds

## ▲ The golden mean and the rule of thirds

The golden mean describes the perfect spatial proportion for composition and design. By placing the principal subject at one of the points of intersection, it is given greater emphasis and increases the power of the overall composition. The rule of thirds is a simplified version that achieves a similar response.

relationships between pictorial elements are formed and new balances created that lead to more exciting and dynamic compositions.

## The elements of design

There are five main elements of design: line, shape, pattern, texture and colour. All of these affect our emotional responses to a photograph and must be considered when composing an image. These basic graphic components are often ignored, with the result that competing and non-complementary elements detract from the compositional strength of the picture. As the photographer, you are responsible for noticing the elements of design within the picture space and isolating or joining them in a cohesive whole.

### ▌Line

Line is the most basic element of design. A straight horizontal line imposes a sense of balance and well-being within us, as we associate it with our most natural point of orientation, the horizon. Conversely, a slanted horizon

#### ▼ The golden mean in practice

In this photograph of a young man admiring the sight of Victoria Falls, I deliberately exploited the golden mean to position the figure in the picture frame at the ideal point.

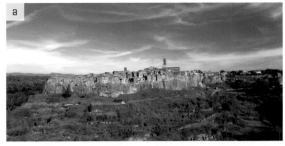

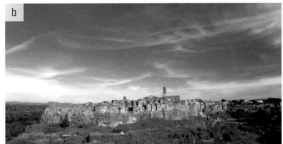

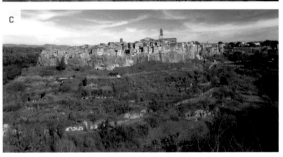

#### Horizon line

Compare each of these images and note how adjusting the position of the horizon line changes the emphasis of the photograph. In image a, equal weight is given to the foreground and the background. In image b, the sky takes on greater emphasis. In image c, the foreground becomes the prominent feature.

exacts a feeling of imbalance and insecurity, as it is opposite to the natural state. In this way, horizontal lines can be used to dictate a visual sense of stability or instability.

### ▌Positioning the horizon line

When the horizon line is positioned across the middle of the frame, equal weight is granted to both halves of the picture space. This creates a feeling of serenity and stasis – an almost peaceful mood within the scene.

If the horizon line is lifted above or dropped below the centre, the weighting changes. With a high horizon line, emphasis is placed on the foreground. Our eye is led into the picture space, creating a greater sense of depth. When the horizon line is positioned in the lower portion of the scene everything above it is accentuated, with the effect that the subject often stands out against the distant background.

### ▌Line and visual energy

When we enclose a horizontal line within the confines of a photographic frame, its energy extends sideways, drawing the eye along its line. Vertical lines insist that our eye follow their journey from the foreground to the top of the picture space, accentuating height. Sloping lines

## Patterns

Inherent patterns are creations of nature, and identifying them can be both challenging and rewarding. By enclosing many pattern elements within the frame, with some cut through by the edge of the frame, this image conveys a sense of infinite space.

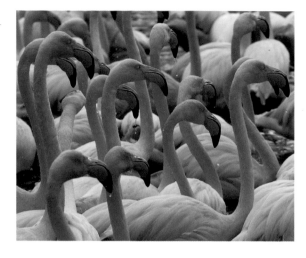

create tension; their energy fights to break the confinement of the enclosed frame, leading to a sense of visual energy and motion.

### Shape

Shape can be found everywhere in nature, from the triangular form of mountains and valleys to the circular shape of the sun and moon. Triangles and polygons evoke a graphic sense of strength and stability – a form of permanence. Think of a mountain – a solid, immoveable object. Inverted, however, triangles lose their stability, becoming imbalanced as they stand precariously on end. When viewed together in the same picture space, this conflict between

balance and imbalance creates a tension that heightens visual energy.

Circles and spheres contain their energy within, thereby drawing visual attention to themselves. They are one of the more powerful graphic components and must be used in the picture space wisely to avoid detracting from the principal subject.

When two competing shapes are combined within the picture space, visual energy is formed by the eye flitting between the competing subjects. Compositionally, this can form a dynamic pictorial structure that emanates power. However, care must be given to the picture design to ensure that this dynamic strength acts in a positive form rather than detracting from the purpose of the image.

### Patterns and texture

Patterns – the organization of shapes that recur and combine – reveal themselves in one of two forms: inherent patterns, such as those found in snowflakes, the petals around flowers, and birds' feathers; and positional patterns, which emerge when a scene is photographed from a certain viewpoint and framed in a particular way.

Inherent patterns are creations of nature, and identifying them can be both challenging and fun. It is possible to find inherent patterns that will create effective photographs in practically any location if you look hard enough.

## The power of colour

Several elements of design combine in this image of a weir in France, but the strongest is colour – the bold and vivid blue of the water and the reflections of the golden sky.

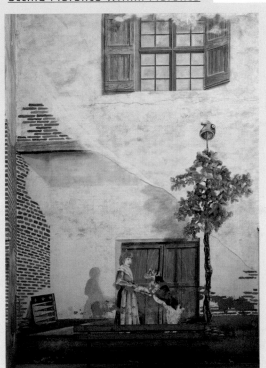

### Colour as subject

Colour can be used as the principal subject in a photograph. Just imagine this scene without colour – it would lack any real interest.

Because inherent patterns often form a small part of a larger whole, it is usually necessary to photograph them at close distance, perhaps using the macro techniques described on page 118. The greatest technical challenge is keeping all the elements in sharp focus, which strengthens the elemental shape. Out-of-focus areas detract from the composition and may lead to the interruption of the pattern itself, thereby defeating the object of the image.

Deciding on the number of pattern elements to include in the picture space also affects the aesthetic qualities of the image. By enclosing many elements with some cut in half by the edge of the frame, the picture suggests infinite space, as if the number of elements is too numerous to fit. However, be careful not to over-organize the composition, as this can result in an overly formal image that lacks energy.

Positional patterns become apparent when we change the visual relationship between objects of perspective and scale. Often, a simple matter of reducing the angle of view (by increasing focal length) or changing the position of the camera can reveal the hidden images within a wider scene.

Light is important to both; its angle and intensity affects a pattern's sharpness and legibility. Raised surfaces can remain hidden in subdued light, whereas direct overhead light can make any surface appear featureless.

Direct, angled lighting from the sun or from a non-diffused flash helps to emphasize and enhance patterns and textures by bringing out well-defined edges. Conversely, omni-directional light will emphasize the colour and shape of softer-edged patterns, thereby minimizing surface textures.

### Pictures that make you look twice

At first glance, it is difficult to tell what is the actual scene in this image of a mural. A closer look identifies a bench in the foreground that gives the image context.

Here's an exercise to try when out with your camera. Pick a number between 1 and 12, another between 10 and 30, and a final number between 12 and 36. Now, from the position you're standing, thinking of a clock face, and walk in the direction of the hour depicted by your first digit for the number of paces determined by the second. Then stop and without moving off that spot take as many different images as the final number.

This exercise is practised on workshops by the American photographer Freeman Patterson and is the best example of seeing pictures within pictures I have ever encountered. Every scene is made up of an infinite variety of subjects. Look at a beautiful vista and within it you will see shapes, colours, patterns and textures – hidden worlds within worlds all waiting to be photographed.

Sometimes we are so busy looking at a scene as a whole that we miss the intricate design of nature from which it is constructed. But these 'building blocks' can form beautiful and evocative images in their own right, either as abstract designs or simply as landscapes on a smaller scale.

Never be too eager to rush to a new location until you have explored every opportunity where you are. Walk around and explore your environment, seeking out the elements of design discussed earlier. Even your own back yard is a great place to start.

## The power of colour

It is a shame that more photographers are not conversant with colour theory, since colour plays such a significant role in photography. Colour is one of the most powerful design elements and can be exploited to enhance compositional properties and evoke emotional responses. It is a strong communicator (think of a set of traffic lights: we don't need to see the word 'stop' to know to stop when we see the colour red) and can be used in art (i.e. photography) to convey subliminal messages and infer meaning.

▼ Composition: colour

Colour is a principal form of communication and can form the subject of a photograph within itself. This image was taken while I was wandering through a village market in France.

In its simplest form, colour describes the surface appearance of an object, such as the blue sky, the rich green of a summer meadow or the vibrant array of colours in a display of flowers or vegetables laid out on a market stall. But colour also has a deeper meaning and can be used to create visual illusions, such as a sense of energy and depth. For example, complementary colours (that is, those opposite each other on the colour wheel – see opposite) that are used together in a picture space cause a resonance, making each individual colour appear more vibrant. One of the most important colour relationships is that between the primary colour red and the secondary colour green, complementary colours that, when paired together, have the effect of causing the eye to constantly shift focus, creating visual energy and making the image appear almost three-dimensional.

Colours also affect body temperature. Warm colours, such as red, orange and yellow actually make us feel warm because we associate them with the heat of fire and the sun. Conversely, cool colours such as blue, which we associate with ice, literally can cause us to shiver. Bold colours, such as the primary colours red, blue and yellow make bold statements, energizing us with happiness (in the case of yellow) or angst (in the case of red). On the other hand, softer pastel colours have a calming influence over our emotions and state of being.

◀ Exploring colours

Experiment with colour combinations that create form and visual energy. Here, the linear arrangement of the composition and the vibrant colours contained within it make for a striking image.

▼ Colour relationships

Combining two colours in the picture space can increase overall design strength. Red and green together, in particular, have a powerful effect on us – the varying wave lengths of the different colours cause the eye to continually adjust focus, creating an impression of three dimensions and visual energy.

## IS IT ART OR SCIENCE?

Unless it is conducted for solely scientific purposes, photography is a form of art. Therefore, every subject is open to the most imaginative of artistic interpretations.

Photography is a form of communication. When we speak, either verbally or through our pictures, people listen when we have something interesting to say or when we provide a new perspective on an existing view.

Images that depict the world in unexpected ways will challenge a viewer's preconceived ideas about how things should be. This questioning of presumptions intrigues the viewer and turns an ordinary scene into a compelling image.

Never be scared to challenge your own ideas, thoughts and ways of doing things. Experiment with your photography, trying new techniques and different equipment to achieve unusual and contemporary effects.

### Photography as art

These two images, which hardly look like photographs at all, are of reflections of riverside homes. Their strength lies in the powerful combination of design elements: colour, line, shape and pattern. With few exceptions, all photography is art and as such is reliant on these basic elements of design to form compelling images.

### ▲ Colour theory

Colour relationships can be visually represented with a colour wheel. According to colour theory, harmonious colour combinations use any two colours opposite each other on the colour wheel, any three colours equally spaced around the colour wheel forming a triangle, or any four colours forming a rectangle.

### ▼ Prime colours

Used in isolation or with a neutral background, the boldness and vividness of prime colours produce a strong graphic impact.

# 4 Preparing for photography in the field

Planning and preparation are often overlooked, and yet they are fundamental to a successful photography trip. Professional photographers don't simply wander around the globe aimlessly in the hope of bumping into the perfect picture opportunity. Assignments are meticulously planned weeks or months in advance so that we know where and when to capture the images we want. To get the most from a photography trip, you need to be cognisant of issues such as weather conditions and what subjects are to be found in different environments. Different types of habitats throughout the world necessitate different photography techniques and equipment needs, which are discussed here.

## Planning the shoot

When you are planning a shoot, you need to consider the following questions:

- What – what is there to photograph at your destination?
- Where – specifically, where are those subjects?
- When – when is the best season and time of day for photography?
- How – what equipment will you need?
- Why – what is the intended purpose of your pictures?

I want to relate a story to put the above statement into perspective. A very famous photographer friend of mine has on his studio wall a photograph of a solar eclipse. It is perfect. The moon is absolutely central, covering the sun, whose rim is just visible around its edges.

That single picture was 18 months in planning. When he arrived at the scene, my friend knew precisely, down to the very second, when to press the shutter. Is this going to extremes? Perhaps. But this man is a very famous photographer for a reason.

## Setting self-assignments

Self-assignments can be a source of inspiration and motivation to any photographer. Giving your picture-taking a sense of purpose helps focus your energy towards learning a specific technique or capturing a long-coveted image. Choosing a subject that you find personally intriguing is also highly rewarding.

I usually work on self-assigned projects alongside my paid assignments. For me, this is a means of keeping in perspective the reason why I became a professional wildlife photographer in the first place, and serves as an escape from commercial realities.

The following steps outline how to set a self-assignment:

1 _ Begin by defining a theme to give your assignment a structure that you can work and plan around. For example, 'The birds in my garden' or 'Life at a badger sett' are two simple ideas. The project should be based on a subject that you are passionate about and should be both motivational and challenging. A well-defined self-assignment will push the boundaries of your knowledge either of the subject or of a particular photographic technique.

2 _ Once you have set a theme, spend some time researching your subject. Use the techniques described left to identify the

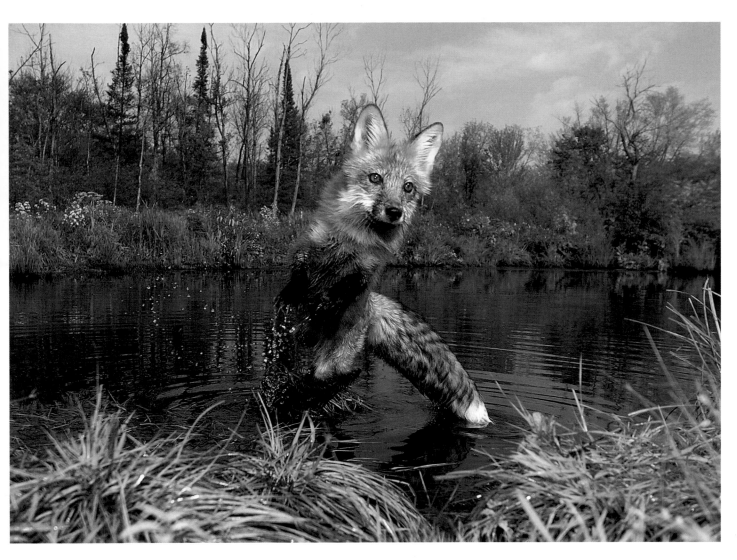

best location and time of year for photography, how to approach the subject, and any behavioural patterns to watch for. Practise your photography skills, particularly if your assignment involves using equipment or techniques unfamiliar to you. If you need equipment that you don't own, consider hiring it rather than purchasing it unless you are certain to use it again.

3 _ Book some time off work or agree on some free time with your family and organize days in the field in advance. Have a plan to cover contingencies, such as inclement weather or family emergencies. Before heading out to the location, pre-visualize some of the images you want to create and think through the photographic processes needed to achieve them.

4 _ Once in the field, experiment with different techniques and ideas as well as using your standard shots. For example, use slow shutter speeds when photographing fast-moving animals (see page 111), or try combining artificial and ambient light (see page 118). Experimental photography has a fairly low success rate, but the few images that make it are usually worth the effort, and it's a great way of expanding your repertoire of skills. Keep a list of the images needed to complete your assignment and tick them off as you make them.

5 _ Once you've processed the images, edit them and put them in order. Like a good story, your assignment should have a beginning, a middle and an end. Think of each picture in terms of a paragraph in the story that you're trying to tell.

6 _ Finally, when the assignment is completed, consider sending it to a magazine with an outline of the project and some sample images. If the work is good enough, they may be interested in publishing it.

**Inspiration and motivation**
I photographed this Red fox during a self-assigned project. Self-assignments are an invaluable means of keeping your levels of motivation high and inspiring great images.

## Researching subjects and locations

The less time you have available for taking pictures in the field, the better your research should be. Time spent looking for suitable viewpoints or subjects on location limits the number of pictures you're likely to take and reduces the chances of your being in the right place at the right time.

The Internet is a good place to begin your research. Searching on a place name or subject via one of the major search engines usually results in several thousand pages of feedback. Although you may need to sift through several web pages to find some useful information, typically the formal information sites are listed near the top.

Get in touch with local tourist offices for information as well as reading books on the area. Also, look at the work of photographers who are known in the area. I don't recommend copying what they have done, but it will give you a sense of the type of pictures that can be taken, and you may come up with a new angle or a better way to photograph a similar subject.

Good viewpoints will often present themselves as you go about your normal day. It is worth noting down these ideas even when not taking pictures, as these spots can be revisited at another time. Keep a notebook and pencil handy to jot down location details, or use a dictaphone (though not while driving!).

### ▼ Keeping ahead of the weather

Weather is critical to successful outdoor photography and can make or break a short venture into the field. Planning ahead will give you the opportunity to benefit from photographically conducive conditions.

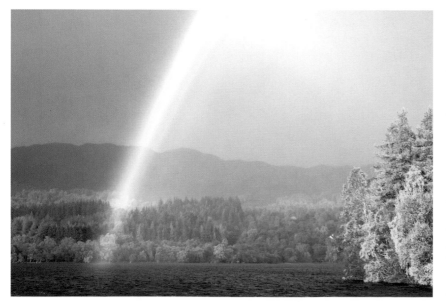

# weather conditions

Nothing is more demoralizing than getting geared up for a day in the field, waking while it's still dark for an early start, only to discover that heavy grey clouds have settled in and it's raining. Understanding weather forecasts will save you time, effort and disappointment. You don't need to be an expert; just learning some of the basic weather patterns will help.

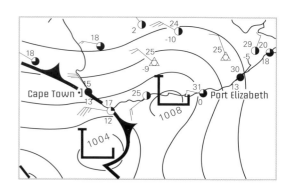

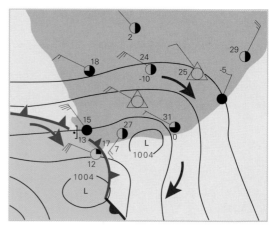

### ▲ Interpreting weather maps

Learning how to interpret basic weather maps will help you to define the best conditions for a field trip – saving time, money and effort.

## Interpreting weather maps

The lines on a weather map are known as isobars; they join points of equal pressure. Isobars identify particular features such as ridges (areas of high pressure) and depressions (areas of low pressure) that are associated with different kinds of weather.

For example, in high-pressure conditions, winds tend to be light and the air is descending, inhibiting the formation of clouds. Therefore, ridges on a weather map indicate high pressure, which usually forecasts a clear day. Conversely, in low-pressure conditions,

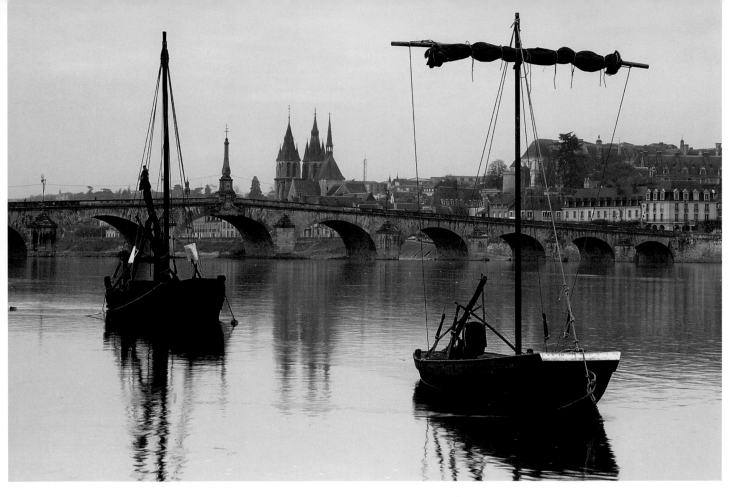

the air is rising. As it rises and cools, water vapour condenses to form clouds and sometimes precipitation. Consequently, the weather conditions in a depression are generally cloudy, wet and windy.

Wind strength can be gauged by looking at the distance between isobars. The closer together they appear, the stronger the wind will be.

## Wind direction

Wind direction is another indication of the type of weather that you are likely to encounter out in the field. Winds from the north, northwest and northeast tend to bring with them cold temperatures and rain showers. Westerly and southwesterly winds tend to bring clouds, whereas winds from the south often mean warm and dry conditions. Easterly and southeasterly winds bring with them warm and dry weather in the summer and cold and dry weather in the winter.

## Fronts

The boundary between two different types of air mass is called a front. Warm fronts bring heavy clouds and eventually rain with cold air. As the warm front passes, the overcast conditions remain but the air warms. When a cold front approaches, the weather changes from being mild and overcast to cold and bright, with possible showers.

## Making the most of poor weather

Inclement weather should never be an excuse for packing away your camera and heading indoors. Some of my very best images have been made in weather that first seemed unsuitable to good photography.

Being able to manipulate light and maximize the power of the elements of design becomes critical when the weather is against you. For example, during conditions of heavy cloud, light has a strong blue cast that is invisible to the human eye but is recorded by film/sensors (see page 43). This blue cast accentuates the feeling of cold and misery that poor weather often engenders in us. This can be overcome by using an 81 series filter to add warmth to the picture and making the lasting impression more comfortable.

Storms are often very dramatic, with thick black clouds rolling in over the horizon and lightning lighting up the often dark sky. The powerful drama inherent in fierce storms, when photographed with an aesthetic eye, always elicits an emotional response.

When photographing in inclement weather, make sure you take adequate protection for your equipment and yourself. Use a waterproof cover over the camera and fit a UV filter to the front of the lens. Avoid using tripods or umbrellas when lightning is present as both can act as a conductor.

**Making the most of inclement weather**
I photographed this scene on the worst day of a three-week assignment in France. This image has been critically acclaimed and is an example that poor weather does not always go hand in hand with a lack of photographic opportunities.

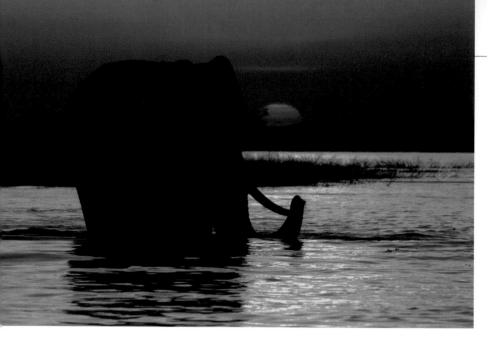

## Tide tables

The proximity of the moon to Earth relative to the sun is the principal cause of tides. There are two types of tide. Spring tides occur after a new and full moon. Neap tides occur during the first and third quarters of the lunar cycle, when the sun is at right angles to the moon.

In most parts of the world, there are two high tides and two low tides during each lunar day (being 24 hours, 50 minutes and 28 seconds). You can buy booklets containing tide times and heights, like the ones listed in the table shown below.

# Looking after your equipment

Simply taking your equipment out of the country presents challenges of its own. You need to think about what sort of environments you are likely to be exposing your photographic equipment to, and take measures to protect and maintain it accordingly.

**▲ Sunrise and sunset**
Knowing the times of sunrise and sunset will help when planning a photographic session in the field, allowing you plenty of time to scout the location for the best vantage point.

## Sunrise and sunset times

Some of the best opportunities for outdoor photography exist around the hours of sunrise and sunset. Therefore, it is worth checking the time of these two events to avoid waking up too early or, worse, too late. Times vary throughout the year and by location and local newspapers often provide up-to-date information. You can also find this information on the Internet.

### Cornwall Newquay — MAY 2005

| DATE | DAY | HIGH WATER Morning Time | Ht m | HIGH WATER Afternoon Time | Ht m | LOW WATER Morning Time | Ht m | LOW WATER Afternoon Time | Ht m |
|---|---|---|---|---|---|---|---|---|---|
| 1 | Su | 11:25 | 5.3 | ** ** | *** | 5:23 | 1.9 | 5:58 | 2.2 |
| 2 | M | 00:07 | 5.5 | 12:58 | 5.2 | 6:58 | 2.0 | 7:38 | 2.5 |
| 3 | Tu | 1:36 | 5.6 | 2:21 | 5.5 | 8:21 | 1.8 | 8:53 | 1.8 |
| 4 | W | 2:48 | 6.0 | 3:24 | 5.9 | 9:26 | 1.3 | 9:51 | 1.3 |
| 5 | Th | 3:45 | 6.3 | 4:13 | 6.2 | 10:17 | 1.0 | 10:39 | 0.9 |
| 6 | Fr | 4:32 | 6.6 | 4:56 | 6.5 | 11:01 | 0.7 | 11:20 | 0.7 |
| 7 | Sa | 5:14 | 6.8 | 5:35 | 6.7 | 11:39 | 0.6 | 11:57 | 0.6 |
| 8 | Su● | 5:53 | 6.8 | 6:10 | 6.7 | ** ** | *** | 12:15 | 0.6 |
| 9 | M | 6:29 | 6.7 | 6:44 | 6.7 | 00:34 | 0.6 | 12:49 | 0.6 |
| 10 | Tu | 7:04 | 6.6 | 7:19 | 6.5 | 1:08 | 0.7 | 1:24 | 0.8 |
| 11 | W | 7:41 | 6.3 | 7:54 | 6.3 | 1:45 | 0.9 | 1:57 | 1.1 |
| 12 | Th | 8:15 | 6.1 | 8:29 | 6.1 | 2:19 | 1.2 | 2:31 | 1.5 |
| 13 | Fr | 8:52 | 5.8 | 9:05 | 5.8 | 2:55 | 1.6 | 3:05 | 1.8 |
| 14 | Sa | 9:32 | 5.4 | 9:49 | 5.5 | 3:33 | 1.9 | 3:43 | 2.1 |
| 15 | Su | 10:22 | 5.1 | 10:45 | 5.2 | 4:20 | 2.2 | 4:35 | 2.4 |
| 16 | M | 11:26 | 4.8 | 11:57 | 5.0 | 5:26 | 2.5 | 5:50 | 2.6 |
| 17 | Tu | ** ** | *** | 12:50 | 4.8 | 6:51 | 2.5 | 7:19 | 2.6 |
| 18 | W | 1:21 | 5.1 | 2:07 | 5.0 | 8:04 | 2.3 | 8:26 | 2.3 |
| 19 | Th | 2:27 | 5.4 | 3:02 | 5.4 | 9:02 | 2.0 | 9:20 | 2.0 |
| 20 | Fr | 3:18 | 5.7 | 3:45 | 5.8 | 9:49 | 1.7 | 10:05 | 1.6 |
| 21 | Sa | 4:01 | 6.1 | 4:25 | 6.1 | 10:30 | 1.2 | 10:46 | 1.2 |
| 22 | Su | 4:41 | 6.3 | 5:04 | 6.4 | 11:10 | 0.9 | 11:27 | 0.9 |
| 23 | M○ | 5:22 | 6.6 | 5:44 | 6.7 | 11:49 | 0.7 | ** ** | *** |
| 24 | Tu | 6:04 | 6.7 | 6:24 | 6.8 | 00:08 | 0.7 | 12:30 | 0.6 |
| 25 | W | 6:46 | 6.8 | 7:08 | 6.8 | 00:50 | 0.6 | 1:12 | 0.6 |
| 26 | Th | 7:32 | 6.6 | 7:55 | 6.7 | 1:36 | 0.6 | 1:56 | 0.8 |
| 27 | Fr | 8:21 | 6.4 | 8:45 | 6.5 | 2:24 | 0.7 | 2:45 | 1.0 |
| 28 | Sa | 9:15 | 6.1 | 9:42 | 6.2 | 3:18 | 1.0 | 3:37 | 1.3 |
| 29 | Su | 10:15 | 5.9 | 10:45 | 6.1 | 4:16 | 1.2 | 4:39 | 1.7 |
| 30 | M | 11:20 | 5.6 | 11:54 | 5.9 | 5:25 | 1.6 | 5:53 | 1.9 |
| 31 | Tu | ** ** | ** | 12:33 | 5.5 | 6:40 | 1.7 | 7:11 | 1.9 |

*Height in metres (1 metre = 3.3ft). Adjusted for G.M.T and British Summer Time.*

### Cornwall Newquay — JUNE 2005

| DATE | DAY | HIGH WATER Morning Time | Ht m | HIGH WATER Afternoon Time | Ht m | LOW WATER Morning Time | Ht m | LOW WATER Afternoon Time | Ht m |
|---|---|---|---|---|---|---|---|---|---|
| 1 | W | 1:07 | 5.9 | 1:44 | 5.6 | 7:49 | 1.6 | 8:18 | 1.8 |
| 2 | Th | 2:13 | 6.0 | 2:47 | 5.8 | 8:50 | 1.5 | 9:17 | 1.6 |
| 3 | Fr | 3:11 | 6.1 | 3:40 | 6.0 | 9:44 | 1.3 | 10:08 | 1.3 |
| 4 | Sa | 4:02 | 6.2 | 4:27 | 6.1 | 10:30 | 1.2 | 10:53 | 1.2 |
| 5 | Su | 4:47 | 6.3 | 5:09 | 6.3 | 11:11 | 1.1 | 11:33 | 1.1 |
| 6 | M● | 5:29 | 6.3 | 5:48 | 6.3 | 11:49 | 1.0 | ** ** | *** |
| 7 | Tu | 6:08 | 6.3 | 6:24 | 6.4 | 00:11 | 1.1 | 12:26 | 1.1 |
| 8 | W | 6:45 | 6.2 | 6:59 | 6.3 | 00:48 | 1.1 | 1:01 | 1.1 |
| 9 | Th | 7:22 | 6.1 | 7:37 | 6.2 | 1:26 | 1.2 | 1:37 | 1.2 |
| 10 | Fr | 7:59 | 6.0 | 8:12 | 6.1 | 2:02 | 1.3 | 2:13 | 1.5 |
| 11 | Sa | 8:36 | 5.8 | 8:50 | 6.0 | 2:40 | 1.5 | 2:48 | 1.7 |
| 12 | Su | 9:15 | 5.6 | 9:31 | 5.8 | 3:18 | 1.7 | 3:28 | 1.9 |
| 13 | M | 9:58 | 5.4 | 10:17 | 5.6 | 4:00 | 1.9 | 4:11 | 2.1 |
| 14 | Tu | 10:48 | 5.2 | 11:10 | 5.4 | 4:49 | 2.1 | 5:06 | 2.2 |
| 15 | W | 11:44 | 5.1 | ** ** | *** | 5:47 | 2.2 | 6:10 | 2.3 |
| 16 | Th | 00:10 | 5.3 | 12:51 | 5.1 | 6:54 | 2.2 | 7:19 | 2.3 |
| 17 | Fr | 1:16 | 5.4 | 1:55 | 5.3 | 7:57 | 2.1 | 8:21 | 2.1 |
| 18 | Sa | 2:19 | 5.6 | 2:54 | 5.6 | 8:55 | 1.9 | 9:18 | 1.8 |
| 19 | Su | 3:15 | 5.9 | 3:45 | 6.0 | 9:48 | 1.6 | 10:11 | 1.5 |
| 20 | M | 4:07 | 6.1 | 4:34 | 6.2 | 10:39 | 1.2 | 11:01 | 1.1 |
| 21 | Tu | 4:57 | 6.3 | 5:22 | 6.5 | 11:26 | 0.9 | 11:49 | 0.8 |
| 22 | W○ | 5:47 | 6.6 | 6:10 | 6.8 | ** ** | *** | 12:12 | 0.8 |
| 23 | Th | 6:35 | 6.7 | 6:58 | 6.9 | 00:39 | 0.6 | 1:00 | 0.7 |
| 24 | Fr | 7:27 | 6.7 | 7:50 | 6.9 | 1:29 | 0.5 | 1:51 | 0.7 |
| 25 | Sa | 8:18 | 6.6 | 8:42 | 6.8 | 2:22 | 0.5 | 2:42 | 0.8 |
| 26 | Su | 9:11 | 6.4 | 9:35 | 6.6 | 3:16 | 0.6 | 3:34 | 0.9 |
| 27 | M | 10:03 | 6.1 | 10:30 | 6.4 | 4:09 | 0.8 | 4:28 | 1.2 |
| 28 | Tu | 10:58 | 6.0 | 11:26 | 6.1 | 5:06 | 1.1 | 5:27 | 1.5 |
| 29 | W | 11:57 | 5.7 | ** ** | *** | 6:05 | 1.5 | 6:30 | 1.7 |
| 30 | Th | 00:28 | 6.0 | 1:02 | 5.6 | 7:07 | 1.7 | 7:35 | 1.9 |
| – | – | – | – | – | – | – | – | – | – |

*Height in metres (1 metre = 3.3ft). Adjusted for G.M.T and British Summer Time.*

**▲ Overseas travel**
When travelling overseas I suggest always storing excess equipment in a purpose-designed hard case that is impervious to the exploits of baggage handlers.

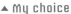

**▲ My choice**
I use a case manufactured by an American company called Storm. Other makes are available.

**▲ Easy on the muscles**
Larger cases come with built-in wheels for comfort but weigh significantly more.

## Travelling overseas with photographic equipment

I am frequently asked about the best methods for carrying photographic gear through airports and on to aeroplanes. My answer has changed over the years, particularly after 9/11.

I now pack a single camera body and two zoom lenses (a 24–120mm AF VR and an 80–400mm AF VR) together with a flash unit, spare battery and several Compact-Flash cards into a suitable bag, which I take with me onto the aircraft. All my remaining equipment is packed into a large, waterproof and airtight hard case kitted out with a pre-cut foam insert. This case is placed in the hold of the aircraft.

To avoid attracting thieves, I place the case in an old army duffle bag, which is secured at the top. When travelling to the US, I remove the padlocks to avoid them being damaged when the bag is inspected before it is loaded onto the aircraft.

By transporting my equipment in this way I ensure that, should my hold luggage end up in a destination different to my own (and not for the first time), I have the essential gear that I need to get on with the job while I'm waiting to be repatriated with my clothes and remaining cameras.

## Airport X-ray machines

CompactFlash cards and similar memory cards are unaffected by airport X-ray machines, so I have no hesitation in passing them through. Slow film is very rarely affected by the X-ray machines used for carry-on luggage, and over the years I have passed many thousands of film rolls through several X-ray machines without suffering any problems.

Avoid using the so-called 'film-safe' lead bags available in some camera stores. They only cause the machine operator to increase the power of the X-ray, which is liable to damage the film. When packing film, keep the canister upright so that the minimum surface area of the film is exposed to the X-ray.

If you plan to request a hand search of film, first empty all of your film canisters or rolls into a clear plastic bag so they are easily visible. Be prepared, however, for your request to be denied. Airport staff, particularly ones at large, busy airports, are under a great deal of pressure, and safety and security are their foremost concerns. Make any requests you have politely and don't make a fuss if you are declined.

## Protecting your equipment

In the field, hard knocks, dust, sand, sharp thorns, branches and moisture can quickly render your cameras inoperable. Professional-specification cameras are designed to withstand the elements; they have dust- and water-resistant seals around openings and durable outer coatings that help to protect them in harsh environments. Even so, taking sensible precautions helps ensure that your cameras continue to work in the most camera-hostile conditions, as well as extending their working lives.

I always carry a clear plastic bag to wrap my camera in if it rains unexpectedly or, when photographing next to the sea, to protect the camera from salty sea spray. The bag is then secured around the lens with an elastic band, and I add a UV filter to protect the front element of the lens.

On the water, store equipment in a watertight bag – the kind sold in outdoor equipment stores for canoeing and kayaking trips. This will keep kit dry if it falls overboard or the boat capsizes. Other equipment can be kept in watertight containers or in one of the latest waterproof camera bags.

In arid environments, dust will be the major concern. Here too, I have found using a plastic bag an effective solution and preferable to using cloth bags, which tend to trap dust within. If dust does attach itself to the sensor, it will need to be cleaned. Ideally only an authorized service centre should undertake this task, as the sensor is extremely delicate and easily damaged. However, as a working professional I find it impossible to rely on the timeliness of this process and clean the sensor myself using some specialist equipment.

After use, always store your equipment in a good-quality zippered pack that will keep out the elements. Attaching a screw-in type UV filter is always a sensible precaution to protect the front element of the lens. Regularly clean the camera body using a compressed air spray and soft brush. Lenses should be cleaned only with a suitable cloth and a blower brush to remove particles of dust and dirt. Used correctly, brushes are more effective and safer than lens cloths, which can scratch delicate surfaces. Avoid touching the front and rear elements of the lens with your fingers.

## Carrying equipment

The easiest method of carrying equipment in the field is in a backpack-style camera bag, such as those made by Crumpler and Lowepro. These come in different sizes to suit the amount of

**▲ Lens brushes**
Carry a lens blower brush to keep optics clean while photographing outdoors.

**▲ Lens cleaning kits**
For camera-hostile environments, special lens cleaning kits can help maintain optical integrity.

**▲ Backpacks**
A good, secure backpack will keep your equipment safe while trekking.

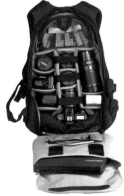

**◀ Compartmentalize**
A compartmentalized backpack makes retrieving equipment fast and easy.

**▶ Pack and go**
Small camera bags are useful for shorter stays in the field.

gear you want to take, from small handy bags large enough for a camera body and a couple of spare lenses to full-size packs that can hold an entire camera system, including a tripod. They have been specially designed for trekking, and have adjustable harnesses for added comfort and lumbar support.

Most of these bag types are designed with compartmentalized interiors that allow you to arrange and organize your equipment for ease of access as well as security. Always make sure that the foam walls of the compartments fit snugly around any piece of gear and, to avoid bits of kit from accidentally falling out, always secure the bag before moving it. I particularly like the Crumpler bags because they provide a

### Bear-proof
Over-zealous baggage handlers are one thing, but you never know what circumstances you may find yourself in the field. Here, a curious bear investigated my camera case – I can confirm that no equipment was harmed during the making of this picture!

zippable inner cover made of netting that secures the equipment even when the main bag is open. Make sure the pack is large enough to hold all the equipment you're likely to carry and that it is light enough for you to carry when full.

## Storing film
Film is particularly susceptible to excessive heat and very cold climates. Above a certain temperature, the emulsion can melt, while, in sub-zero temperatures, the film can freeze and become very brittle.

Ideally, film should be stored in watertight containers, such as those it is shipped in, within an airtight box and at a temperature of below 15°C (59°F).

In very hot climates, such as Africa, an ice-box is a useful item to carry in your vehicle. In very cold climates, such as the Polar regions, keep film beneath your clothing, allowing your body heat to keep it warm.

# A GUIDE TO WORLD SUBJECTS

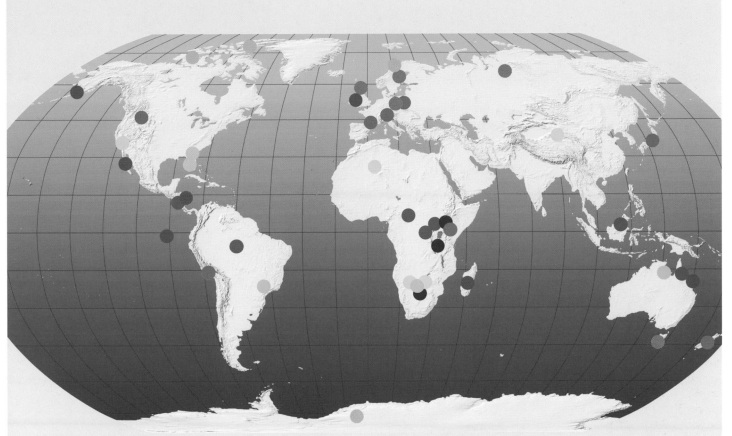

The list below is a guide to my favourite photographic locations for different habitats. It is in no way exhaustive, and different photographers will each have their own preferences. The following section discusses in greater detail the wealth of photographic subjects that you may encounter in these different habitats, and outlines the specific techniques you might need to successfully capture images in these locations.

● **Tropical rainforests**
The Amazon, Brazil; Costa Rica; northern Queensland, Australia; Borneo; Rwanda; Uganda; Democratic Republic of Congo

● **Temperate forests**
Poland, Tasmania, Scandinavia, Scotland, Siberia

● **Savannahs**
Serengeti National Park, Tanzania; Masai Mara National Park, Kenya; Kruger National Park, South Africa

● **Deserts**
Namib, Namibia; Sahara, Algeria; Kalahari, Botswana; Mojave, California, USA; Gobi, China and Mongolia

● **Oceans and coasts**
The Great Barrier Reef, Australia; Honduras; Baja California, Mexico; Pembroke-shire, UK; Katmai, Alaska, USA; Madagascar; Galapagos Islands

● **Wetlands**
The Everglades, Florida, USA; Okefenokee, Georgia, USA; the Pantanal, Brazil; Okovanga Delta, Botswana; Kakadu NP, Australia

● **Mountains**
New Zealand Alps, South Island, New Zealand; European Alps, central Europe; the Andes, South America; the Rocky Mountains, USA and Canada; Mount Fuji, Japan; Mount Kilimanjaro, Tanzania; the Pyrenees, France and Spain; the Carpathian Mountains, Poland

● **Polar regions**
Antarctica; Svalbard, Norway; Churchill, Canada; Ellesmere Island, Canada

**▲ Temperate forests**
Although very secretive animals that are difficult to spot in the wild, lynx are native to the temperate forests of Europe, America and Asia.

## Tropical rainforests

Flora and fauna are abundant in tropical rainforests, which form some of the world's richest ecological environments. Exotic plant species, large mammals such as jaguar, insects, reptiles, amphibians, and many hundreds of bird species make their homes in the canopy or on the forest floor. Many of the animal species here are difficult to spot, so working with a local guide or biologist is often essential.

### Photographic techniques

Flash is essential, as the cover of the canopy limits the amount of light reaching the forest floor. When photographing flora, use a combination of CC20 green and 81A filters to reduce the level of cool blue light reaching the film/sensor and to enhance the vivid green of leaves.

### Working in the field

For anything more than a day trip, you should consider using only cameras that are resistant to impact, precipitation and humidity. Humidity, in particular, causes fungus to form and grow inside lenses, on camera electronics and on film emulsion.

Always store equipment in a dry box with sufficient moisture-absorbent silica gel. Expose lenses to sunlight whenever possible, as ten minutes of sunlight can kill off dark-loving mildew spores. Remove traces of moisture as soon and as often as possible and at least once daily to keep cameras in working condition.

Films should be stored in a cool bag in their original plastic tubs to avoid moisture penetrating and to protect from extreme variations in temperature. Similarly, memory cards, such as CompactFlash cards, are best stored in plastic wallets.

Allow time for the condensation that forms when a camera is moved from a cool environment to a warm one to dissipate.

## Temperate forests

Human interference has altered many of our temperate forests. Primary temperate forests are few and far between, existing only in isolation in regions of Poland, Siberia and Tasmania. Secondary temperate forests are more widespread and are the natural habitat of predatory mammals, such as bear, wolf, lynx and fox, as well as many smaller mammals and numerous bird and insect species.

Because temperate forests are influenced by the vagaries of seasons, photography is possible all year round. As well as attracting different species, the changing colours provide an ever-varying backdrop and can form the principal subject in themselves.

### Photographic techniques

Levels of illumination vary throughout the year. After the brisk autumn winds have swept the leaves from the trees, light falls freely on the forest floor. In the summer, however, when a dense canopy of leaves blocks out the sun's rays, light levels are intermittent in the forests,

**◀ Temperate forests**
Temperate forests provide year-round photographic opportunities, with changing fauna and flora.

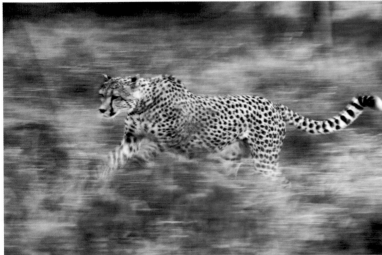

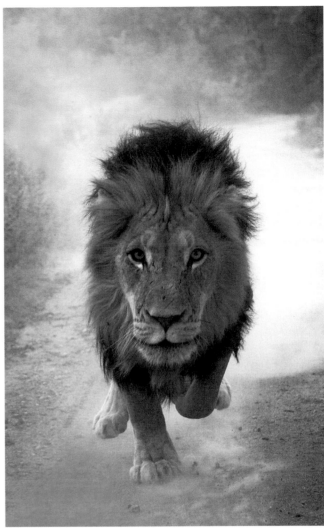

▲ [all] Savannah
Our strongest savannah association is with Africa, where it is possible to photograph a vast diversity of wildlife within relatively short distances.

which tends to make controlling exposure quite a challenge.

## Working in the field
In very wet conditions, camera equipment should be well protected from the elements with a waterproof cover. During spells of freezing weather, cover any exposed metal surfaces with cloth-backed tape to make touching them more comfortable. Protect your batteries from the cold to prolong their working life by insulating them.

## Savannahs
Ranging from southwest Australia to the Pampas of South America and the wildlife-rich Serengeti and Masai Mara in East Africa, savannahs are a paradise for nature photographers, offering a wealth of compelling subjects. Wildlife is perhaps the commonest subject, from the hundreds of thousands of grazing animals to the big cats – lions, leopards and cheetah – that prey on them.

## Photographic techniques
A lack of dense vegetation and cloudless skies make lighting harsh from mid-morning to mid-afternoon. Photography is best early in the morning when the quality of light is warm and diffused. Rising before daybreak to start shooting around 6:30am is the norm, giving two hours of beautiful light before the harshness of the sun really begins to penetrate.

## Working in the field
Camera equipment is prone to excessive vibration caused by the jolting vehicle you will be travelling in. When not in use, keep your camera gear easily to hand in a well-padded camera bag, which should be kept closed to prevent dust from settling on any exposed camera parts.

A UV filter keeps the front element of your lens clean and is cheaper to replace than the lens itself. Film and memory cards should be stored in a cool bag and kept in containers when not in the camera.

I make greatest use of my zoom lenses on my digital cameras in Africa to minimize dust on the sensor. I use two bodies, one with a 70–200mm VR lens and another with a 200–400mm VR lens. Together, they cover a wide focal length range. This means I have little need to change lenses, avoiding exposing the sensor to dust.

**Oceans and coast**

The world's oceans and coastlines present numerous photographic opportunities and challenges. An imaginative photographer could spend an entire day in a single spot and never run short of ideas for images.

## Deserts

Photography is challenging in the harsh environments of the world's great deserts, such as the Namib, the Sahara and the Kalahari, but the rich colours and natural forms of sand dunes the size of small mountains make for some dramatic landscapes. Wildlife, such as Fennec foxes and jerboas, can be hard to spot, as they spend most of the day sheltering from the heat.

### Photographic techniques

Get up early to photograph wildlife in the desert. Many species of mammal prefer to hunt in the cooler temperatures of night and head back to their dens in the early morning. Haze, caused by heat, is less apparent during early morning, making sharp imagery more practical. Use a tripod to obtain pin-sharp landscape images.

### Working in the field

Keep cameras out of direct sunlight. A well-ventilated icebox stowed in a shady place is ideal for storing equipment when on the move. Once the sun has risen and the temperatures climb, shield cameras and lenses from the sun by keeping them covered. Lenses, in particular, must be kept cool, as excessive heat can melt some of the glues used to hold them together.

## Oceans and coasts

Rugged, rocky coastline, prehistoric rock formations, seashells, rock pools, sweeping palm-treed tropical beaches, sea birds, large mammals, reptiles and amphibians, colourful reefs and fish attract nature photographers to the coast. It would be quite possible to spend a lifetime photographing a single location.

### Photographic techniques

Photographing the coastline from above with a wide-angle lens gives landscapes an increased perspective of wide-open space. Experiment with other focal length lenses and keep your macro lens to hand to capture small creatures and intricate patterns and textures.

Because water and sand are both highly reflective surfaces, try using the techniques described on page 53 to ensure accurate exposure readings. A polarizing filter will also help to remove unwanted reflections from the surface of water, as well as saturating strong, bold colours.

### Working in the field

Corrosive salt and sea spray is hazardous to camera equipment. Fit UV filters to all the lenses you are going to use and cover any exposed joints with plastic tape. A special protective camera cape (or a modified plastic bag) can be used to protect the camera body and lens barrel. Change lenses only in a protected environment to shield against sand and spray.

Similarly, you should protect the camera when loading film. Sand in the film chamber can cause scratches on the film and damage the shutter curtain.

▲ **Deserts**
Deserts are challenging environments for photographers to work in, but can produce very strong graphic images.

Clean your equipment thoroughly whenever you can, and take particular care when cleaning the glass element of the lens. Use a blower brush or compressed air spray to remove any stray particles of sand or salt before wiping the lens surface with a clean lint-free cloth.

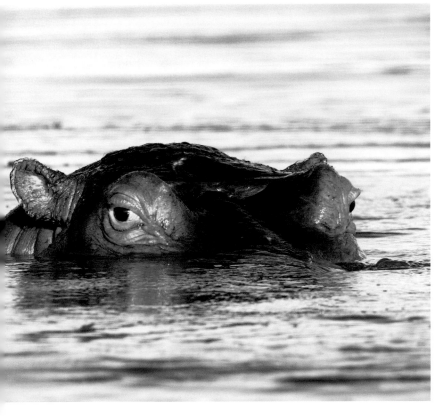

# Wetlands

Birds, amphibians and reptiles are the principal subjects for photography in the world's wetland regions, which can be found on every continent. These self-contained ecosystems support copious avian fauna, as well as small reptiles and amphibians, such as Green frog, Fire salamander, Palmated newt and Common toads. Larger reptiles, such as alligators and crocodiles, sit at the top of the food chain.

### Photographic techniques

A floating hide (see page 104) enables you to get closer to shy subjects for frame-filling images. Beware of the effects on exposure metering of bright sunlight reflecting off water, and use some of the techniques described on page 53. A beanbag is an ideal camera support if photographing from a boat.

### Working in the field

When photographing on, in, or near water, make sure the camera is protected against inadvertent submersion. Purpose-made underwater housings that allow you to safely submerge the camera can be quite effective.

◀ **Wetlands**
Wetlands are self-contained ecosystems that support copious fauna, from mammals (such as this ungainly hippopotamus) to reptiles, amphibians, birds and, of course, fish.

**Cropping tightly**

When venturing in mountain country, keep an eye open for the less obvious shots. This pool, with its turquoise water contrasting greatly with the surrounding burnt earth, is high in the Tongariro National Park in New Zealand.

◀ **Mountain high**

The dramatic form and exotic locales of mountain ranges make them an ideal subject for landscape photography, particularly when warm evening or early-morning light plays on the rugged surface of the rock to bring their solid mass to life.

▶ **Contrasts**

The contrast between the dark rock and the autumnal colours of the foliage was what first attracted me to this scene of a waterfall in the Scottish Highlands.

As well as variations in vegetation, different animals are found at varying altitudes. At the mountain's foot, plains creatures such as cervids and boars are prevalent. Higher up, grouse and capercailie thrive, while further still is the realm of the Golden eagle and Griffon vultures.

The position of mountain slopes influences what sort of species live there. Mountainsides that are bathed in sunshine cause flowers and colonies of marmots to flourish. Shaded slopes, however, attract ibex and chamois, which prefer the cool shade and the isolation from hikers.

## ▌Photographic techniques

Use wide-angle lenses to create a sense of place, with wildflowers or wildlife in the foreground and sweeping mountain vistas providing the backdrop. You will need extensive depth of field, so select a small aperture and make use of the hyperfocal distance focusing technique (see pages 62–63).

When using film, a UV filter helps to reduce the levels of ultraviolet light that are more prevalent at very high altitudes (digital sensors are less affected by UV rays than film). Also, a polarizing filter will help to saturate colours and make white clouds stand out from blue skies. If the tone of the foreground differs greatly from the sky, use a neutral density graduated filter to even them out (see page 33).

To keep horizons level, particularly in rocky environments, a small spirit level attached to the accessory shoe will provide you with an accurate guide.

A UV filter protects the front element of the lens, and any stray droplets of water can be wiped clear with a lint-free cloth. Keep film and memory cards in their plastic containers for safe-keeping.

## Mountains

Mountains are miniature ecosystems that contain great contrasts within a relatively small area. In Europe, the flora changes from deciduous forest through tundra to diminutive grasses. In the tropics, rainforests form at the base of mountains before giving way to a barren tundra at their peaks.

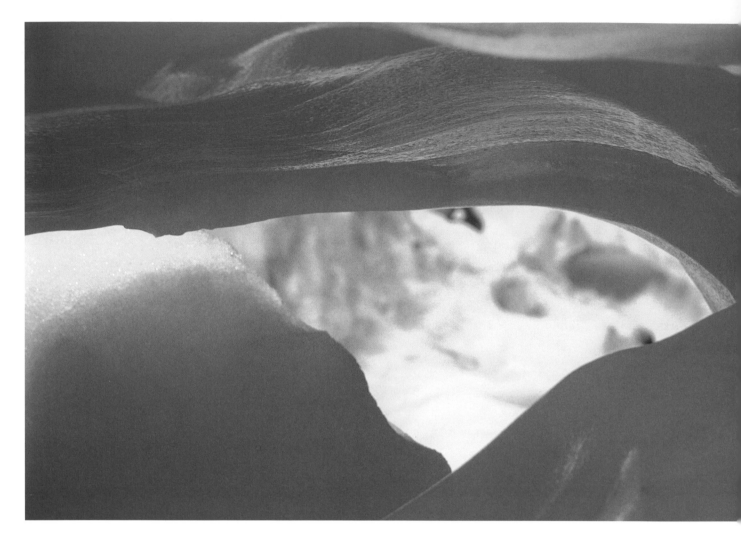

## Working in the field

Complacency is the nature photographer's main enemy in the mountains. Keep weight down to a minimum; the effort of climbing will be enough to contend with on its own. Use a zoom lens with a wide focal length range to minimize lens changes and restrict the number of lenses you need to carry.

Always take plenty of water and high-energy foods with you, as well as a rain jacket, warm winter fleece, sunglasses, hat and gloves, and a detailed map and compass. The weather can change very quickly at high altitude, catching the unprepared photographer by surprise. Always put your own safety and survival before the photograph.

## The Polar regions

The short summer season is the only practical time for photography in Antarctica, when the mountainous icebergs form a floating landscape that is hard to match anywhere else in the world. November is an ideal month for photographing Polar bears in the Arctic, as they migrate through the Canadian town of Churchill, Manitoba. The Arctic is also the place where you are most likely to see the Aurora Borealis (the Northern Lights).

## Photographic techniques

Bright white snow and ice make calculating exposure complex (see page 53). Ice is also one subject that benefits from a slight blue cast, so avoid using 81 series filters when photographing it. Low light can make a photographer's life difficult, so consider using a fast film, such as 400 ISO, or setting a fast ISO-E rating on digital cameras.

Polar bears are one of the most dangerous animals on earth and should always be photographed from a safe distance. Take long telephoto lenses to make the most of any opportunity. The tundra buggies used in Churchill are well off the ground and dictate that shots of close bears are taken from an unnaturally high perspective, which is rarely appealing. Photographing bears from a greater distance reduces the angle for better pictures.

## As cold as ice

The feeling of cold evoked by the blue of the ice perfectly balances with our preconceptions of the Polar regions. This is one occasion when an 81 series 'warm' filter would have been inappropriate.

## CLOTHING

The clothing you wear should be practical and water-resistant. Military surplus stores are a useful source of functional clothing made of tough fabrics in appropriate colours. Patterned camouflage is not essential, but choose colours, such as green, brown, tan or khaki.

Pockets should have zippers rather than Velcro, which is noisy, and you should avoid synthetic fibres that make a noise when they rub together. Natural fibres such as cotton and linen are generally a better option.

Wear clothes in layers so that items can be added or removed easily as you get cooler or warmer. Avoid wearing cotton underwear in hot weather (it takes a long time to dry). A high-quality polar fleece will keep you warm in very cold temperatures, along with a hat and gloves. You may need to remove the gloves when accessing the shutter release control, but they'll stop your fingers from going numb during long periods of inactivity.

When photographing in very wet environments, such as in rivers or wetland areas, rubber boots will provide the best protection. Alternatively, a pair of sturdy hiking boots lined with GORE-TEX® or similar materials will keep your feet dry without causing excessive perspiration. For safety, choose footwear with VIBRAM® soles. These stick to most surfaces, reducing the risk of falls.

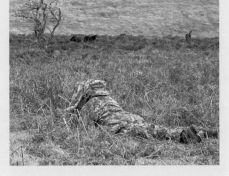

▲ **Camouflage yourself**
When working with some species of wildlife, camouflaged clothing will help you blend in with your surroundings.

▼ **Camouflage everything!**

For the ultimate in camouflage, patterned material is available to cover both your tripod and your lenses. Remember, however, that for some animals sound and smell are their primary senses and all the camouflage clothing in the world won't help if you ignore how you smell and the noise you make.

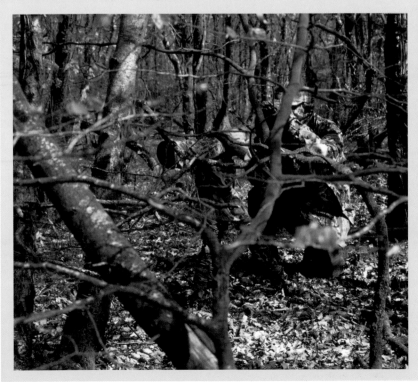

## ▌Working in the field

The extreme nature of the Arctic and Antarctic regions makes using professional-standard equipment essential. Even then, this must be prepared with expert knowledge to prevent lubricants used in lenses, in particular, from freezing. Zoom lenses should be avoided as they contain more of this lubricant than prime lenses, making them more liable to failure.

Use lithium-type AA batteries, which are more resistant to cold than other types, or, better still, use an external battery pack kept within your clothing. Always take a fully manual camera as a back-up. Keep film insulated whenever possible, as the extreme cold will cause it to become brittle.

When transferring cameras and lenses between indoor locations (tents or igloos) and the cold outdoors, allow the temperature of the two environments to equilibrate before exposing equipment, or frost will quickly form.

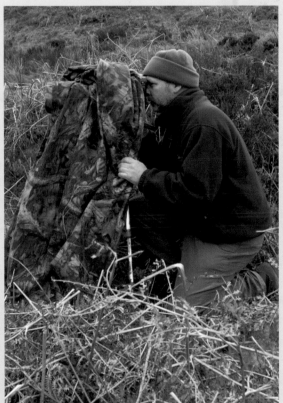

▲ **Wrap up**
When photographing in the field, take a warm hat and fleece jacket to keep you warm. When on the move, a pair of gloves is a sensible addition, although they can make operating a camera fiddly and are best removed when photographing.

# Photographing wildlife

Photographing wildlife is an activity that requires a lot of preparation, patience, time and commitment before you get to the point of pressing the shutter. You should learn about the behaviour of the animal that you hope to photograph so you can seize the moment and grab compelling pictures once you are out in the field. If you are serious about capturing images of a certain species, you may need to set up a blind and lure animals into the area. Learning remote-controlled camera techniques and capturing animal movement are some of the other specialist techniques that you may need to master if you are to achieve any success in this area of photography.

## Understanding animal behaviour

The importance of understanding animal behaviour and the ability to read an animal's body language cannot be underestimated. The best wildlife photographs depend on the photographer's ability to anticipate the moment and be prepared for any eventuality.

Almost all animals act far faster than we are able to react – it is paramount to their survival. If you are dependent on following the action because your instincts allow no alternative, the likelihood is that your subject will have been

**Time and patience**
Successful wildlife photography requires time and patience. This image of migrating wildebeest may look random, but it was perfectly timed to ensure the perfect positioning of each animal within the frame.

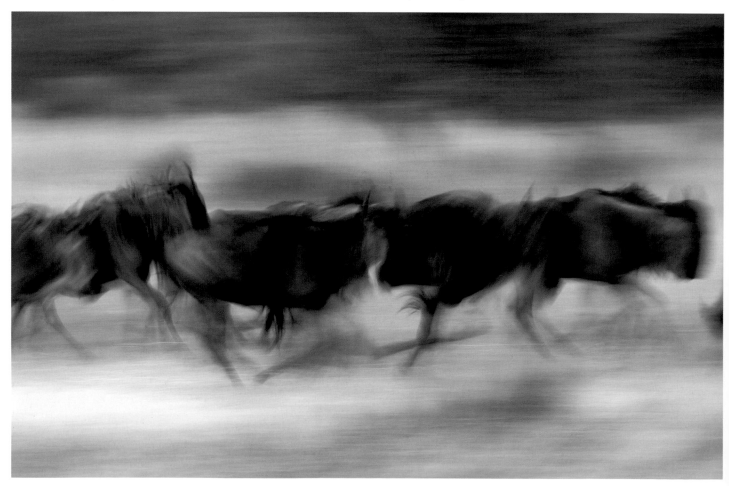

**Reading body language**
A bear standing on its hind legs is not an indication of an impending charge – merely the bear trying to get a better sense of its surroundings.

Take the following examples:

- A bird on a perch that flutters its wings and then defecates is about to fly away.

- The position of an elephant's trunk can tell you how much danger you're in: ears flapping and trunk thrust forward is a threatening pose, while the trunk in teapot-spout position indicates a mock charge. If the trunk is held tightly against the body, when the elephant charges it isn't going to stop and you're in serious trouble.

- A bear standing on its hind legs is usually just getting a better view of its surroundings and sniffing for danger, but quickly stamping its front paws on the ground is the initiation of a charge.

In addition to maintaining your own safety, the ability to read the signs that all animals communicate is how professional wildlife photographers manage to capture great action shots regularly and consistently.

## Tracking and stalking

For many species of wildlife, the only way to get close enough to take good pictures is by effective tracking and stalking. Before starting out, consider what equipment you're going to need and how it will affect your chances of success. Army-size backpacks and big, heavy lenses only impede you and make it harder to obscure your presence. Take only essential gear into the field; if light levels allow, opt for the lighter and smaller slow lenses, such as the 300mm f/4 that is often a fraction of the size and weight of the 1-stop faster f/2.8 version of the same focal length. Optically stabilized lenses (see page 28) will

and gone long before you press the shutter even half-way.

Facts about animal behaviour can be found in many places. The Internet is a valuable source of material, and there are also many useful and well-researched books on the subject. Better still, talk to wildlife experts and biologists who specialize in the species that you want to photograph. Their knowledge can prove invaluable in obtaining the shot.

Always be prepared to spend time in the field. Hike your local area and keep an eye out for clues to animal presence, such as paw prints, torn ground and fresh spore. Take a field guide to help you with identification and a pair of binoculars. There is nothing better than first-hand experience and personal field observation for building your knowledge of a species and its habitat.

## Reading animal body language

All animals communicate. They tell us how they are feeling and what they are about to do in any given situation. Your ability to interpret their language will determine whether you can translate their messages into pictures.

**▶ Tracking and stalking**
Some animals are expert stalkers, such as this wily coyote. You need to master the art of field craft and hone your own skills of tracking if you expect to beat the professionals at their own tricks.

## THE NATURE PHOTOGRAPHERS' CODE OF ETHICS

Many professionals and associations in the environmental and conservation fields regard wildlife photographers with some mistrust. Such feelings are well founded. There are notorious incidents of photographers – professionals included – destroying sites to ensure exclusivity of photographs, and of using live bait to capture unique images. Through ignorance more often than malice, protective vegetation is cut down, leaving nest sites exposed to predators, and adult birds are disturbed near the nest, causing them to abandon their young. Dens are intruded on, loose talk reveals the location of endangered species to those with malicious intent, and animals are chased and cornered by vehicles. Such acts undermine our reasons for taking photographs of wildlife and make photographers unwelcome in some places. No animal should suffer distress in the pursuit of photography. Admittedly, on occasions it is impossible to tell how an animal

### Avoiding distress

No animal should be put in the position of feeling undue stress in order that its photograph can be taken. Many parks in Africa are now limiting access to tourist vehicles to avoid the types of scenes witnessed here.

will interpret our actions, but a knowledgeable photographer learns to recognize the signs of distress and is the first to back away from a confrontation – one of the important factors in learning about fieldcraft.

Many countries have laws that define the rules by which we take photographs of nature and wildlife. For example, in the UK, it is unlawful to photograph certain bird species at or near their nest without an appropriate licence. Wildlife laws are many and varied and subject to continual change – so much so that it would be impossible for me to recount them all here. It is the responsibility of the photographer to ensure that he or she is conversant with, and respectful of, the environmental laws of the country in which he or she is photographing. You can obtain information from government embassies or consulates or by contacting the government ministry in charge of wildlife and environmental affairs in that country.

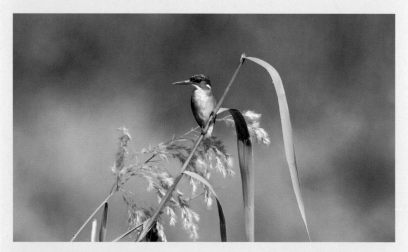

### Photography and the law

In some regions, it is necessary to have a licence to photograph certain species. This kingfisher was photographed freely in South Africa, but would have required a permit in the UK.

aid handholding the camera, while a monopod can be an effective alternative to a tripod, which can prove unwieldy to carry silently through rough terrain.

Use trees and bushes for cover when you are stalking an animal in underbrush. However, be aware that most animals possess senses far more acute than our own and will hear or smell you long before they see you. You must move noiselessly, avoiding the crackle of dead leaves, the rustling of foliage and the snapping of twigs. When making an approach, assess all possible routes for the one most hidden and that offers the least resistance. Avoid wearing perfumes or scent, carry no food and don't smoke. If possible, rub yourself in the earth and smells of the terrain you're in and always approach from downwind, even if that means making a long and arduous detour.

In open terrain, when the subject is likely to see your approach, you will need to use alternative tactics. Minimize the animal's perception of the threat you pose by approaching indirectly and showing no interest in the subject by avoiding eye contact. Wearing clothing of natural colours or with a camouflage pattern will also help.

You will need a lot of patience and should be prepared to fail. I once spent three hours on my belly covering a distance of 100m (300ft) to photograph crocodiles at a pan in South Africa. When I began my approach, there were 18 crocodiles sunning themselves on the riverbank. As I edged closer, one by one they slipped into the water and sank out of sight. By the time I was close enough to take a picture, only one remained. Thankfully, I managed several minutes of productive shooting.

## The circle of fear

Around every animal exists a circle of fear – an imaginary line that, once crossed, causes the animal to flight. The extent of this circle depends on several factors, including available cover, access to escape routes, the season and the animal's own temperament. Some birds, such as ducks, egrets and spoonbills, are easily approached, particularly when feeding. Herons and cranes, on the other hand, are far more wary, and have a circle of fear of several hundred meters.

The circle of fear can also be affected by season. For example, the Brown bears in Katmai National Park, Alaska, are quite approachable during the summer salmon run in June and July, but are far less accommodating immediately after hibernation in the spring.

## ▼ ▶ The circle of fear

Around every animal there exists a circle of fear – an imaginary line that, once crossed, can cause an animal to flight or fight. It is a wise wildlife photographer who learns to interpret the signs given by animals and to know when to back away and when to stay. Getting it right can mean producing startling images. Getting it wrong can put your safety and that of the subject at risk.

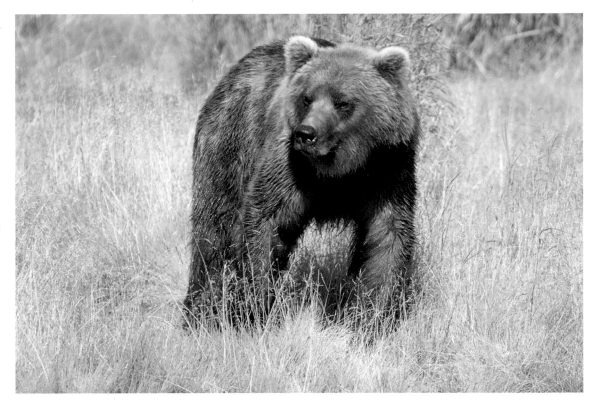

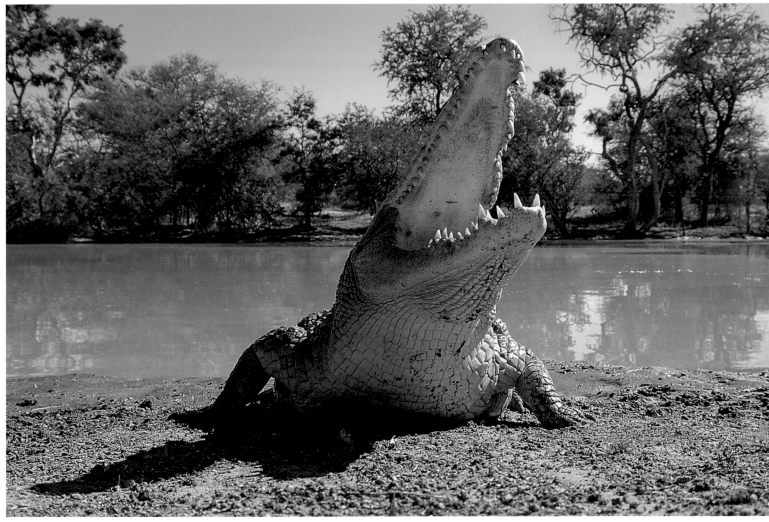

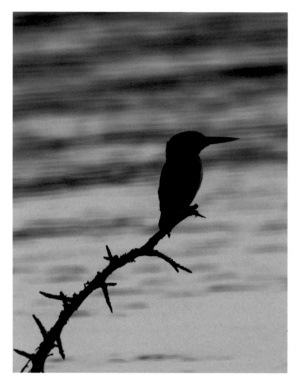

▲ **Using blinds**

Blinds are ideal for photographing shy or elusive wildlife species, such as this Malachite kingfisher, which I photographed from a static hide in South Africa's Kruger National Park.

# Using blinds

Before you set up a photographic blind (or hide) you should scout a location, looking for signs of animal activity such as fresh tracks and spore. Once you have identified a suitable location, assess all the potential lighting conditions for various times of the day. In particular, consider the position of the sun at sunrise and sunset so that you site the blind in the best spot for taking well-lit photographs.

Animals and birds are very wary of new additions to their environment, particularly territorial species. When first setting a blind, you will need to position it some distance from its ultimate position, moving it closer gradually every few days. Doing this gives resident creatures the chance to become accustomed to the blind's presence and settle before you start photography.

## Static blinds

Static blinds should be built using a solid frame, with the roof and walls being covered in a light waterproof canvas. Avoid using synthetic

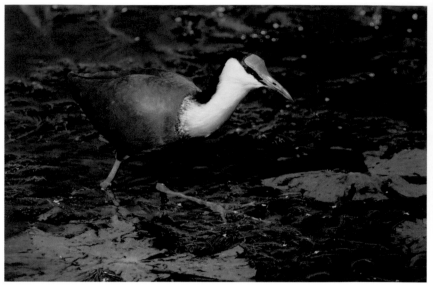

materials, which are noisy and prevent moisture from evaporating. If you intend to use the blind for extended periods, build it so you can stretch out without drawing attention to yourself. When everything is ready, you can move in. Arrive early, before animals and birds become active.

For many creatures, you will need the help of a friend or family member who can enter the blind with you and then leave immediately. This will ensure that any creature that notices the activity around the blind will assume it to be empty once the second person has retreated and the site becomes still. However, it's worth noting that with some birds, such as raptors and members of the crow family, you may need the help of three or four people to fool them.

Once in position, prepare your equipment quietly and make accessible any spare gear and accessories. Film should be removed from boxes and left in the protective plastic film

▲ **Getting close**

Used properly, blinds make it possible to get closer to many wildlife species than would otherwise be possible. I spent a couple of hours with this African jacana without it ever becoming aware of my presence.

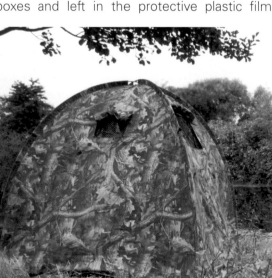

◄ **Camhide**

For some wildlife subjects, blinds (hides) provide an ideal cover, allowing you to photograph without disturbing the subject.

## PHOTOGRAPHING BIRDS

Photographing birds is a rewarding pursuit because, no matter where in the world you are, you have a rich choice of subjects engaged in a wide variety of photogenic activities.

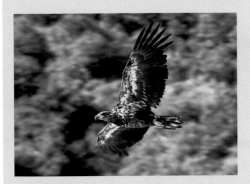

**▲ Eagle**

A juvenile eagle soars in the high country of the Katmai National Park, Alaska.

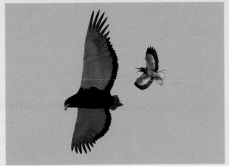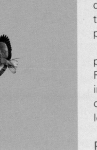

**▲ Bateleur eagle and lilac-breasted roller**

I was lucky enough to witness this territorial dispute between a Bateleur eagle and a distressed Lilac-breasted roller in Serengeti National Park. Quick reactions and an excellent AF system ensured I got the shot.

### Photographing birds in flight

One of the main challenges you face when photographing birds in flight is the relative size of the subject in the viewfinder. Small birds, such as swallows and finches, that can turn rapidly at high speed, require long, fast telephoto lenses and highly accurate and responsive AF systems with multiple AF target sensors. These are often found only in more expensive SLR cameras. Life becomes a little easier with some of the larger species, such as the bigger birds of prey, cranes and herons, because they fill a larger portion of the picture space.

In either case, it is a distinct advantage to be able to predict the flight path of the bird. Mostly this can be very difficult. However, during the breeding season, birds tend to follow a consistent route between their feeding areas and the nest. A few hours of careful observation will help you to detect any patterns and predict the shot.

AF may prove unpredictable in some cases. If so, the predictive focus technique may provide a worthy alternative. Attach the camera to a tripod and set the focus mode to manual. Focus on a point along the line of travel – perhaps just before the nest site. Start taking images as the bird approaches the predetermined point and expose several shots with the camera in continuous frame advance mode. If the shutter speed allows, gain some focusing leeway by selecting a small aperture to increase depth of field.

### Photographing birds at the nest

Warning: refrain from photographing birds at the nest until you are fully experienced in camera techniques and aware of the environmental issues. Nesting is a precarious and stressful time for birds and the slightest provocation can result in adults abandoning unhatched eggs or young chicks. In some parts of the world, including the UK, photographing many species of bird at the nest requires a licence from the appropriate authority (see page 136 for contact information). This system was implemented to protect threatened species from the sometimes over-eager attention of inexperienced photographers.

Careful observation of the nest site is essential before any photography takes place. Use a powerful pair of binoculars to make notes on the frequency and timing of the adult birds arriving at the nest and to assess flight patterns. If the adults are on the nest constantly then the eggs haven't yet hatched and you should withdraw until a later time.

Open nests reduce technical and photographic complications, although you may find foliage blocking your view. Whatever the temptation under these circumstances, never cut away or permanently remove branches or foliage. They are there for a reason: to protect the nest from predators.

A less obtrusive method of photographing birds at the nest is to set up a remote camera. This should be done only when the adults are absent and preferably at a suitable distance so that the camera doesn't scare them on their return. With an appropriate infrared remote-control device the shutter can be activated from a significant distance away.

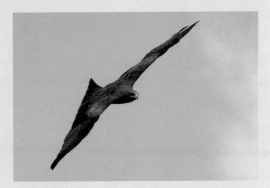

**▲ Red kite**

Red kites are now returning to the UK in healthy numbers and several birds can be found in mid-Wales and central England.

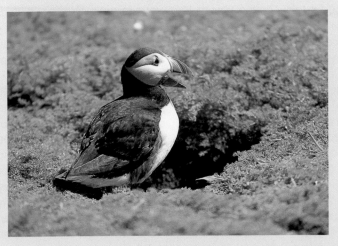

**◀ Nesting puffins**

Puffins make particularly photogenic subjects and can be found easily in certain regions of the world. This image was taken on Skomer Island off the coast of Wales.

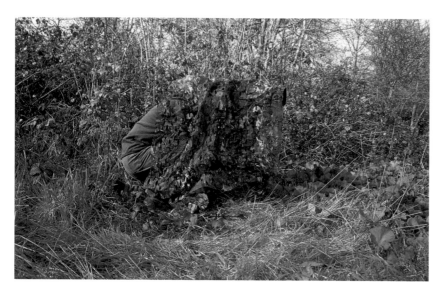

**Mobile blinds**
When photographing animals that are constantly on the move a mobile blind may make a better alternative than a static version.

tubs. If you plan on using a long telephoto lens, keep handy a second camera body with a zoom lens in the range of 28 to 135mm in case any picture opportunities arise closer to the blind than expected.

Take plenty of water, nourishing food (kept in a plastic bag to hide any smell), a blanket and an empty bottle (to relieve yourself without marking your 'territory' outside). A good field guide and binoculars will help when identifying species.

When you are exiting the blind, do so with the same care that you entered it to avoid ruining any chance of using the blind again.

## Mobile blinds

Mobile blinds make it easier to photograph animals that are continuously on the move. A good mobile blind will have no floor and a rigid tubular skeleton to which your camera can be mounted to make moving on the go a practical option. They should have plenty of pocket space for keeping film and accessories. Try to relocate the blind noiselessly and only when the area is devoid of subjects. Used intelligently, mobile blinds are more flexible than static blinds, enabling you to cover large areas of ground with greater success than you can expect when stalking in the open.

## Buried and elevated blinds

Buried blinds, consisting of a hole large enough to lie in and covered with a natural-coloured waterproof canvas secured with tent pegs, can be used to photograph animals in open ground, but require a lot of effort to build.

Entering and leaving the buried blind must be done just as stealthily as for any other blind, and photographic equipment will need protecting from dust and dirt, which often is more preva-

lent at ground level. If the weather is rainy, slightly raise the cover in the middle using a tent pole or wooden stake to allow rainwater to drain away. When you leave the blind, you must always warn of its existence by cordoning it off with tape or cones.

Elevated blinds can be difficult and costly to erect; they often necessitate the use of builders' scaffolding in order to create a collapsible tower. If you have the knowledge, time and inclination, however, they are an ideal means of photographing species at high level, such as nesting birds and primates.

It is essential that you seek expert advice on assembling scaffolding, particularly given the litigious nature of modern society. For safety, when using an elevated blind, you should secure yourself with a safety harness. Otherwise, the same advice applies as for using other forms of blind.

## Floating blinds

To photograph wading birds and waterfowl, as well as some species of mammal (if you're lucky), a floating blind enables you to get closer than would normally be possible. This is the best method for photographing courtship displays and nest building during the mating season.

To build a floating blind, you need to find a buoyant base structure and cover it with a camouflaged canvas stretched over a framework. Holes must be cut in the sides for the camera, with camouflage netting used to obscure the protruding lens.

The photographer then stands or kneels (depending on the depth of the water) under the blind. Safety is very important and the base structure should cover an area large enough to ensure stability. When moving with the floating blind, tread carefully over the waterbed, keeping an eye open for large rocks or dips that may cause you to lose your footing. When it's cold, wear suitable clothing, such as a wet suit or dry suit, to protect you from hypothermia. If you plan to be in the blind for any length of time, remember to carry food and water.

Stow equipment safely in sealed dry boxes that are kept in pockets on the inside of the canvas. To avoid the problem of camera shake, use a tripod head mounted on the frame of the blind or a beanbag. Buried, elevated and floating blinds are all specialist structures used for particular subjects or types of photograph. They are used infrequently in general photography and require a lot of planning and expert advice. It is perhaps better to try to adapt simpler hides and techniques to suit your environment.

## Attracting animals to a blind

All animals are attracted by food. Scattering a few sunflower seeds, suet or overripe fruit around the site will be sufficient to attract passing birds, particularly in winter when food is often scarce. It is imperative that you continue feeding throughout the winter, even after you've finished taking pictures, as birds and animals will have become dependent on the food with which you have lured them.

To attract mammals to your site, you will need to identify their feeding habits. Most badgers, for example, are particularly fond of peanuts, while salt licks will attract herbivores, such as deer and Bighorn sheep.

If you want to attract carnivorous creatures to your site, you will face a new set of complications. Most species are territorial, and blinds must be sited within the territory to be effective. Identifying the extent and make-up of a territory can be time-consuming and may involve the help of local experts.

Food lures can be successful at attracting carnivores, but be prepared for food to be devoured as soon as you leave the site. In some instances, it may be necessary for you to secure the bait with some form of tie to avoid it being dragged into nearby bushes and therefore out of sight. You need to be patient and continue the feeding process until the animal comes to recognize the site as a safe and productive food source for it.

As with any animal that you habituate to food, you must continue to provide food until natural resources become readily available, which is usually in springtime. To do otherwise is likely to put the animal's life in peril.

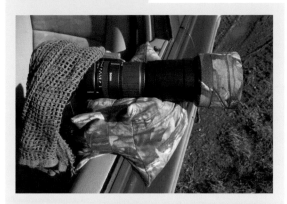

**VEHICLES AS BLINDS**

### Using a car as a blind

Used wisely a car makes an ideal hide. The colour of the car matters little but try to minimize any movement within so as not to scare the subject.

Cars are ideal temporary blinds. They are particularly effective when used in areas such as National Parks, where animals are used to seeing them. In an ideal scenario, scout locations in advance and, once a suitable site has been identified, arrive and park early, before the subject. Use camouflage netting to cover the windows and to obscure any movement inside the vehicle.

Beanbags provide an ideal support for the camera, absorbing small vibrations and allowing great flexibility of movement. There are several tripod-like gadgets available on the market that attach to the door frame with the window open, but I have yet to find one that does a better job than a beanbag.

A beanbag should be secured to the vehicle with a strong cord so that if it is accidentally knocked and falls it can be easily retrieved without disturbing any wildlife present.

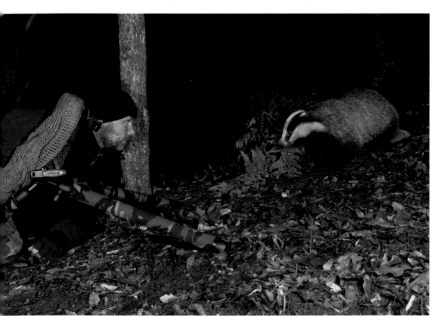

## Lures

Lures can be an effective means of attracting birds during the mating season, but they must be used carefully and with due consideration to the safety of your subject. Decoys used on a pond or lake encourage members of the same species to land there. However, acoustic lures should be avoided, as they can upset the local ecosystem by disturbing nesting birds, encouraging overly aggressive behaviour in neighbouring male birds, and attracting predators to the area.

◀ **Attracting animals to a site**
Most animals are attracted by food and careful and patient effort at the beginning of the shoot can ensure that your subject comes to recognize the site as a safe and productive source of nutrition. Once this is established, it will hopefully become a frequent visitor.

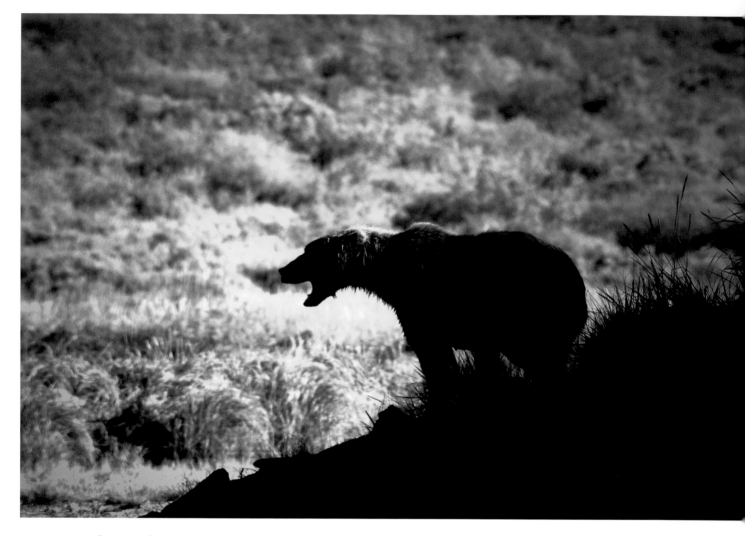

# General techniques for photographing wildlife

You can exploit various techniques for capturing images of wildlife subjects. Don't just go for the standard shots: telephoto lenses might be considered the usual lens of choice, for example, but don't neglect wide-angle lenses either. Visual and emotional impact should always be your goal, no matter how that is achieved.

## Determining the point of focus

The most important part of any wildlife subject to keep sharp is the eye. Humans are visual creatures; our primary sense is vision. When we look at another living being, we immediately look to the eye as our first point of communication. If the eye is obscured or unsharp, we lose an important orientation reference.

When aligning the AF sensors in the viewfinder, try to ensure that the active sensor covers the nearest eye. If the subject is moving,

select continuous AF mode (see page 27) or any focus-tracking function on the camera so that the camera adjusts the point of focus to match the movement of the subject.

The second most important feature to keep sharp is the nose. Often with wildlife subjects, the eyes and nose are at different focal distances. This means it can be a challenge to get both features sharp, particularly when using long telephoto lenses, as these reduce depth of field.

Although other factors affect depth of field, from experience I have found that, for most species, setting an aperture around 2 stops closed from maximum (e.g. if the maximum aperture of the lens is f/2.8 then set an aperture of f/5.6) provides enough depth of field to keep both the eyes and nose within the zone of acceptable sharpness. For subjects that have particularly long noses, such as zebras and crocodiles, you need to increase depth of field to keep both points sharp.

This advice is somewhat subjective and you will need to take into account all the factors that

▲ **Wildlife techniques**
Learn to experiment with your wildlife photography. Avoid the obvious and try out new techniques. Not every experiment will be successful, but you'll be pleasantly surprised by those that are.

▶ **Changing perspective**
Using a wide-angle lens when photographing wildlife may not be your first thought, but the wider angle of view creates an interesting perspective.

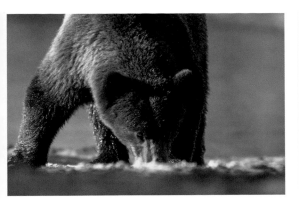

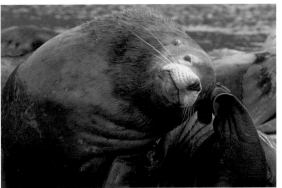

◀ **Point of focus**
There is only one point of focus, and for wildlife subjects it must nearly always be centred on the eye.

▲ **Narrow depth of field**
Because I wanted to emphasize the behaviour of this bear searching for clams, I set a wide aperture to minimize depth of field. The blurred foreground and background isolate the bear in the picture space.

affect the depth of field for any given image. If the conditions make it impossible for both features to be sharp and you have to compromise, then focus on the eye.

## Using depth of field creatively

How you manage depth of field in wildlife photography determines the emphasis of the image. A narrow depth of field, where foreground and background detail is blurred, isolates the subject from its surroundings, placing the accent on the animal. Increasing depth of field to render close and distant objects sharp makes the habitat become an integral part of the image, thereby creating a greater sense of place.

In this way, depth of field can be used to shift the viewer's attention to those elements within the picture space that you deem important and to exclude other elements that may conflict with the message you are trying to convey.

## Using wide-angle lenses

Just as wide-angle lenses are synonymous with landscape photography, so telephoto lenses are generally considered the norm for wildlife photography. However, wide-angle lenses should not be excluded from the wildlife photographers' arsenal.

Using the techniques described on page 100 to get within an animal's circle of fear opens opportunities for using short focal length lenses to completely alter your perspective: you can create a frame-filling image of the subject with a landscape vision of its environment. Such images have the power to shock and astound as they provide glimpses of nature that few will ever witness.

▼ **Wide-angle lenses**
A wide-angle lens will produce an interesting perspective on wildlife. Here, I used a 28mm lens to emphasize the elephant's trunk and tusks.

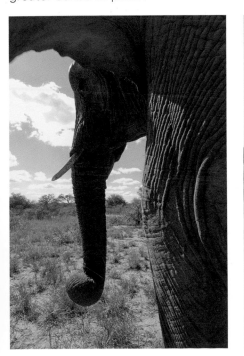

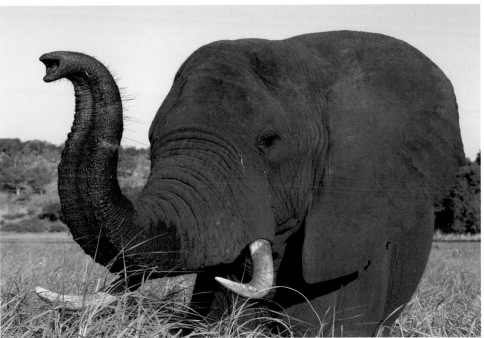

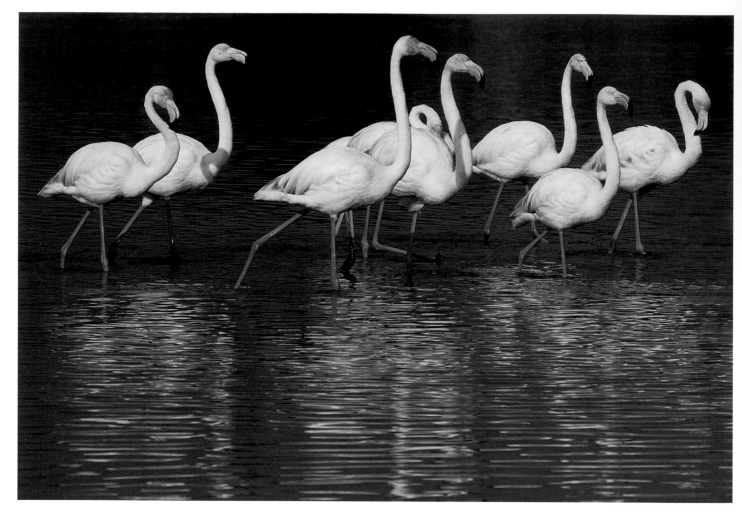

## Using super-telephoto lenses

When using super-telephoto lenses, you are confronted by two challenges, both of which can result in 'soft' images and blur caused by camera shake.

Super-telephoto lenses tend to be large, heavy and unwieldy. Without proper support they can easily move during exposure, and the extreme nature of the magnification power ensures that even the slightest movement is exaggerated in the resulting image.

When using these large lenses, the ideal form of support is a tripod with a gymbal-style tripod head (see page 30). I have even known photographers to use two tripods, one to support the camera body and another to support the lens. Some tripod manufacturers offer an optional 'fourth arm' that serves a similar purpose.

If you are using a beanbag with a very long lens, it is best to do so in conjunction with a wide base to support the bag and a second beanbag placed on top of the lens to help to reduce movement and vibrations.

Whenever possible, always fire the shutter using a remote cord or infrared remote control.

▲ **Telephoto lenses**
When shooting distant subjects it is necessary to use a long telephoto lens in order to reduce the angle of view, making the subject(s) appear closer than they are in reality.

◀ **Using telephoto lenses**
There is an art to using super-telephoto lenses successfully. When shooting from a vehicle, a beanbag makes an ideal support, so long as everyone in the vehicle remains perfectly still.

◀ **Handholding telephotos**
Most telephotos are too heavy to be handheld successfully. Some recent models have optical stabilization built in.

# Action photography techniques for wildlife

Capturing animal action is one of the toughest photographic techniques to master, but it is also one of the most rewarding. We tend to think of wildlife as being unpredictable when in fact the opposite is often true. Herds of elephants, for example, follow well-trodden tracks for many years across the grasslands and savannahs of Africa. And a satellite view of the territory occupied by a wolf pack would reveal a network of 'roads' not dissimilar to those that humans build.

## Capturing erratic movement

Animals are typically very predictable in their behaviour. However, their movement can be erratic and it is this lack of a predictable course that can be hard to photograph. Erratic movement means that anticipating the point of focus is practically impossible. However, with modern AF technology, the camera can help significantly.

Set the camera to continuous AF, which engages AF tracking. With AF tracking on, as the animal crosses from one AF sensor to the next, the AF system quickly adjusts the focus distance to keep the subject in focus. It is important to select the most appropriate origination AF sensor to attain focus in the first instance. While the camera worries about focusing, it is the photographer's job to keep the subject within the picture space.

When photographing erratic movement, try to avoid cropping too tightly in-camera. Use a focal length that provides some space within the frame of the viewfinder into which the subject can move. This minimizes the likelihood of accidentally cropping heads, feet or tails. You will find that using a monopod or hand-holding the camera makes it easier to capture erratic movement.

To freeze the movement of the subject, set a fast shutter speed and select a medium lens aperture, if the levels of illumination allow, to provide greater depth of field. I have found an exposure setting of around 1/250 sec at f/11 or 1/500 sec at f/8 gives good results for many subjects. However, for particularly fast-moving

### a) Auto-tracking
It was hard keeping the eyes the point of focus, as the bears' heads were moving quickly. The shot was made possible by my D2X's auto-tracking.

### b) Continuous AF
To capture these two battling coyotes, I trusted the continuous AF system on my Nikon D2H.

### c) CAF auto-tracking
Some AF systems enable auto-tracking, making shots such as this crocodile pouncing obtainable.

### d) Tracking movement
The actions of this bear were quick but predictable, so I could track the movement within the viewfinder.

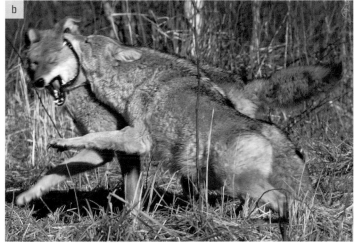

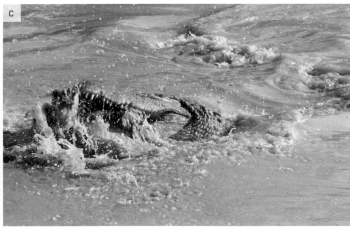

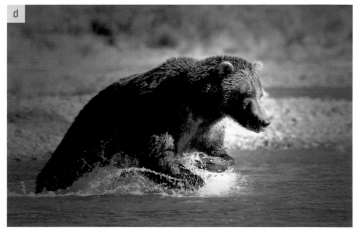

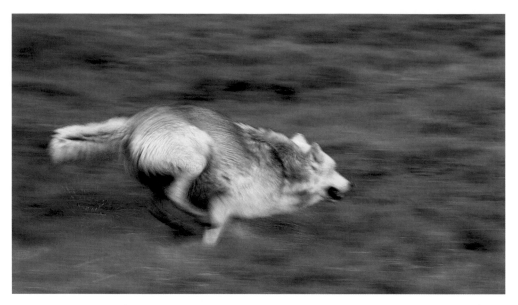

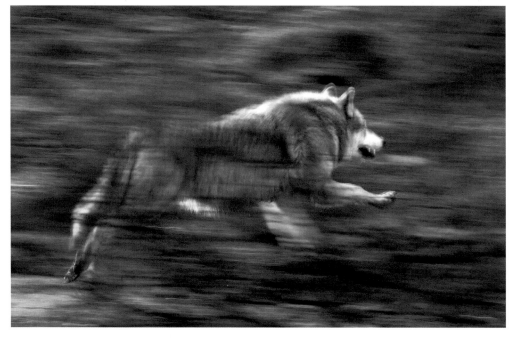

**Sense of motion**

In these images of a wolf running, I used a relatively slow shutter speed to create an element of blur, which gives the photographs a sense of motion. The streaked backgrounds are caused by the horizontal movement of the camera during panning.

a few frames. Once the memory buffer is full, the camera will lock the shutter until there is spare capacity, which can be several seconds. Undoubtedly this will change as new technology comes to market. In the meantime, it's something to be aware of.

Action photography is a skill and, like any skill, it needs practising regularly if it is to be perfected. If no wildlife is immediately accessible to you, then any fast-moving subject, such as pet dogs or cats, or a toddler at play, will be just as challenging. Alternatively, a visit to a local safari park or wildlife sanctuary may provide the right conditions for practice. Initially, don't worry about composition; just attempt to take consistently sharp images. Once you have mastered keeping the subject in focus, think about how to create well-composed action shots.

Predictable action, such as animals using a known track through their habitat or flying between a feeding site and the nest, is easier to photograph because the shot can be anticipated. Closely observing the subject's behaviour will help you to form a strong composition.

## Capturing motion

A carefully composed and well-executed photograph that uses the aesthetic effects of blur to capture the essence of motion is one of the most rewarding challenges of wildlife photography. It is also one of the most difficult to master. There is a difference between intentionally created blur and an image being simply blurred or out of focus, so being in complete control of the camera functions is essential to your success.

Shutter speed is the primary control. It needs to be slow enough to blur the movement of the subject and fast enough that the blur is kept to an acceptable level. The actual speed will vary depending on the subject. For example, a cheetah's legs when running at full speed are likely to appear blurred even at a shutter speed of 1/1000 sec. Conversely, a shutter speed of 1/1000 sec will freeze the appearance of motion of a Giant tortoise.

wildlife, such as cheetah and antelopes, you may need to shoot at speeds in excess of 1/1000 sec. Typically, shutter speed will have priority over lens aperture so, if a compromise is necessary, open up the aperture before sacrificing shutter speed.

A fast auto-frame advance will simplify things. However, be wary of simply pressing the shutter until the film runs out or your memory card reaches full capacity. Some cameras can expose a 36-frame film in just over four seconds and invariably the action will be over by the time you have reloaded the camera.

With digital cameras, it is important to keep an eye on the burst rate. Although some models of D-SLR can expose many tens of frames consecutively, others have a burst rate of just

Of course, these are extremes and most subjects fall somewhere in the middle. Most mammals, for example, run at speeds suitable to setting a shutter speed in the range of 1/20 to 1/40 sec. If the intensity of light is too bright to attain a slow shutter speed, use a neutral density filter to reduce the level of light entering the lens.

Once you have determined the shutter speed, frame the subject in the viewfinder, allowing enough free space around it to give it room to move within the picture space. Cropping too tightly in-camera is liable to cause feet, tails or heads to disappear out of frame.

Follow the animal's line of travel through the viewfinder. With the frame advance mode set to continuous (if your camera has this function), take several shots while panning the camera. Continue to pan the camera for a second or two after you have taken the final shot to avoid any sudden jolts causing camera shake.

The quality of detail in the background can be altered by lens aperture. A wide aperture will give the streaks of movement caused by the camera panning soft edges and the appearance of merging. A smaller aperture gives a more pronounced result, with the streaks having harder, well-defined edges.

## Capturing a sequence of images

A sequence of several images viewed together can reveal many of nature's secrets and the behavioural traits of animals. For the sequence to succeed, each picture must tell its own story while simultaneously merging with the images on either side. In essence, each image acts like a paragraph in a chapter of a book.

It is important that you make good use of your viewfinder for action sequences rather than just pressing the shutter release and holding it down. Without careful thought, you are liable to end up with several uninteresting pictures with little discernible difference between them, and you are also likely to run out of film or capacity at the vital moment.

Watch the action carefully as it unfolds in front of you and be objective about the images you take. Wait until there is a noticeable difference in the scene before firing each new image to maximize the potential of the sequence and avoid wasted frames.

When adopting this technique, you should keep a close eye on your frame count. A professional film SLR will expose a 36-exposure film in roughly four seconds. Slowing down the frames per second (fps) rate to 3fps increases shooting time to about 12 seconds – long

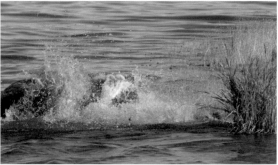

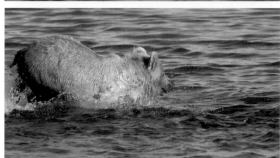

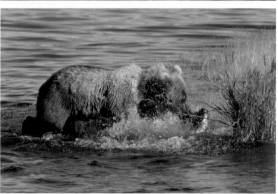

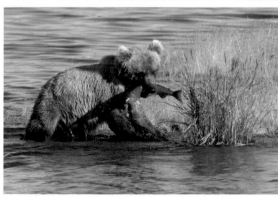

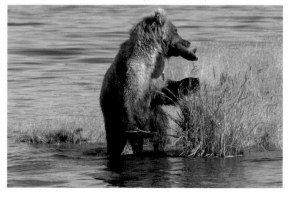

### Photographing sequences

Capturing a successful sequence of images means learning to use your viewfinder effectively, carefully watching the action unfold and deciding on the most appropriate occasions to press the shutter. Simply holding the shutter release down and firing off several shots may work but could also mean missing the important shot if the film ends or the buffer on a digital camera fills at an inopportune time.

◀ **Using fill-in flash with wildlife**

Fill-in flash is useful to lighten areas of shadow. When photographing this Black bear, I was shooting into the sun and used a burst of fill-in flash to keep an even balance between the subject and the background.

protected from inclement weather. Make sure there are enough frames available for the duration of the timed exposures.

## Using fill-in flash with wildlife

With some notable exceptions, gorillas in particular, few animals are bothered by lighting from a flash unit.

Fill-in flash is used predominantly to lighten areas of shadow. The technique is particularly useful when you are photographing animals in bright, harsh sunlight when the quality of illumination will cause dark, unflattering and obtrusive shadows to form, particularly under the eyes and around and under the nose of animals. Hard side lighting can also cause the subject brightness range to extend beyond the latitude of the film/sensor, thereby making exposure complicated.

In both instances, fill-in flash can be used to throw additional light into the shadow areas, bringing out detail and evening the tonal balance. It is important to manage the right balance between natural and artificial light. Not enough fill-flash will be ineffectual, while too much overpowers the ambient light and detracts from your original composition. The correct balance obscures the use of the flash for a natural-looking image.

Modern flash units work in conjunction with the camera's computer to provide accurate exposures and need little if any interference from the photographer. However, as a simple guide, at close distances it is advisable to set a flash compensation value of around half to 2 stops to reduce the flash output. To avoid red- or green-eye (the effect of light reflecting directly off the retina), position the flash unit at an angle of between 30 and 45 degrees.

When photographing in low light, fill-in flash can cause backgrounds to become underexposed, often rendering them black. To avoid this, use the slow-sync flash setting on the camera. This reduces the shutter speed to a level that allows enough ambient light to illuminate the background for a more natural result.

In order to create a natural-looking image when using fill-flash, try positioning the flash unit so that the angle of the flash falls from above the subject. This replicates the effect of low sunlight falling on the subject.

▲ **Fill-in flash**
I photographed this Black bear cub using a small burst of fill-in flash to light the front of the bear, keeping the background lighting within the dynamic range of the sensor.

enough to ensure that you capture a more expressive sequence of images.

A variation on the shot-by-shot technique, which is more suited to static subjects such as nest building, is to use an intervalometer. This is an electronic or mechanical device that controls the timing between exposures, ranging from a few seconds to many hours. Some high-spec digital cameras have a built-in function to achieve the same result.

As it is likely that you won't always be present and the camera will be left in the field, it should be securely mounted on a sturdy support and

# Remote camera techniques

Using remote camera techniques is sometimes the only means of photographing dangerous, shy or vulnerable species successfully. The disadvantage to remote-control photography can be the hit-and-miss nature of the technique and the amount of time required to set up. You need to have scouted the location carefully. This is a time when the advice of field biologists working in the same area can be vital.

## Remote-controlled cameras

When using remote-controlled cameras, the equipment must be set up when the subject is away from the site, and you will need to have predetermined the positioning of the camera or

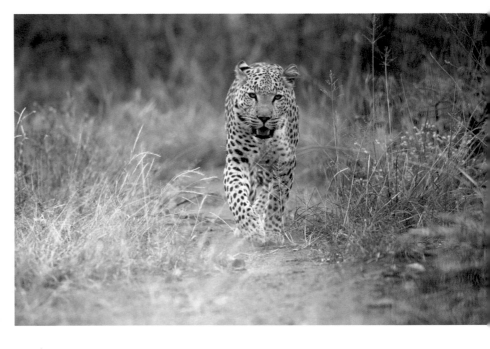

### ▼ Using a remote trigger

For this image of a leaping Mountain lion I set the camera on a rock directly in front of the cat and attached an infrared receiver to the accessory shoe. I fired the shutter with a handheld transmitter from several feet away.

### ▲ Using camera traps

A standard camera trap was used to photograph this leopard advancing towards the camera. An infrared transmitter and receiver were placed opposite each other on either side of the track, triggering the shutter of the camera when the advancing animal broke the connection.

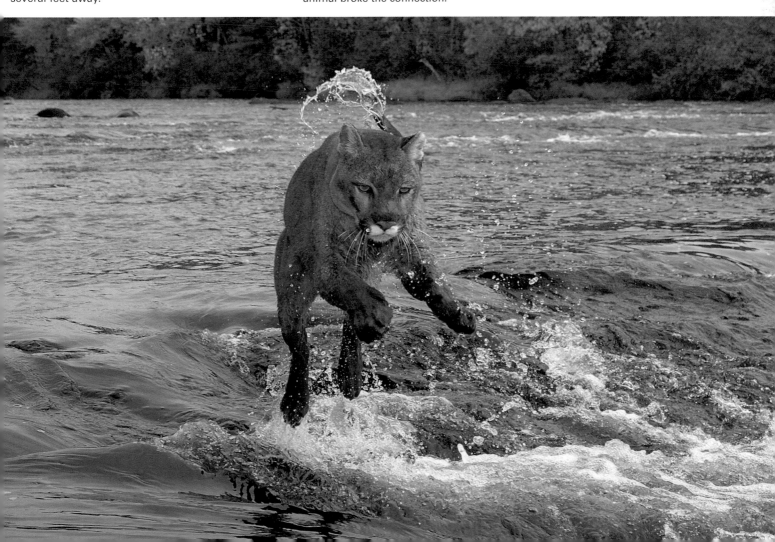

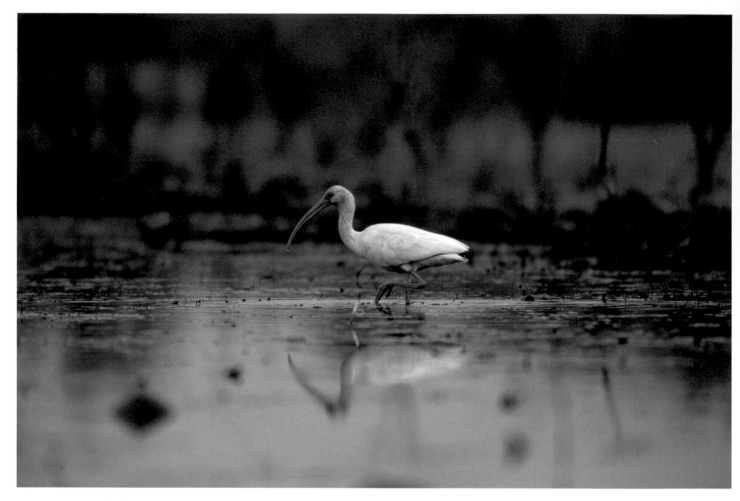

cameras. Typically, the shutter is released either by hand from a remote and hidden location or by a motion-detection trigger, using infrared light or lasers. Some remote set-ups have a monochrome video link so you can view the scene from close to the viewfinder position.

For active remote-control photography (that is, where the photographer activates the shutter), two types of system are typically used. Infrared is the least costly but has a limited range (about 30m/100ft) and is liable to fail if the line of sight between transmitter and receiver is lost. The alternative is to use radio-control, which has a range of around 200m (650ft) with no reliance on line of sight. With an appropriate tripod head, radio-control also makes it possible to alter the camera's position. The downside, of course, is the cost of the equipment, which can be extremely expensive.

## Simple camera traps
Camera traps use motion-detection to activate the shutter. Sophisticated systems are available but can also be set up with an inexpensive infrared remote-control device, such as the ML-3 made by Nikon.

The camera must be positioned where animals are active and their movement predictable, such as along a well-trodden path or close to the entrance of an active den. A transmitter and separate receiver are then sited opposite each other along the line of travel. When the subject passes, it breaks the invisible infrared beam and the shutter is triggered.

Suitably protected, camera traps can be left in place until the complete film roll is exposed or the memory card is full. This makes it well suited for photographing nocturnal creatures, such as leopards and badgers.

However, the system has its limitations. Notably, the photographer has no control over composition other than when initially selecting focal length and camera position. It is also a technique that often requires significant experimentation before a useable image is captured. A digital camera helps speed the process.

Lack of control also means that, although you may be trying to photograph badgers, the detection sensors don't know that and any animal breaking the infrared connection will trigger the shutter. Still, it can be fun finding out which other creatures use the same route.

**Using remote-controlled vehicles**
It is not easy to obtain an eye-level view of wading birds. Here, I used a camera built into a remote-controlled boat and a radio-controlled shutter release to get within range of the bird.

## Remote-controlled vehicles

Remote-controlled vehicles have been used extensively in recent wildlife film-making, with dung-cam and plop-cam helping to make the wildlife of Africa famous. Their use is less common in stills photography, partly due to the differences in camera design, as well as cost, and they are cumbersome to transport. However, cameras mounted on remote-controlled vehicles offer a perspective that is rarely captured with a handheld camera.

Although remote-control vehicles are available from most high-street model shops, remote vehicles for carrying cameras should always be purpose-made for the equipment that they are going to carry. It is worth seeking the advice of a model-builder who will be able to help you design a rugged and well-balanced vehicle.

Practically, the wheelbase must be wide enough to avoid the rig tipping over, and four or six wheels (rather than three) will make sure it can cope with most obstacles. Stability and balance are essential and the design must be able to support the load of the camera and lens used. For flexibility, the camera can be mounted on a motorized universal joint that enables movement in all directions. Camera tilt can be controlled using a gyroscope. Both can be controlled by radio wave transmitter.

Remote vehicles need not be limited to dry ground. For example, radio-controlled boats can be used to photograph wildlife on or near water. Extra precautions need to be taken to ensure that water doesn't enter the area of the camera.

### BINOCULARS

When photographing wildlife, it is advisable to carry a pair of binoculars to help with spotting and identifying subjects. For general use, I have found 8 x 32 (8x magnification, 32mm diameter) an ideal balance between quality and portability. However, when working in low light conditions, such as during dawn and dusk, the enhanced light-gathering ability of the more powerful models (e.g. 8 x 40 or even 8 x 56) may prove useful.

To calculate the light-gathering ability of binoculars, divide the diameter of the lens by the magnification. For example, 8 x 32 provides an exit pupil of 4mm (32/8 = 4) while 8 x 40 gives an exit pupil of 5mm (40/8 = 5). The larger the exit pupil, the greater the light-gathering ability of the binocular.

For identifying subjects that are either very small or far away, spotting scopes provide longer and variable focal lengths compared with binoculars.

### Binoculars

You should always carry a good pair of binoculars to aid wildlife spotting.

### Spotting scopes

Spotting scopes are ideal for bird watching but less useful for wildlife photography.

To ensure optimum image quality, ensure that the scope has achromatic optics and, preferably, is fitted with a fluorite lens and/or very low-dispersion glass.

From my experience, a tripod-mounted scope with a diameter of 60mm, having a fixed eyepiece and a magnification factor of between 20x and 30x, will give adequate results for wildlife spotting.

### Wildlife spotting

Most animals are able to detect human presence long before the photographer ever gets close enough for the shot. In the wild, a good-quality pair of binoculars will help you to spot shy and elusive animals.

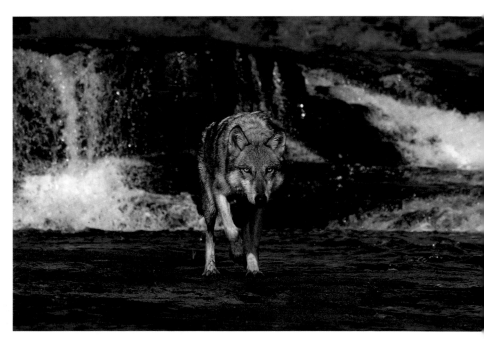

# Close-up and macro photography

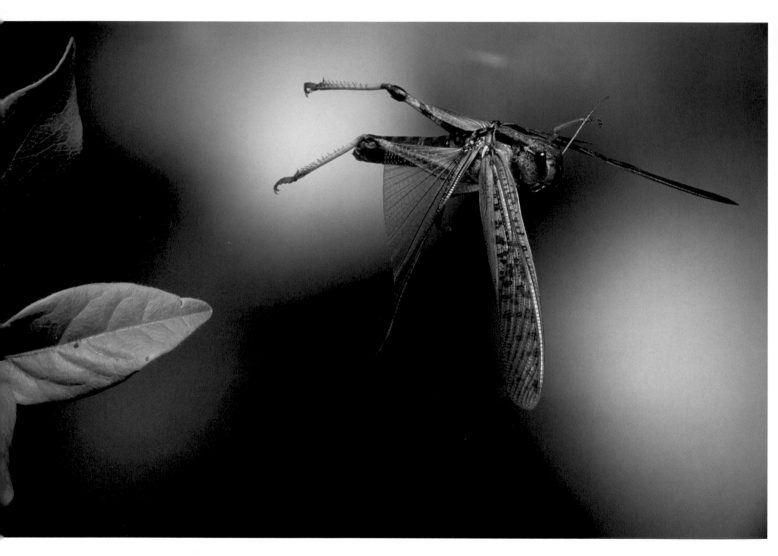

**Up close and personal**
Macro photography provides the opportunity to open new and hidden worlds to the avid photographer. The techniques aren't all easy to master, but the results warrant the effort.

**C**lose-up and macro photography open up whole new worlds to the wildlife and nature photographer. New creative possibilities can be found once you start to look at the fascinating details of the natural world, such as the intricate patterns of petals and the iridescent wings of insects.

Technically speaking, close-up photography refers to images where the reproduction ratio is between 1:20 and 1:1 (life-size). Macro photography strictly covers magnification from life-size (1:1) to around 25x. Beyond that, we enter the realms of photomicrography and the

microscope. Whatever the technical definition, however, in nature close-up and macro photography are generally concerned with making small things big.

Reproduction ratio refers to the relative magnification of the subject. For example, a caterpillar 30mm (1in) long that is reproduced at 15mm (½in) length on film/sensor is said to have a reproduction ratio of 1:2 (half life-size). When reproduced on film/sensor at 30mm (1in) (i.e. life-size) the reproduction ratio is 1:1. The reproduction ratio relates solely to film/sensor and not to prints made from the original.

# factors for close-up and macro

Most camera systems and formats have accessories for macro and close-up photography, although by far the most versatile for fieldwork are 35mm SLR and 35mm-type D-SLR systems. The main equipment needs that you will have to consider are specialist macro lenses and flash lighting, both of which are discussed in detail below. Otherwise, focus and depth of field are the main issues you will have to tackle in this type of photography.

## Autofocus

Although it is difficult to find a modern camera without autofocus, AF is not essential for close-up work and, indeed, can often be a hindrance as it is liable to switch into 'hunt' mode at the slightest movement of the subject. TTL metering, on the other hand, can be invaluable as it takes into account any extenders used or modifications made to lenses.

## Depth of field

One of the main challenges of close-up and macro is that depth of field at such close distances and high reproduction ratios becomes very narrow, measuring mere millimetres. Often, almost any part of the subject that isn't parallel to the film plane falls outside

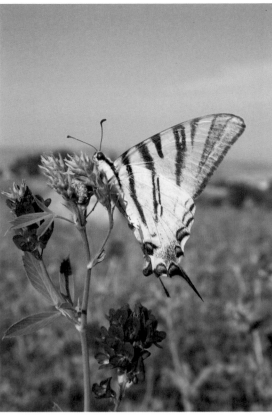

of the zone of acceptable sharpness, which is nearly always the case when photographing a three-dimensional subject. Manoeuvring the camera into a suitable position can be quite a task, if not impossible. This often means having to decide which part of the subject is the most

**Depth of field**

Managing depth of field is one of the more challenging techniques required of the macro photographer. At such close distances and high levels of magnification, depth of field can be minimal even with very narrow apertures set.

The following simple steps outline the process for running the tests mentioned above:

1 _ Set your camera on a tripod, or other secure support, with the flash unit attached and angled at around 45 degrees to the subject.

2 _ Make a set of exposures at f/8, f/11, f/16 and f/22. These will form your base exposures.

3 _ Examine the images. If they are all too bright, move the flash further away, maintaining the angle at 45 degrees. If they are all too dark, move the flash unit closer, again maintaining the 45-degree angle.

By trial and error, identify the best exposure at f/16, making a note of the flash-to-subject distance, with the flash angled at 45 degrees. This will form your standard shooting position with flash.

With the flash unit at around 45 degrees to the subject, the light will fall on the surface at an acute angle, causing tiny shadows to form. These shadows will accentuate detail and texture and add to the overall impression of sharpness.

important to the composition and focusing on that point.

This means that a depth of field preview monitor (see page 62) will be an important feature of any camera used for macro work.

Similarly, because such high levels of magnification exacerbate and highlight even the slightest camera movement, a mirror lock-up facility to reduce the tiny vibrations caused by the movement of the reflex mirror to expose the shutter is ideal.

## Wind and camera movement

The limited depth of field you have to work with makes any subject movement or camera movement critical. Even the slightest breeze can blow a leaf or a flower, for example, away from the point of focus and render it blurred. To minimize the effects of this movement, always use a tripod (the multi-movement style of tripod, such as those from Benbo, are ideal) and shield your subject using a windbreak.

## Light levels

Narrow apertures to maintain depth of field and fast shutter speeds to reduce the effects of movement combine to limit the amount of light reaching the film/sensor, which causes problems of its own. Often one must be sacrificed for the other, particularly if slow film or slow ISO-E ratings are required to maintain image quality. Sometimes, the only solution is to use flash.

## Close-up photography in natural light

Many of the considerations relating to light discussed earlier (pages 40–44) apply equally well to macro and close-up photography. The quality, direction and colour of natural daylight will all affect how your pictures appear and will either enhance or detract from the overall composition.

For most close-up subjects, hazy, diffused light is ideal, with the lower levels of contrast helping to retain detail in highlights and shadows. At mid-morning, when the sun is at an angle of around 45 degrees, the direction of the light helps to create shadows on textured surfaces that will add form. However, if the light is too direct, you may find the shadows overly harsh and you are better off waiting until the sun disappears behind a cloud or utilizing a reflector.

# macro lenses

Most manufacturers, including independent manufacturers, produce one or more macro lenses that enable reproduction ratios of 1:1. More recently, macro zooms have become prevalent, particularly from the independents, and focal lengths typically range from between standard (around 60mm) to short telephoto (105mm) and medium telephoto (180mm). The longer the focal length, the further away you can be to achieve any given magnification – this can be beneficial when photographing nervous insects. Beware of lenses that are classified as macro when in reality they simply enable close focusing without producing significant reproduction ratios.

The advantage of a macro lens is that auto-exposure functionality is usually maintained, making assessment of exposure a rather simpler task. Such lenses are also more convenient for fieldwork. However, the very nature of

**Light**

Make the most of available light and consider how the quality of light affects the appearance of the subject. Here, bright illumination has added sparkle to the flower buds and caused beautiful reflections in the dewdrops.

## Close focusing

Macro accessories, such as close-up attachment lenses, extension tubes and bellows, help to reduce the focusing distance and enable focusing much closer to the subject than when using a standard, non-modified lens.

macro photography tests the optical quality of lenses to the extreme and you should invest in the best you can afford. That does not mean going for own-brand lenses only. Some of the independents, notably Tamron and Sigma, produce high-quality macro lenses that are the preferred choice of many professionals.

## Close-up attachment lenses

Close-up attachment lenses offer the cheapest way into close-up photography. They attach to the front of the camera in much the same way as a filter. They work by bending the light rays that pass through them, causing them to focus at a nearer point than would normally be the case. However, they will degrade image quality and are best used as a means of assessing

your interest in the style before moving on to more expensive equipment.

Close-up attachment lenses come in varying strengths, the most typical being +1, +2 and +3. They can be used singly or in combination (although this is best avoided as image quality is markedly reduced). The greater the value, the higher the magnification.

## Extension tubes

Extension tubes (sometimes referred to as spacers) increase the distance between the lens and the film plane, enabling closer focusing distances. They are typically available in three sizes and can be used singly or in combination. The greater the distance between the film plane and the lens, the greater the magnification that can be achieved.

Early models were manual-based and prevented AE and AF functions from working. However, more recent designs are fully automated, maintaining all the automatic functions of the modern SLR.

The principal advantages are a relatively low cost, in-the-field convenience and no degrading of image quality, as tubes contain no glass. On the downside, they are limited by their physical size, making fine adjustments impossible. They can also be inconvenient to apply and dismantle as needs arise. They also reduce the amount of light reaching the film/sensor, necessitating slower shutter speeds (possibly inducing camera shake), larger apertures (with the resulting reduction on depth of field), or faster ISO/ISO-E ratings (increased graininess or noise).

## Bellows

Perhaps the ultimate in close-up and macro accessories, extension bellows, like tubes, fit between the lens and the film plane, increasing the distance between the two. The main advantage of bellows is that they allow precise adjustment of the distance for total control over image magnification. Also, having a greater maximum extension, they enable greater levels of magnification. This makes them far more versatile than extension tubes, while maintaining the advantage of no degradation of image quality.

Of course, bellows have their disadvantages. Few models maintain automatic diaphragm

## Macro lenses

To photograph some macro subjects, such as these tiny tree frogs, macro lenses offer a more flexible and versatile option than using macro attachments. A true macro lens will give a reproduction ratio of at least 1:1 (life-size).

control and AE functions. They are also bulkier than tubes, which makes them less versatile to use in the field.

## Reversing rings

The purpose of reversing rings is to enable lenses to be mounted backwards. At high magnifications, optical quality is often improved when the lens is reversed. Reversing rings can be used with the camera and lens alone or with a combination of tubes or bellows.

Being relatively inexpensive, reversing rings provide a cheap route into close-up photography, with even a standard 50mm lens reversed giving a reproduction ratio of close to life-size. However, they have their limitations, as magnification is fixed and all automated functions are lost. Lenses with diaphragms towards the rear also cause diffraction and image quality degradation when reversed.

## Stacking rings

Stacking rings enable a reversed lens to be fitted to a lens in the normal position. The reversed lens then acts as a high-quality close-up attachment lens (see page 29), with far greater levels of magnification possible.

Ideally, the main lens should be a short telephoto of around 100mm and the reversed lens of a wide-angle or standard focal length (between 28mm and 50mm). To calculate the effective magnification, simply divide the focal length of the main lens by that of the reversed lens (e.g. 100mm/50mm = 2x life-size).

The advantage of this system is macro photography at low cost, assuming you own both lenses. You don't even need a lens compatible with your camera, as the lens mount of the reversed lens is unused. Any automatic functions, including TTL metering, are also maintained. The main disadvantage is that the lens aperture used must be small to avoid vignetting. This may reduce exposure options, although it will maximize depth of field.

# macro flash photography

There are numerous challenges to be faced in the field of macro flash photography. Not the least of these is finding a light source that is large enough and close enough to give maximum depth of field while minimizing hard shadows and light fall-off.

In many ways, close-up and macro photography ideally lends itself to artificial light. I appreciate that a few photographers will be critical of

this statement, citing unnatural overtones, hard shadows and black, featureless backgrounds as reasons against using flash. Admittedly, all of these factors can occur. However, they can be easily overcome by careful selection of flash position and subject-to-background separation.

## Single flash set-ups

Contrary to general photographic practice, where powerful flash units are the generally preferred option, in macro photography a small, low-powered flash unit positioned close to the subject becomes a broad, large light source, similar to daylight on an overcast day – an ideal form of lighting.

**Flash**
In many ways, close-up and macro photography ideally lends itself to using flash. Although flash can produce many challenges for the macro photographer, these can be overcome by careful selection of flash position and subject-to-background separation.

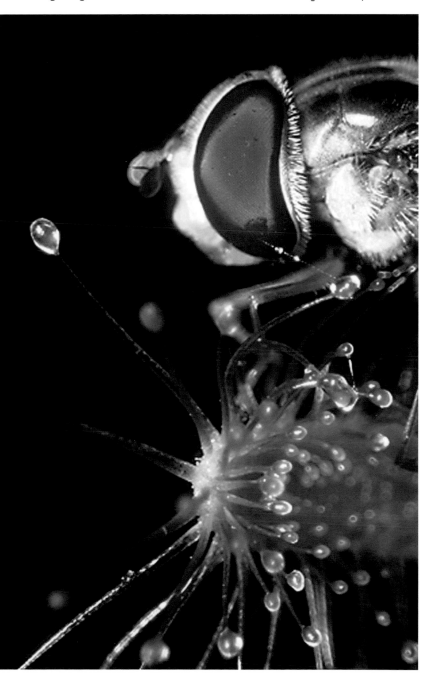

Experimentation is often the key to success, particularly if you are working with a non-TTL flash unit. When photographing with a manual unit you will need to set up some test shots, repositioning the flash unit until you identify the best position for your particular make and model. Although this may seem a laborious and labour-intensive task, once the ideal position is known this set-up will produce consistent results for most subjects.

The exceptions will be when photographing very bright or very dark subjects, when you will need to make some minor exposure adjustments using the exposure compensation function on the camera (e.g. around -1 stop for white or highly reflective subjects and between +1/2 and +1 stop for predominantly dark subjects).

With auto-TTL flash the process becomes easier, as the flash unit will, in theory, modify flash output to suit the situation. In practice, however, I would suggest running some tests since the auto-system is likely to slightly overexpose the scene. This is mainly caused by the flash head being unable to respond quickly enough to instructions from the control chip, resulting in some excess light spilling onto the scene.

### Macroflash unit

Some manufacturers produce special flash units dedicated for macro photography. This simple macroflash unit provides even illumination of small subjects. More sophisticated models are available that enable greater control over the lighting.

## Macroflash units and twin-flash set-ups

Macroflash units are specially designed for close-up and macro photography. They consist of two flash tubes attached to either side of the

### Twin-flash set-ups

An alternative to a macro ring flash is a twin-head flash set-up. Here two flash units work in tandem to provide illumination of the subject. Each flash can be controlled independently to vary the level of lighting on either side of the subject.

lens. In more sophisticated units, the power output from each tube can be adjusted to give even lighting all round or to make one tube the key light and the other a secondary or fill light. The advantage of macroflash is that it produces even lighting that retains some direction to bring out form.

Twin-flash set-ups effectively achieve the same thing as macroflash. They consist of two flash units attached to the camera via a bracket at an angle of around 45 degrees to the subject. When fired together, they produce uniform lighting across the scene.

The disadvantage is the possibility of double shadows, which appear ugly in any picture. To overcome this, you can set the power output of each flash separately, making one unit the main light and the second unit a fill light. Alternatively, you can achieve the same effect by moving one unit further away from the subject. As a guide, doubling the flash-to-subject distance will reduce the level of illumination by around 2 stops.

### Black backgrounds

Some people like black backgrounds, finding the effect dramatic. Others dislike them, citing them as unnatural. Whatever your point of view (and there is no right or wrong) there is a way of avoiding them. Black backgrounds occur because of the rapid fall-off of light from

### Black backgrounds

Black backgrounds often feature in macro photography. Although some people think they look unnatural, they can produce striking effects, particularly when the subject is of bold colouring.

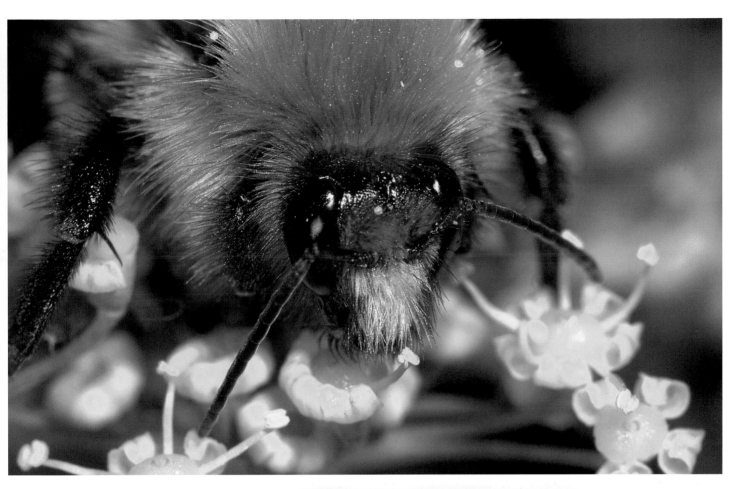

smaller flash units. One solution is to place an artificial background, such as a piece of green card or naturally coloured piece of cloth, behind the subject and at a distance where enough of the flash light will illuminate it but not so much that it becomes overpowering and distracting.

## Highly reflective surfaces

Surfaces with a high reflectance can produce hot spots when photographed with flash. To prevent these hot spots from overpowering your composition, use a diffuser over the flash head(s). This softens the quality of light and mutes any overly bright areas of the image in much the same way that cloud cover diffuses sunlight.

## Twin highlights

When using a twin-flash set-up it is sometimes impossible to avoid recording twin highlights in the eyes of insects and other creatures. These look unnatural because we are used to seeing only a single highlight (as the Earth has only one sun). There is not much you can do to avoid this effect other than using a single flash unit when appropriate. The same effect sometimes occurs when flash is mixed with direct sunlight.

### ▲ Highlights
Using a single flash creates natural highlights in the eyes of subjects such as insects. Using a twin-flash set-up sometimes makes it impossible to avoid twin highlights, which can appear unnatural simply because we are unused to seeing them.

### ◀ Pictures within pictures
The beauty of macro photography is its ability to reveal hidden worlds. The opportunities for photography are infinite, as shown by this image of patterns and texture, a close-up view of a butterfly's wing.

# Photographing the landscape

### Landscape challenge
The ability to see and manipulate light; to manage contrast and create form; to isolate those pictorial elements that add to the image and remove those that detract from the composition; and to create structure from chaos – these are the challenges facing the landscape photographer.

Although some of the techniques faced by the landscape photographer are different to those posed in wildlife and macro photography, they are nonetheless challenging. The ability to see and manipulate light, to identify and isolate elements of design, to structure the picture space to create the illusion of a living landscape, and to manage camera settings to achieve technical excellence all form part of capturing compelling landscape images. Landscape photography is full of infinite possibilities. Simply altering your perspective can change the focus of a picture, perhaps from a wide, sweeping vista into a more intimate close-up or even an abstract design. Time spent in the field means that you can eschew modern technology and revert to a more hands-on approach to camera technique that puts you in greater touch with your craft.

## Techniques for the field

There are many techniques that can be used to help you capture vivid and effective landscape images. Choice of lens is important in successfully photographing vistas, and depth of field and correct exposure will also be considerations. Landscape photography can also necessitate the exploitation of specific techniques, such as the use of polarizing filters to deal with reflected glare off bodies of water, and addressing the issue of converging verticals.

### Choosing lenses
The wide-angle lens has long been synonymous with landscape photography: the expanded angle of view of such lenses helps to include more of the vista and enhance the feeling of space that we associate with the outdoors.

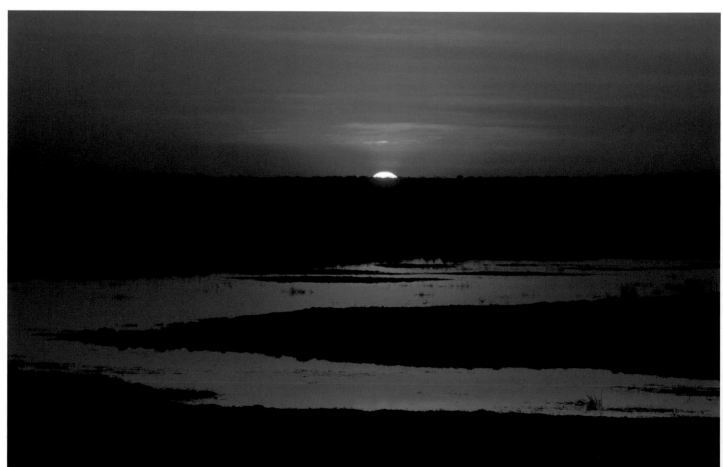

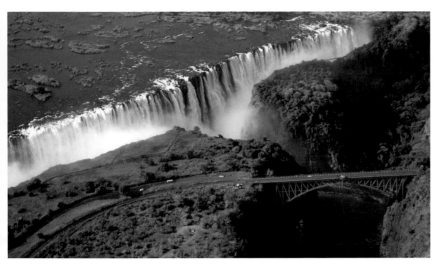

### ◀ Short focal length

Here a short focal length has enabled me to include more of the scene for a more traditional landscape view – albeit overhead – of Victoria Falls in Africa.

### ▼ Telephoto lens

This is also an image of Victoria Falls – very different from the image left. I selected a long telephoto lens to isolate a tiny portion of the falls.

### ▲ Long focal length

By choosing a longer focal length lens for this image of the arches of a bridge in France, I have created an image that relies more on design that aesthetics for interest.

This sense of space is caused by the apparent increase in the spatial relationship between objects in the scene, with subjects close to the camera appearing to be far larger than those in the background.

However, other lens types should not be ignored. Short and even medium telephoto lenses can produce interesting effects in the landscape, by visually compressing the space between distant objects. In certain circumstances, this compression can be used to heighten the impact of graphic elements, thereby strengthening the composition.

When you are photographing a landscape, you should consider all the possible angles and combinations of camera placement and focal length. Try to avoid the trap of thinking that the current position of your tripod is the only possible one. Think deeply about what it is you are trying to achieve visually. Your choice of lens should be dictated by composition, not by physical position.

## Preventing lens flare

Lens flare is caused by light bouncing around inside the lens barrel. It occurs especially when using telephoto or super wide-angle lenses and when photographing into the sun. While the phenomenon may appear atmospheric in moving images, it rarely adds to the quality of a still image and should generally be avoided. To prevent lens flare, always use lenses with an appropriate lens hood attached. To avoid the possibility of vignetting (the blocking of light at the corners of the frame resulting in significant underexposure), it is always preferable to use the manufacturer's recommended lens hoods, many of which, for wide-angle lenses in particular, are sculpted to minimize vignetting. In extreme cases, when even a lens hood fails to prevent lens flare, there is a product available called the flare buster, or you can use a piece of stiff card or your hand to shade the front element of the lens. Be wary of these creeping into the picture frame, though.

### Bracketing
These three identical images were shot at 1-stop increments between the camera's meter reading (image a); the meter reading +1 stop (image b); and -1 stop (image c). In this instance, the camera's meter reading proved the most accurate.

## Focus point and depth of field

Typically, in landscape photography, it is essential that the image appears sharp from the closest foreground detail to the furthest point in the background. As there is only ever a single point of focus, you must exploit the effects of depth of field.

Calculating depth of field accurately is essential to producing effective landscape images. Elements that are relevant to the composition yet appear blurred will be ignored by the brain when viewed as a photograph. The impact of these elements will be lost and the composition weakened. If the detail is important, it must be kept sharp.

To maximize depth of field, it is essential to focus the lens at the ideal point. For example, when relying on autofocus often the nature of the landscape dictates that the camera focuses on infinity, which will minimize depth of field. Instead, switch the camera to manual focus and use the techniques described on page 63 to focus on the hyperfocal distance.

## Exploiting manual exposure

It is typical in a landscape scene for there to be numerous and varying levels of brightness (contrast). To achieve faithful exposures, it is important that the brightness range falls within the latitude of the film/sensor. In particular, when you are using a digital camera, it is essential that no area of the image is overexposed to the point where pixels are burned out (feature-less white).

Although the autoexposure systems in many cameras are highly accurate, they can become unreliable under very complex lighting conditions. In such instances, I recommend switching to manual metering mode and using good old-fashioned exposure techniques to attain the best images.

Consider the following example. Using a pencil and pad, I sketched the scene as the camera saw it. Then, using the greyscale described on page 54, I appended to each distinct area of the scene a brightness value. The sketch clearly shows a brightness range (SBR; see pages 54–56) of 9 stops, in excess of the ability of the sensor to retain detail in both the highlights and shadows simultaneously. Because of the nature of the image, it was impossible to apply an appropriate filter (see pages 31–33), so I was left with a decision to make on whether to expose for the highlights or the shadow area. Photography often involves having to compromise in such ways and, in terms of exposure, it is typically appropriate to expose for the highlights. This is because humans are used to seeing areas of featureless black (e.g., our own shadows) but rarely, if ever, experience large areas of burned-out highlights. Therefore, we feel more comfortable when viewing an image in which what we see is what we might expect to see in reality.

To set the exposure for this image, I set the camera to manual metering and, using a handheld reflected light meter for accuracy, took a precise 1-degree spot-meter reading from the brightest area of the scene. I then set an appropriate exposure on the camera and applied +2 stops' exposure compensation to compensate for tonality (see page 46).

## Bracketing

Bracketing is often used in landscape photography for recording scenes where calculating an accurate exposure is complex and difficult to achieve. The technique requires multiple images to be taken of the same scene but at slightly varying exposures.

For example, a sequence of five images may be taken, the first one using the camera's suggested exposure settings, and then four additional shots at half-stop increments between 1 stop over the camera's reading and 1 stop under. The theory is that, of the five images taken, at least one of them should be exposed correctly.

Some modern cameras offer bracketing as an automated function. A series of bracketed images are taken in a sequence determined by the photographer beforehand.

A polarizing filter will help to reduce the amount of reflected light from a non-metallic, shiny surface, such as water. If using an SLR-type camera, rotate the filter until you see the right effect through the viewfinder.

In large-format photography, a similar technique can be achieved using just two sheets of film. Both of the film sheets are exposed at the same exposure value and only one is processed. The processed image is assessed and, if needed, the duplicate is processed at a different equivalent ISO rating to either increase or decrease the exposure (see the discussion on 'pushing and pulling film' on page 49–50).

While at first it may seem sensible to bracket every shot, taking three, five or more images of the same scene can prove costly over time. It is also less effective when photographing non-static subjects.

## Slow shutter speeds and image sharpness

Setting narrow apertures often necessitates the use of slow shutter speeds in landscape photography. The problem this causes is an increased likelihood of image blur due to camera shake.

There is rarely an excuse, aside from laziness, for not using a tripod in landscape photography and I recommend that you always travel with

one. All tripods have a weight limit and your tripod should be equal to supporting securely the equipment you intend to use.

There are two centres of gravity that determine the stability of a tripod. The first is the distance between the ground and the base of the tripod head. The second is the distance between the base of the head and the camera. For added stability, you should always angle the legs to the widest possible position, given the physical circumstances, and only extend them as far as absolutely necessary. Avoid using the centre column.

In particularly windy weather, weighting the tripod with a heavy bag hung from a hook screwed into the centre column will help to increase its stability.

## Polarizing filters and water

The shiny surface of water can cause non-polarized light to increase the effects of reflections on photographic film/sensors, often diminishing colours and detracting from the scene as a whole. A polarizing filter (see page 33) will block non-polarized light and alleviate the problem it causes when photographing scenes with water on bright sunny days. For best results, polarizing filters should be used when the camera is positioned at right angles to the sun.

## Dealing with converging verticals

Landscape scenes that include tall structures, in particular buildings, can often suffer from converging verticals, caused by tilting the camera upwards. Without specialist equipment, it is impossible to avoid converging verticals other than to find a higher viewpoint from which to take the picture that negates the need to tilt the camera.

Tilt lenses (see page 29) will help to alleviate the problem by enabling the lens to remain on a plane parallel to that of the subject. Alternatively, cameras that allow the physical movement of the lens or film back, or both, (typically large-format cameras – see pages 15–16) provide even greater flexibility in overcoming the effects of converging verticals. These cameras require more specialist knowledge and are not typical of most photographers' kit bags. If all else fails – though not the subject of this book – converging verticals can be corrected in image-processing software.

### Polarizing filter

A polarizing filter has been used in this image to remove the glare from the water, leaving just a few highlights.

**Converging verticals**
Photographs that contain tall buildings typically suffer from converging verticals (as in image a). Specialist lenses can help alleviate the problem (image b), as can the camera movements indicative of many large-format cameras. An alternative is to worry about the problem later and fix it in Photoshop!

# The psychology of photography

Landscape photography is a genre in which the composition of the image can have a significant psychological impact on the viewer. There are many ways in which you can frame a picture to produce the most compelling visual and emotional effect.

## A sense of scale

Because of the two-dimensional nature of photographs, it is often difficult to achieve a true sense of scale of the subject being photographed. Mountains that impress with their sheer magnitude can appear ordinary; giant sequoias seem far from gigantic; and mighty rivers look like mere streams.

Including subjects within the picture frame that help to emphasize the scale of the principal subject will add to the compositional value of the image. A carefully placed climber on a mountain ledge or a well-positioned boat on a river or sea can completely change the impact that a picture makes.

## A sense of depth

Like scale, depth can be elusive in photographs. Humans see with two eyes, which is how we gauge depth. Cameras, on the other hand, have only one 'eye', which restricts their ability to define depth. Try closing one eye when sitting in the passenger seat of vehicle and see how much harder it is to assess the distance between you and the car in front. (Important note: never attempt this when actually driving a vehicle!)

The sense of depth must, therefore, be created through composition. Increasing spatial relationships through choice of focal length (as described earlier; see page 120) is one technique. Others include using carefully positioned objects in the foreground that help lead the eye into the picture space and the emphasis of converging lines seen in roads and rivers.

## Balance

The natural human state is one of equilibrium. In this state we feel comfortable and at peace with the world. When our balanced existence is knocked off course, our state changes, and we become more animated and tense. How the pictorial elements are positioned in the frame in relation to each other affects how we respond to an image emotionally. When objects are photographed in such a way that their position appears symmetrical, our sense of equilibrium is heightened and such images calm and soothe us. Conversely, if the same objects were to be placed in an asymmetric pattern, the opposite feelings would be invoked and our emotional response to the image would be distinctly different. When composing your landscape scene, try to gauge what mood you are attempting to impart and use the tools at your disposal (such as focal length and camera position and angle) to assert your authority as the picture-maker.

## Visual energy

Landscapes tend to be static. Sometimes this stillness is complementary to the composition, helping to accentuate a feeling of calmness and well-being. On the other hand, lack of movement

**Tilting the lens**
It was impossible to keep the camera parallel to the building in this shot, but by adding a degree of tilt to the lens I have maintained the integrity of the vertical lines.

◀ **Leading the eye**
The converging lines of the two rows of trees along this pathway lead the viewer into the picture space, creating a sense of depth and drawing attention to the castle in the centre of the image.

▲ **A sense of depth**
Here I have used two strategically placed buildings to create a sense of depth. The eye naturally flicks between the two structures, giving the impression of three dimensions.

can invoke apathy and leave a photograph wanting. The careful use of graphic elements can induce visual energy in a landscape scene. For example, diagonal lines are visually energetic, and competing shapes can cause the eye to physically move from one portion of the picture space to another (see pages 68–81 for more on composition).

When you view a scene, look for the graphic elements that form it and use your camera to isolate and accentuate the elements that create the visual impression you are trying to achieve.

## A sense of motion

It is not always necessary for every aspect of a landscape photograph to appear frozen in time. Movement, portrayed by selecting a slow shutter speed that allows objects to blur, creates a sense of visual energy that can bring some landscape scenes to life. Obvious examples are of water cascading over the lip of a fall or of leaves gently blowing in the

breeze. Another, lesser-known, effect of motion blur is to minimize harsh edges. Soft edges are calming and will complement a landscape scene that relies on serenity for its appeal. In this instance, the hard edges of complementary pictorial elements can conflict with the soothing properties of an ethereal landscape and detract from the composition.

## Straight and level

The horizon is our natural point of orientation, so a sloping horizon tends to create a sense of imbalance that puts us on edge. Therefore, unless you are deliberately trying to create a sense of tension, it is important that any horizon line is perfectly level. The best method of ensuring a level horizon is to fit a small spirit level to the accessory shoe on the camera – a technique I employ all the time due to a fault in my eyesight that makes sloping lines appear level! Some tripods have a spirit level built in that can serve equally well.

## The sky's the limit

Skies can make or break a landscape photograph and, consequently, how you deal with them can either enhance or detract from the overall composition of your images. Typically, the worst-case scenario is a featureless grey or white sky, devoid of any detail and unpleasant on the eye. If this is the sky that confronts you, the best course of action is usually to exclude it altogether by framing the image space appropriately.

Grey skies where individual clouds are discernible are a slight improvement, but adding a little colour via a graduated tobacco filter or warming the scene with an 81-series filter will greatly improve the mood of the picture. Additionally, heavy storm clouds in a thunderous sky can prove quite evocative, given the right balance and setting.

While featureless blue skies are better than grey ones, they too lack visual interest if handled poorly. It is important that any large area of single-tone space be made to work within the image frame and complement the overall composition rather than detract from it. Too much space may lead the viewer to question what is missing. The picture-postcard sky is one where deep blue tones are punctuated by

bright white fluffy clouds. I am not suggesting that this is a requirement of every landscape – far from it. However, the inclusion of clouds can add visual interest to a scene.

When exposing areas of sky that are considerably brighter than the foreground, you may need to use a graduated neutral density filter to keep the sky from overexposing (see page 33).

## Light, the clock and the seasons

Earlier in the book I talked about light (pages 40–44) and its importance in photographic composition. Light is also affected by the seasons, particularly in temperate regions of the world. During the summer months, for example, the sun can rise quickly and reaches an overhead peak that is non-conducive to successful landscape photography because of its harshness. Conversely, in winter the sun never reaches the same height and is angled throughout the day in a way that is aesthetically pleasing for photographers. Some subjects can only be photographed well at certain times of the year simply because of the position of the sun. Durdle Door on Britain's south coast is one example that springs to mind.

**◀ Evening light**
During the summer, the sun is often high overhead. At such times, late evening produces a warm tone to pictures that otherwise suffer from cool, harsh light.

**▼ Photographing skies**
Skies can make or break a landscape image, adding pictorial interest (as here), particularly when cloud formations add a sense of energy and motion.

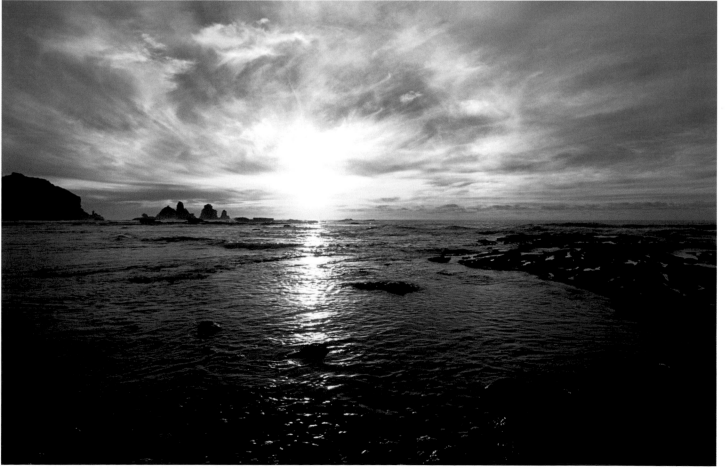

## ▲ Light and the landscape

Early-morning light bathes this scene of Kruger National Park in South Africa in a warm glow. Later in the day, the same scene will appear bland and drab. Lighting can make or break a photograph, so understanding how it affects your images is key to mastering landscape photography.

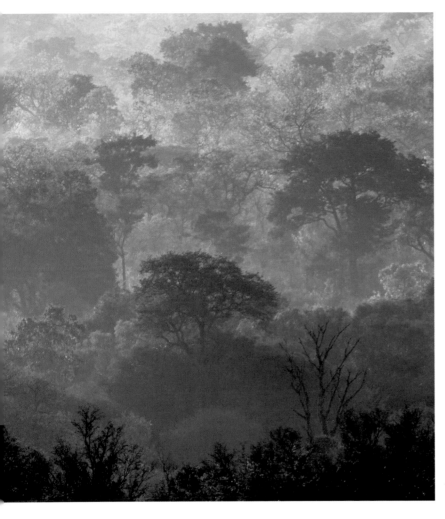

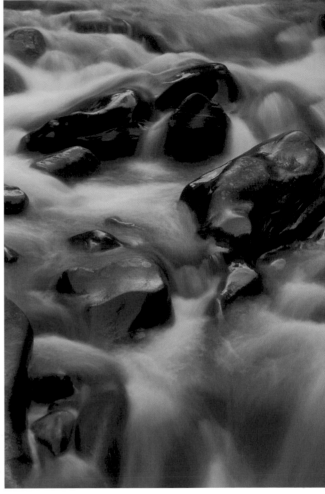

**▲ (right) The abstract landscape**

The overly blue tone of this scene, caused by overcast lighting and deep shadow, evokes an unearthly feel in this picture. This abstract use of colour can produce interesting and emotive images.

**◀ Using filters**

An 81B filter was used for this scene to enhance the warm glow of the early morning light. Setting an appropriate digital WB value would achieve the same effect.

When travelling around the country scouting for suitable locations for photographing, always consider the relative position of the subject and the prevailing lighting conditions. Make some notes of scenes that might be worthy of revisiting at different times of the day and during different seasons of the year.

Also consider how filters (or the use of digital white balance settings) may help to improve the poorer photographic qualities of light at varying times. At its summer noon peak, for example, daylight has a strong blue cast (see 'the colour temperature of light', page 43) that is rarely appealing in landscape images. Other conditions can also adversely affect the colour temperature of light, including heavy shadows and generally overcast weather. In each of these cases, an 81-series filter will reduce the level of blue light waves entering the camera, thereby creating a warmer cast to your photographs.

Adjusting the digital white balance settings depending on the colour temperature of the prevailing light (see page 44) will have a similar effect as filters when using a digital camera.

## The abstract landscape

If you look in detail at the landscape and extract its constituent parts you will notice that amid the apparent chaos, a mix of graphic elements helps to form and structure all landscapes. Lines, shapes, patterns and colours merge to create what we see as a greater whole.

One aspect of photography that turns ordinary pictures into compelling images is an ability to render the world in unexpected ways. By isolating graphic components and presenting them outside of the confines of expectation, we can create photographs that question our natural perceptions of the world and shake us from everyday apathy.

The successful landscape photographer has an ability to decipher these constituent parts and organize them in such a way that simplifies the photographed scene. Sometimes the resulting image can be a graphic statement, other times it can be a truly abstract portrayal of our world. In both cases, it is the simplicity of the image, the isolation of elements of design and the landscape recognized at its most basic level, that creates the visual power.

# Useful websites

**Form**

The petals of a rose take on graphic form when photographed close up.

**Composition**

The texture of the sand gives this image life, while the leading lines of residue water draw the eye into the picture space.

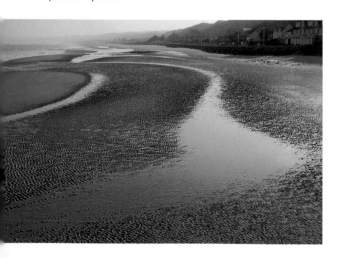

## AUTHOR'S WEBSITE
www.chrisweston.uk.com

## MACRO PHOTOGRAPHY
PAUL HARCOURT DAVIES
HIDDEN WORLDS
www.hiddenworlds.co.uk

## DIGITAL PHOTOGRAPHY
DP REVIEW
www.dpreview.com

ROB GALBRAITH
www.robgalbraith.com

ADOBE (USA)
www.adobe.com

ADOBE (UK)
www.adobe.co.uk

PHASE ONE (USA)
www.phaseone.com

PHASE ONE (UK)
www.phaseone.co.uk

## FILM
FUJI FILM (USA)
www.fujifilm.com

FUJI FILM (UK)
www.fujifilm.co.uk

KODAK (USA)
www.kodak.com

KODAK (UK)
www.kodak.co.uk

## PHOTOGRAPHIC WORKSHOPS AND HOLIDAYS
NATURAL PHOTOGRAPHIC
www.naturalphotographic.com

LIGHT & LAND
www.lightandland.co.uk

## NATURE PHOTOGRAPHY
CHARLIE WAITE
www.charliewaite.com

JOE CORNISH
www.joecornish.com

NIALL BENVIE
IMAGES FROM THE EDGE
www.imagesfromtheedge.com

ART WOLFE
www.artwolfe.com

## CONSERVATION
CANOPY
www.thecanopy.org

WORLD WILDLIFE FUND
www.wwf.org

ROYAL SOCIETY FOR PROTECTION OF BIRDS (RSPB)
www.rspb.org.uk

ENGLISH NATURE
www.english-nature.org.uk

SCOTTISH NATURAL HERITAGE
www.snh.org.uk

COUNTRYSIDE COUNCIL FOR WALES
www.ccw.gov.uk

US FISH & WILDLIFE SERVICE
www.fws.gov

WILDLIFE TRUSTS
www.wildlifetrusts.org

## PHOTOGRAPHY EQUIPMENT
CANON (USA)
www.canon.com

CANON (UK)
www.canon.co.uk

NIKON (USA)
www.nikon.com

NIKON (UK)
www.nikon.co.uk

PENTAX
www.pentax.com

KONICA MINOLTA
www.konicaminolta.com

OLYMPUS
www.olympus-global.com

INTRO2020
www.intro2020.co.uk

SIGMA IMAGING
www.sigma-imaging-uk.com

TAMRON
www.tamron.com

WILDLIFE WATCHING SUPPLIES
www.wildlifewatchingsupplies.co.uk

GITZO TRIPODS
www.gitzo.com

## CAMERA CLUBS
CLUB FINDER (UK)
http://cameraclubs.photopro.co.uk

CAMERA CLUB INDEX (NEW ZEALAND,
AUSTRALIA, SOUTH AFRICA, USA)
http://www.ivan.co.nz/ClubIndex.htm

CAMERA CLUB LINK (CANADA & WORLDWIDE)
http://www.fredsphoto.on.ca/camclub.htm

**Behaviour**
Wildlife photography is all about waiting for the right moment to press the shutter.

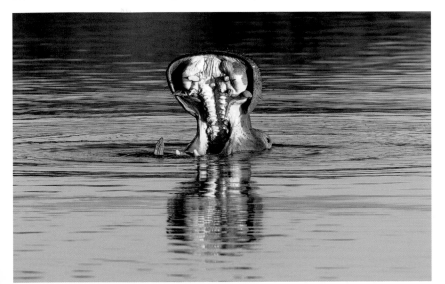

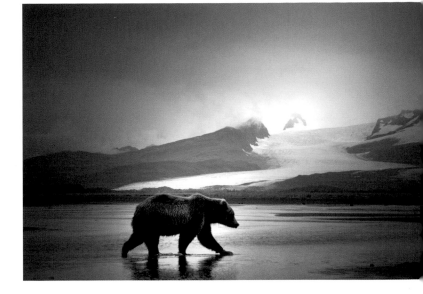

**Sense of place**
Zooming out for a wider view gives this image of a coastal Brown bear a strong sense of place.

## ONLINE PHOTOGRAPHY MAGAZINES
APOGEE
www.apogeephoto.com

E-PHOTOZINE
www.ephotozine.co.uk

NATURE PHOTOGRAPHERS ONLINE
www.naturephotographers.net

## NATURE PHOTOGRAPHY ASSOCIATIONS
NORTH AMERICAN NATURE PHOTOGRAPHERS
ASSOCIATION (NANPA)
www.nanpa.com

## PHOTOGRAPHY BOOKS
BY CHRIS WESTON
www.chrisweston.uk.com/links.html

AMAZON (USA)
http://www.amazon.com/exec/obidos/tg/
browse/-/2081/ref=br_bx_c_2_3/002-6719732-
8665647

AMAZON (UK)
http://www.amazon.co.uk/exec/obidos/tg/
browse/-/267664/ref=br_bx_1_c_1_5/202-
1039271-9604647

# Wildlife photography and the law – useful contacts

**ROYAL SOCIETY FOR THE PROTECTION OF BIRDS (RSPB)**
Website: www.rspb.org.uk

**BIRDLIFE INTERNATIONAL**
Website: www.birdlife.net
Global Office: Wellbrook Court,
Girton Road, Cambridge, CB3 0NA, UK
Tel: +44 (0) 1223 277 318
Email: birdlife@birdlife.org

**BIRDLIFE AFRICA REGIONAL OFFICE**
Regional Office: c/o ICIPE Campus,
Kasarani Road, off Thika Road, Nairobi, Kenya
Postal address: PO Box 3502, 00100 GPO, Nairobi, Kenya
Tel: +254 2 862246
Email: birdlife@birdlife.or.ke

**BIRDLIFE AMERICAS REGIONAL OFFICE**
Regional Office: Vicente Cardenas,
120 y Japon, 3rd Floor, Quito, Ecuador
Postal address: Casilla 17-17-717, Quito, Ecuador
Tel: +593 2 453 645
Email: birdlife@birdlife.org.ec

**BIRDLIFE ASIA REGIONAL OFFICE**
Regional Office: Toyo-Shinjuku Building,
2nd Floor, Shinjuku 1-12-15, Shinjuku-ju,
Tokyo 160-0022, Japan
Tel: +3 3351 9981
Email: richardg@indo.net.id

▶ **Know the law**
It is important for wildlife photographers to be respectful of their subject's welfare.

**BIRDLIFE EUROPEAN COMMUNITY OFFICE (ECO)**
Regional Office: Rue de la Loi 81A,
B-1040 Brussels, Belgium
Tel: +32 2230 38 02
Email: bleco@birdlifeeco.net

**BIRDLIFE MIDDLE EAST REGIONAL OFFICE**
Regional Office: c/o Royal Society for the Conservation of Nature, PO Box 6354,
Amman 11183, Jordan
Tel: +962 6 535 5446
Email: birdlife@nol.com.jo

**US FISH & WILDLIFE SERVICE**
Website: www.fws.gov
Tel: 1-800 344 9453 (within US only)

**THE WILDLIFE TRUSTS**
Website: www.wildlifetrusts.org
Address: The Kiln, Waterside,
Mather Road, Newark, NG24 1WT, UK
Tel: +44 (0) 870 036 77 11

**An eye for a picture**
Always be open to picture ideas, which can manifest in unexpected places.

# Acknowledgments

Many people contribute to a book and the extent of contributions varies, but all are vital to the success of the project. I would like to thank everyone involved with *Photographers' Essential Field Techniques*, in particular Chris Morgan in the USA, Stu and Justyna Porter in South Africa, my various guides in Kenya, Tanzania, Botswana and France, Paul Harcourt Davies in Italy, Neil Baber and Ame Verso at David & Charles, and Fraser Lyness in the studio in Weymouth. Thanks also to Nikon, Fuji, Hasselblad, Ebony and Intro2020 for the numerous equipment images and to Wildlife Watching Supplies for clothing and blind/hide images.

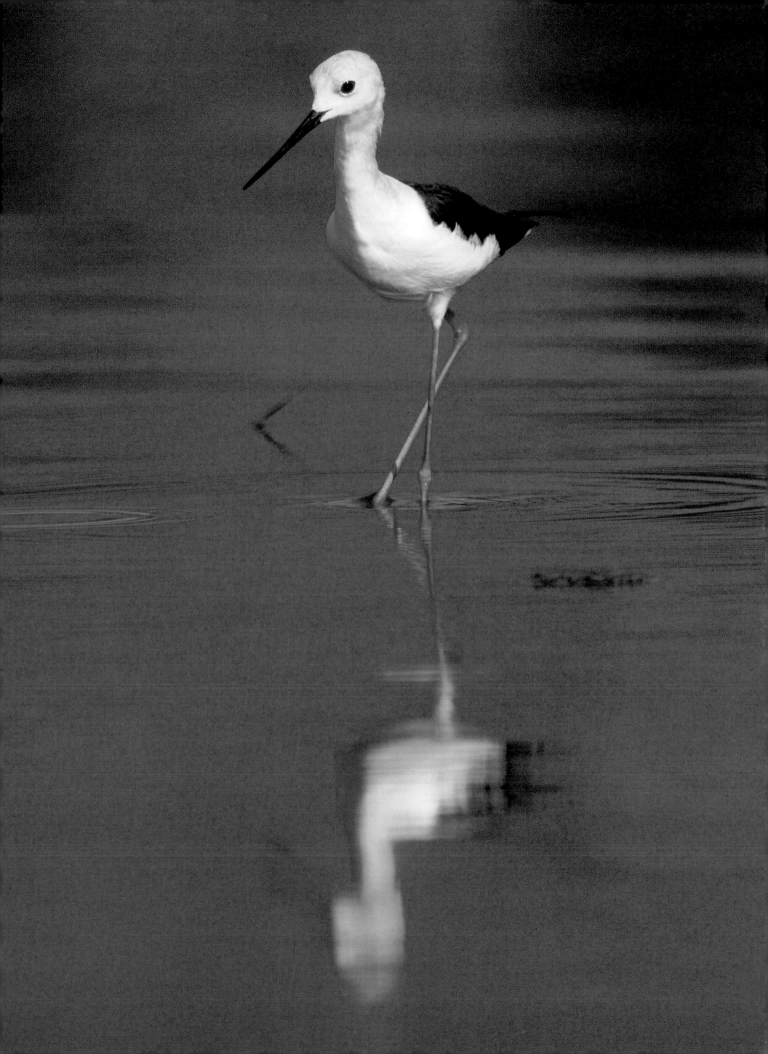

# Glossary

ABERRATIONS – Causes completely blurred images. There are six types of aberrations: spherical, coma, astigmatism, curvature of field, distortion and chromatic.

AF [AUTOFOCUS] LOCK – Used to lock AF operation once the subject is in focus.

AF SENSOR – The sensor used to detect focus in cameras equipped with autofocus operation.

APERTURE – The adjustable opening in a camera lens used to control the amount of light reaching the film/sensor.

APOCHROMATIC – Lenses designed to correct for colour aberrations. Usually used in telephoto lenses that have large maximum apertures. See Chromatic Aberration.

ASPHERICAL – A non-continuous curve. Refers to elements in lenses that have been designed to compensate for distortion by having different curves on individual elements. Allows for a more compact lens.

BACK LIGHTING – Light coming from behind the subject.

BELLOWS – Accordion-like device that allows the lens to move towards or away from the film plane. Usually used for close-up or macro work.

BLACK-AND-WHITE FILM – Light-sensitive film that, when processed, produces a black-and-white, negative image. The resulting 'negative' is projected onto light-sensitive paper to make black-and-white photographic prints.

BLUR – Unsharp. Caused by inaccurate focus or excessive movement of the camera or subject.

BOUNCED LIGHT – Light reflected off opaque materials, such as a ceiling, softening the light and reducing contrast.

BRACKETING – Practice of varying exposure to ensure accurate exposure of a given subject.

BULB – Shutter speed setting that enables the shutter to remain open so long as the shutter release is depressed. Sometimes referred to as Time setting. Usually indicated by a B or T on the shutter speed selector.

CABLE RELEASE – A cable device for releasing the shutter. Usually used for slow shutter speeds when the camera must remain absolutely still.

CCD – Type of digital sensor used in many D-SLR-type cameras.

CHROMATIC ABERRATION – A type of image distortion that usually appears as a rainbow on the edge of objects towards the outside of an image. Occurs when light rays passing through a lens focus at different points, depending on the light wavelength. An apochromatic lens corrects for this problem.

CMOS – Type of digital sensor, typically used in professional-specification digital cameras.

COLOUR-NEGATIVE FILM – Light-sensitive film that, when processed, produces a coloured, negative image. The resulting 'negative' is projected onto light-sensitive paper to make colour photographic prints.

COMA – Where light rays pass through an off-axis point, causing the lens to focus at different points causing blur.

CONTINUOUS SERVICE AF – Used to allow the camera to continue focusing as long as AF is active. Used for taking pictures of fast-moving subjects. Also know as 'Continuous Predictive Autofocus' or 'Predictive Autofocus'.

CONTRAST – The difference between light and dark values. Usually refers to the gradation between black and white. Fewer grey values are described as 'high-contrast.' Many shades of grey are low-contrast.

CROP – To enlarge an image so that parts are cut or left off the print.

D-TYPE LENS – Nikon lens designation for lenses that communicate distance to subject information with Nikon camera bodies.

DEDICATED FLASH – Electronic flash designed to work with the meter and exposure system of a specific camera.

DEPTH OF FIELD [DOF] – The distance between the farthest and nearest points that are in focus. The term can also be used to describe the zone of acceptable sharpness before and behind a given focused subject. DOF varies according to numerous factors such as lens focal length, aperture and shooting distance.

DIAPHRAGM – See Aperture. Can also be a type of shutter, e.g., a leaf shutter.

**DIFFUSER** – Material that softens and diffuses light in order to reduce contrast.

**DIGITAL SENSOR** – The light-sensitive device in a digital camera.

**DX CODING** – Type of bar coding used to electronically communicate film speed to the camera.

**ED [EXTRA LOW DISPERSION] GLASS** – A glass developed and trademarked by Nikon Corporation, used in telephoto lenses to obtain optimum correction to help prevent chromatic aberration. These lenses are resistant to temperature changes, preventing focus shift problems in lenses that use calcium fluorite crystal elements.

**EF LENS** – Designation for Canon EOS system AF lenses.

**EMULSION** – The light-sensitive, chemically active surface on photographic film and paper.

**EXPOSURE** – The amount of light that reaches the film/sensor or the combination of f-stop and shutter speed that controls the amount of light. Also used to describe an exposed piece of film.

**EXTENSION TUBES** – Hollow metal tubes used to extend the length of a lens. Used for macro or close-up photography.

**F-NUMBERS** – Numbers on the outside of the lens corresponding to the aperture opening. The larger the number (e.g. f/22), the smaller the opening of the lens; the smaller the number (e.g. f/2.8) the larger the opening of the lens. The f-number is equal to the focal length divided by the aperture diameter.

**FILM** – Photosensitive material used in a camera to record an image. Made from a thin, transparent base coated with light-sensitive chemicals.

**FILTERS** – Transparent lens attachments used to change the colour, or other characteristics, of an image. They are used both on the camera and in the darkroom.

**FISHEYE LENS** – A type of super wide-angle lens with an angle of view that can approach 180 degrees.

**FIXED FOCAL LENGTH** – A lens with a fixed focal length, e.g., a non-zoom lens.

**FLASH** – An artificial light source.

**FLASH SYNC [SYNCHRONIZATION]** – The shutter speed that corresponds to the timing of the flash.

**FOCAL LENGTH** – The distance between the back lens element and the focal plane, measured in millimeters.

**FOCAL PLANE** – The area of the camera where the lens focuses on the film/sensor.

**FOCAL POINT** – The point on the optical axis where light rays form a sharp image of a subject.

**FOCUS** – To move the lens in relation to the focal plane in order to record a sharp image on the film/sensor.

**FOCUS MODE** – Three basic types of focus modes exist for AF cameras: Single servo AF, Continuous AF and Manual. Different cameras may use different nomenclature to identify these modes.

**FOCUS PRIORITY** – A camera mode where the shutter cannot be released until the subject is in focus.

**FOCUS TRACKING** – Where the camera's microprocessor analyses a moving subject's speed, anticipates the position of the subject at the exact moment of exposure, and focuses the lens based on this information.

**FORMAT** – Refers to both the size of the camera (e.g. medium format) and the size of the film/sensor (e.g. 35mm format film).

**GRAIN** – Exposed and processed silver halide crystals and coloured dyes. After processing they turn black or appear coloured and form the miniature grain that makes up an image on a piece of film.

**GUIDE NUMBER [GN]** – A number used to describe the output power of a flash. Usually expressed using an ISO film speed and a distance measurement.

**HIGHLIGHTS** – The bright to white range of tones in an image.

**HYPERFOCAL DISTANCE** – The closest point at which a camera can be focused where the depth of field includes infinity.

**INFINITY** – In relation to camera focus: the horizon.

**INTERNAL FOCUSING [IF] SYSTEM** – A system used where the internal elements in the lens are the only parts that move during focusing. This prevents the physical length of the lens from changing.

**IS [IMAGE STABILIZER]** – Used in some Canon EF lenses and compensates for camera shake.

ISO – The International Organization for Standardization (ISO).

ISO-E – Digital equivalent to the ISO rating used for film.

◻LATITUDE – The range in stops of film's ability to retain detail in both shadow and highlight areas.

LCD (LIQUID CRYSTAL DISPLAY) – An information display, usually used for external displays on cameras or other electronic devices.

LENS – An optical device used to control and focus light.

LENS COATINGS – Thin anti-reflective materials applied to the surface of a lens in single or multiple layers to help reduce light reflection and increase amount of transmitted light.

LENS HOOD/SHADE – A lens addition used to minimize lens flare or unwanted light from reaching the lens.

LIGHT – Radiated energy that forms the portion of the spectrum visible to the human eye.

LIGHT METER – A light-sensitive device used for evaluating the amount of light in a scene for exposure.

◻MACRO PHOTOGRAPHY – Commonly, close-up photography. Specifically, any photography where the level of magnification is 1:1 (life size) or larger.

MAGNIFICATION – The size of an image relative to the subject as expressed in a ratio.

MEMORY DEVICE – An in-camera device used for the semi-permanent storage of digital images.

MENU – List of controls and functions in a digital camera usually accessible via the LCD monitor.

MODE – Type of exposure method used by a camera, e.g., manual mode, aperture priority mode, etc.

◻NEGATIVE – A processed piece of film where the image is reversed so that the shadows are light and the highlights are dark.

NEUTRAL DENSITY (ND) FILTER – A dark, colour-neutral filter used to control the amount of light reaching the film.

NOISE – Coloured, random and unrelated artefacts caused by excessive heat or high amplification in digital photography.

NORMAL LENS – A lens where the focal length is approximately equal to the diagonal of the film/sensor size it is being used for. This is also representative of the field of view of human sight.

◻OVEREXPOSURE – When light-sensitive material is exposed to too much light, resulting in film that is too dense to print or view well.

◻PANNING – The act of following a moving subject with the camera while releasing the shutter.

PANORAMIC – An image proportionally more rectangular than a 35mm film frame. Also, a type of camera for exposing film in a panoramic format.

PARALLAX – In rangefinder cameras, the difference between the image seen by the lens and the viewfinder. The discrepancy increases as the subject moves closer to the camera.

PERSPECTIVE – The visual representation of three-dimensional space in a two-dimensional medium. Three dimensions are implied by converging lines and a focal point.

POLARIZING FILTER – Two pieces of polarizing material that rotate on an axis so that the polarizing effect can be increased or decreased.

PRIMARY COLOURS – Red, yellow and blue. The three colours that, combined, make white light.

◻RANGEFINDER – A camera with a viewfinder separate from the lens. Not an SLR.

RECYCLING TIME – The time it takes for a strobe or battery-pack to recharge enough that it can power a flash burst.

REFLECTED LIGHT READING – Light meter reading of the amount of light reflecting off a subject, as opposed to falling on a subject (incident light).

RELEASE-PRIORITY AF – In release-priority autofocus operation, the shutter can be released at any time whether the subject is in focus or not.

RESOLUTION – The ability to reproduce small details in a photograph (also known as resolving power). Resolving power is used to quantify lens performance and is measured in lines per millimeter (l/mm). The measurement indicates how many black lines placed at equal intervals within 1mm can be resolved by a particular lens.

ROLL FILM – Film that comes in a roll and can be exposed in multiple frames.

SHEET FILM – Film that is cut into individual sheets usually 4x5in or larger.

SHUTTER – The device in a camera that controls the amount of time light is allowed to expose the film/sensor.

SHUTTER PRIORITY – A camera exposure mode where the photographer chooses a shutter speed and the microprocessor in the camera sets a corresponding aperture for best exposure.

SILVER HALIDE – The light-sensitive component in chemically treated, photosensitive surfaces.

SINGLE-SERVO AF – An autofocus mode that locks focus after detecting the point of focus until AF is deactivated.

SINGLE LENS REFLEX (SLR) CAMERA – A camera that uses a mirror and prism to allow the photographer to see through the main lens.

SLIDE FILM – Light-sensitive film that, when processed, produces a transparent film image.

SPEED – In photography, the sensitivity of a photosensitive material. This is expressed as either an ASA or ISO number.

SPOT METER – A light meter, which takes its reading at an angle of between 1 to 8 degrees. Used for the Zone System or to determine the reflective values of specific elements in a scene.

STANDARD LENS – See Normal Lens.

STOPPING DOWN – To decrease the size of aperture in a lens, e.g., to stop down from f/3.5 to f/16.

TELECONVERTER – An optical device used to increase the effective focal length of a lens.

TELEPHOTO LENS – A lens with a focal length longer than the diagonal of the film format used.

TONE – In photography, usually refers to the grey values in an image.

TRANSPARENCY – A processed and stabilized positive film image.

TRIPOD – A collapsible camera support with three legs.

TTL – Refers to flash or exposure metering that is read through-the-lens at the film/sensor plane.

TUNGSTEN – A metal filament used in most light bulbs.

UD GLASS – A Canon designation for lenses designed to correct for chromatic aberration.
ULTRA LOW DISPERSION (UD) – A type of glass used by Canon to make lens elements. UD glass corrects for chromatic aberration.

UNDEREXPOSURE – Allowing too little light to reach a photo-sensitive material. Results in a thin or light image with negative material and a dense or dark image with reversal material.

USM – Canon designation for 'Ultrasonic Motor'. Canon's fastest autofocus lens technology.

UV FILTER – Filter used to reduce the amount of ultraviolet light reaching film. Ultraviolet light can cause an image to appear hazy.

VIBRATION REDUCTION – Nikon's equivalent technology to Canon's Image Stabilization. See IS.

VIEWFINDER – An optical viewing device for framing and focusing an image in a camera.

VIGNETTING – The effect of blocking the light at the edge of an image. Can be caused accidentally by a combination of wide-angle lens and filters, or on purpose as a deliberate effect.

WHITE BALANCE – Control for setting the Kelvin value relative to the colour temperature of the prevailing light.

WIDE-ANGLE LENS – A lens with a focal length less than the diagonal of the film format it's being used for.

ZONE SYSTEM – A system developed by Ansel Adams, Fred Archer and Minor White to pre-visualize, optimize and control black-and-white film exposure as well as the print process.

ZOOM LENS – A lens that has a variable focal length, e.g., 70–200mm.

# Index